High Praise for Language of Scars

"A transparent autobiographer must reveal his or her intimate facts with mesmerizing floridity. Your readers will remember your magnetic story forever. Your book is a triumph of the human spirit, times ten. This memoir is bursting into a cinematic bonanza."

—Tom Carter, NY Times Best Selling Author

"Patti R. Thompson has written a deeply personal, painfully honest revelation of her own journey of faith. I was profoundly moved by the telling of her unique tale, and her struggle to fully understand and ultimately accept the glorious beauty of her spiritual scars. I so admire her willingness to be 'naked and redeemed' for the sake of the Kingdom of God."

—Kathie Lee Gifford, contributing NBC news correspondent, Emmy award winner, and former co-host of NBC's *Today* show with Hoda Kotb

"While some teach that God will keep his followers out of all trouble, Patti Thompson and Carole King know better. They've tasted of heartbreak and tragedy and have the scars to prove it. But this book goes beyond their pain to tell a story of great hope and joy as God's love works in the darkest places to let his glory shine through our weakness. Through compelling stories, honest struggles, and delightful insights, they show us how to let God work in us, so our

scars don't remind us of our pain, but reflect his majesty. If you've known pain and disappointment, this is a book not to be missed.

—Wayne Jacobsen, Author of, *He Loves Me*, *Finding Church*, *A Language of Healing for a Polarized Nation*, and co-author of *The Shack*.

"Patti Holcombe-Thompson's latest book, *Language of Scars,* is captivating, thrilling and stimulating. It will stir your heart, agitate your thinking and provoke you to pray for and trust in God's guidance when you undergo difficult challenges that can inflict fear, pain and heartbreak. Patti creatively prescribes a resolution for every struggle you may endure. She lays the foundation that with faith in God we can endure hardship and turn our tragedies into triumphs. Patti makes it abundantly clear that with God we can find healing from every hurt and restoration from every scar."

—Kelly Wright, winner of two local Emmy awards and former co-anchor of America's News headquarters (FOX), and co-host of Fox and Friends Weekend

"Most authors write only of lands they have visited briefly or of knowledge recently acquired. Patti Thompson writes of what she has lived, and she does so in an authentic, raw, compassionate manner. We can all be made better by the courage in these pages."

—Stephen Mansfield, The Mansfield Group

The Language of Scars

*The most profound
language of the soul*

by

Patti Roberts-Thompson
&
Carole L. King

Publisher contact:
ThelanguageofScars@gmail.com
P.O. Box 35366
Tulsa, ok 74153

ISBN: 978-1-7351279-2-7 (paperback)
 978-1-7351279-0-3 (ebook)

The Lamb of God limoges box on cover: Ronda Roush Studio • https://rondaroush.com

The Authors' Preface

The Language of Scars

A Word from Patti …

This book has been somewhat of a mystery to me. The timing, the long ago beginning of the writing, the recent finish of the project and… the title. *The Language of Scars* dropped into my heart over a decade ago. I knew it was to be a book and I knew that I was to write it. What I did not know was what the content should be, or what it would cost me to write it. What would the writing of such a book do to me? What would I have to face within my own self to be able to approach such a subject?

What was *The language of Scars* to be about?

There is the obvious answer: It is about scars. But whose scars, what kind of scars, and why go on and on about injuries that produce scars? Initially, I thought the scar thing must be about my own experiences in life. Yes, those could be included. But in time I realized that this book was biographical only for the purposes of providing context for the various ragged scars of other people. And it was to provide hope for wounds within our country, our various faith-walks, and even profound hope for the more ancient injuries that produced

scars on mankind thousands of years ago. One of the most consistent things about humanity is that we are scar producers. We think and act in such a way as to injure ourselves, and others, even while not meaning to do so. It started in the Garden of Eden, found in the book of Genesis, the very first book of the Bible. Even there we see that humans are scar prone creatures.

There is a scar on my right thigh that came about because my brother and I were fighting over who would get the last bit of peanut butter out of the jar. The glass jar broke and I got a rather nasty gash in my leg. My brother got a little bloody, too. I was two and he was four. Already we could be scar makers. While not all siblings go to war over the dregs in the peanut butter jar, they do go to war over the smallest things. And sometimes the smallest things produce lasting gashes on the bodies and souls of their loved ones.

And, of course, our ability to scar others reaches far beyond the peanut butter jar.

It is the unfortunate condition of being human. We each want what we want, and we are willing to fight small battles or big wars to have what we want. And even those wars that we sometime consider 'righteous wars' still manage to kill, maim and crush humanity.

Fast forward to 2020. Watch even one evening news broadcast and one will be overcome with the brutality of our national scars and the scars on our planet. There is not a country, not a society, not a culture, not a people group, not a religion, not a government, not a family and not an individual that has escaped the giving and receiving of injuries that have been so crippling, so heinous that we are walking death bombs. These injuries have the power to bring our world to

the brink of private and personal hells, social calamity, civil war, even international conflicts so dangerous that we could literally all be vaporized in a few seconds. Safe-guards aside, it could easily happen if some angry, broken hateful person touched the wrong button on the destruction machines that many countries either already have, or are secretly scurrying around in the shadows of humanity fashioning the lethal weapons that are beyond our imaginations.

This book is not about transforming the world's societies. It is about transforming you and me, and the many people we love so deeply. If I can submit myself to what it takes to become whole in my spirit, my personality, my body, and my work, then I can recommend this same liberating and transformative prescription to you. And together we can offer it to our families, our communities and to our world. It just takes one having the courage to let the light of God's tenderness search out what ails us and then allow him to put his finger into those bleeding gashes.

The soul will vibrate with such powerful love and faith that healing will happen. And such a healing of one's being causes an explosion of light and God-breathed energy in the very one that was once darkened by the pain of life's difficult experiences.

This is the hope that can be found within the pages of *The Language of Scars*.

I know this because I have experienced it. And this healing is not a onetime deal, just as injuries are not a onetime occurrence. It puts one on a path of healing for a lifetime. And, that wonderful healing power of God that invades your being will drip out of your own soul in powerful streams that will heal whoever comes in true contact with it.

I know you are hurting. And, whether you are a believer in God, Jesus, and the Holy Spirit or not, you are the target of Heaven's intended remedies for your wounds. And you can experience the wonderful wave of healing freedom for which God is famous!

I know there is something wonderful that can be done about your pain.

Read on, my friend…read on.

Patti Roberts-Thompson

A Word from Carole …

Eight years ago, Patti invited me into her home, and into her story…

"I am writing a book, and I have the title," she said. "But I am not really sure what it means. I only know this is the title God has given me." She held on her lap several boxes of printed emails, notebooks, and old journals. There were folders of saved conversations, partially written chapters, and snippets of quotes and ideas. "Can you help me find the story?"

I was here because I do *exactly that* for a living. I help people find their story. I help them write their books. At the time I met Patti, I was also a business journal editor.

"What is the name of the book?" I asked. "*The Language of Scars*," she said. The name arrested my attention, as perhaps it has yours. Nearly everyone I share the title with -- both then and now – registers an instant recognition of shared human experience. And quickly, always, they also share the same response.

"I want to read that book when you're done."

What is it about *The Language of Scars* that we find so universal?

As Patti and I got to know each other, we discovered ourselves to be soul sisters in suffering. We have a similar faith background and went to the same university -- Oral Roberts University -- in its early days when Oral was still building the school. Although we were not students at the same time, we both rose to leadership as students, and we both learned to believe in miracles at ORU. *Really believe in them.*

For a time, though living in separate worlds, our experiences were parallel in many other ways. Both of us fell in love and married

ORU men, who became ministers, and for a season we both lived in happy bubbles of Christian success. And sadly, at different times and yet still in similar ways, we both experienced a day when our successful Christian bubbles burst.

Oh the specifics of our life circumstances were vastly different, to be sure. But at the end of the day, both our minister-husbands wanted out of the marriage, yet intended to keep the ministries we had built with them, moving on without us. Patti and I both "expected a miracle" to keep our homes and marriages and ministries together. We sought counseling, contacted hundreds of "prayer warriors," kept our "faith-confessions" positive, died a thousand deaths and cried buckets of tears, repented of everything we could think of and believed for a better day. We literally ticked off all the boxes.

But the divorces happened anyway.

And so, as ex-spouses of ministers, we fell hard, on the unforgiving pavement of Christian divorce-reality. Due to divorce we lost everything - our social standing, the ministries we helped to build, our careers, and our reputations. We even lost ourselves. The agony and confusion were indescribable. We were broken. And so were the hearts and innocence of our children.

There are no easy answers for what happened to us. We expected miracles, but the divorces happened anyway. The wounds did not heal quickly. Yet strange as it may seem, the day that our "Christian success bubbles" burst was the day that the *real work of Christ in us* began. The longer we lived with our scars, the softer our hearts became. We became less judgmental; less apt to "correct" someone who was down on their luck, and more apt to be simply kind. We found

ourselves less apt to tell a single mother to "get a job" and more apt to share our bread and soup and our kids' hand-me-down jackets.

Scriptures like "Act justly, love mercy, and walk humbly with God" (Micah 6:8) make SO much more sense to both of us now. Little did we realize that we were transforming, learning a new way of thinking, and speaking a more compassionate language, the Language of Scars.

And so, Patti and I discovered together what the book was to be about. *The Language of Scars is a language of humility, of wisdom, and of love. It is not a language of who is right and who is wrong, who is to be blamed for the condition of their lives and who is to be awarded for their great accomplishments. The language of scars is sometimes not even talking. Sometimes it is listening, or serving comfort food, or believing in someone who has been cast aside. The language of scars is the language of redemption.*

And so, Patti and I shared such a rich journey, learning and writing *The Language of Scars*. In fact, this book re-wrote our own stories, along the way. We discovered that every broken place in our lives led to an intersection, not a dead end. Hurt and loss led to intersections with grace and opportunity. Our very scars led us to the person of Jesus, and always to His redemption.

"So, it is with the broken pieces of your life and mine. If offered to Christ for repair, He can make our broken places more beautiful than before the breaking. Life breaks us, but the scars from the breaking are not to be feared or hidden in shame – as if we *alone* are scarred. No, the scars of life come to everyone. Instead, the scars of life offer redemption – an intersection with the grace of God and the deeper purposes of life. This intersection invites us to escape the

confines of a "perfect life" and experience a "redeemed life" in which our scars become a part of our beauty. When Jesus heals our broken places and restores us, our scars gleam as if the pieces of our lives were put back together with liquid gold. By the grace of God, we are now beyond perfect. We are redeemed." (Chapter 1, Kintsugi and the Language of Scars) – *conversations with Patti and Carole.*

To the beautiful *Language of Scars*,

Carole L. King

Acknowledgements

From Patti...

A heartfelt thank-you to the following people

I BEGAN MAKING NOTES FOR this book over 10 years ago. There were thoughts that I wrote in notebooks, random pieces of paper, or even the back of envelopes. The title, The Language of Scars, came to me before I knew what the book was to be about. After the title came to me, I began to collect my thoughts and stories that I thought might relate to the title. The Lord graciously gave me the title, yet he did not tell me what the content of the book should be. I had to "walk out" that understanding.

In 2011, I married Dr. Chris Thompson, my long-time friend from university days. Marrying him brought a beautiful, yet unintended consequence into my life. His love and friendship, as well as his ever-present encouraging voice kept me on course to get my writings put together and into this book. If you like this book, you have him to thank that it exists. I do not think I would ever have decided to publish without his ardent and generous responses to each chapter. He kept telling me that 'right now, there are people who need the healing that is found in this book. You have to keep going, you have to finish this.'

His presence in my life is a constant source of grace and joy. I am forever grateful.

A few years back, I asked Carole King to help me put these random thoughts into some sort of a format. I engaged her to help me find an appropriate structure that would carry my pieces of paper into a cogent document. She did, and she did so with great understanding. In short, she 'got me.' Her labor spans several years and several phases of *The Language of Scars*. Thank you, Carole for your wonderful talents and immense care to detail. I thank you from the bottom of my heart.

The famous and wonderful writer Tom Carter and his wife Janie really did a marvelous job in encouraging me to write this book. Tom helped me in a mountain of ways to believe in myself as a writer and, he gave wise advice about getting this book to the marketplace. Thank you, Tom and Janie. You guys are purely gold.

To my many friends who have hounded me to write another book, I say 'thank- you' for the prodding. Here it is! And I hope you love the results. Linda and Harry Moessner, Connie Beals and Byron Bartlett, Ronda and John Roush, Stephanie and Wayne Boosahda, Sharalee and Alan Sherman and so many others, for years have prompted me and encouraged me with their love. You guys are all gifts from Heaven, not only to me, but to thousands of other people who have benefited from your various gifts and callings. I am more than proud to call you 'friends.'

Finally, it is Christ who brought these wonderful people into my life. It is He who has accepted me into the fellowship of saints, and it is He from whom I get whatever talent I possess. So, it is He who gets all the praise and all the glory, if you feel inspired or helped by this book.

Table of Contents

The Golden Thread

God is a Potter…
He designs and transforms each of us from clay vessels
into Divine works of art.

But in this life, clay pots - even the best ones in
the house - often fall to the ground and are
broken. And so do we. We also often fall and are
broken — even the best of us — our shattered selves
lying in pieces on the unforgiving pavement.

And then what? What can be done once a
clay pot is broken? Is the broken pot's only
option to be swept up and thrown out?
No. No. No.

God, the Potter, knows a better way.

Chapter 1

Kintsugi and the Language of Scars

WHEN THE SHOGUN ASHIKAGA YOSHIMASA came into a room, everyone bowed low and dared not even lift their eyes until the Shogun passed by. Brutality shored up his iron-fisted rule of Japan's military and gave him nearly complete control over the government and all else. The Emperor wisely kept his place in name only. It was the Shogun who wielded the real power. All of Japan knew that the Shogun's stature eclipsed that of the Emperor.

Never was this more evident than in his own home.

Opulence was evidenced even in the minimalist surroundings of his quarters. His wardrobe boasted the finest silks in lush reds and yellows, brilliant blues and greens, with elaborate designs embroidered in gold threads.

His cooking pots were beautifully embellished, his noodle bowls were made by the finest artisans, his teapots were items of splendor. And his imported Chinese tea bowls were renowned for their exquisite beauty.

Yoshimasa's life was a marvel of structure and beauty, whether he was at war on the battlefield or sitting in his tea house indulging in his

daily ritual of tea. His desire for ordered beauty was as profound as his need for absolute power.

On a beautiful afternoon in the spring of 1550, Yoshimasa opened a silk-lined box that contained his most treasured tea bowl. He instructed his servants to use it that afternoon for a most important tea ceremony. He always felt elevated in importance when he used this simple, yet perfect, vessel for Chanoyu, a Japanese tea ceremony. It truly meant something to him. Along with his magnificent sword, this tea bowl was probably the one other thing that gave him immense pleasure to use. Everyone knew of his gratification in lopping the heads of his enemies with one single swoop of his powerful sword. But fewer knew the secret pleasure of using a perfect bowl for tea.

As if on cue, the servant moved soundlessly through the tea house, tea bowl in hand. He was skillful in performing the Chanoyu, performing it dozens of times before his supreme master. And each time, he did it with renewed devotion and honor. Today was no different.

Suddenly the song of a bird temporarily stole his attention, and a protruding edge of a low table caught the front edge of his sandals. He stumbled to the floor. The tea bowl went flying, hit the ground, and broke into five pieces. Death! It was likely that the next breath that the servant drew would be his last; of this he was sure.

Yoshimasa's temper was as famous as his brutality. He thundered, jumped up from his mat, and picked up the servant with one hand, throwing him over a railing and into a thicket of trees. The gathered guests were shaking and dumbstruck but dare not even look up at the furious Shogun.

The Shogun tenderly picked up the five shards and immediately instructed another servant to prepare them to be sent back to China to be repaired.

Months went by. When the tea bowl returned to the Shogun, it was "repaired" with a clumsy collection of staples along the lines of the breaks. Again, he was furious. He deemed the Chinese repair job unworthy of the tea bowl, or of him. Japanese artisans were then ordered to come up with a way to remove the metal staples and repair the vessel in an elegant and worthy manner.

Ordered to resolve the problem in a way that would please the Shogun, the Japanese artisans considered the task with fear and trembling. What material could they use to piece the cup back together that was both elegant and strong? What would satisfy the Shogun's demand for perfection? What would make the vessel not only worthy of the Shogun, but also delightful in his eyes?

Gold. They could repair it with liquid gold.

And so, the art of Kintsugi was born. This brilliant solution, the art of repairing a broken object with liquid gold, produced a tea bowl that was not flawless, but fascinating. Every place of brokenness provided an opportunity for a new thread of golden art. And, when the bowl was complete and returned to the Shogun, he pronounced it to be more beautiful for having been broken and restored to service. Even upon his death, this cherished tea bowl was among his most highly esteemed inheritances left to his son, the next Shogun.

Kintsugi remains a fine art to this day, one that gives a new sense of vitality and resilience to an object which has been broken. Indeed, some artisans go even further, saying that the true life of the bowl

only begins the moment it is shattered. Kintsugi glories in the crafts-man who patiently reconstructs the pottery with his skillful hand, artfully mending the fractures with threads of gold, burnished and hand-rubbed until each crack glows with the rich gleam of whole-ness, creating a unique design even more beautiful than when the bowl was unbroken.

So, it is with the broken pieces of your life and mine. If offered to Christ for repair, He can make our broken places more beauti-ful than before the breaking. Life breaks us, but the scars from the breaking are not to be feared or hidden in shame – as if we *alone* are scarred. No, the scars of life come to everyone. Instead, the scars of life offer redemption – an intersection with the grace of God and the deeper purposes of life. This intersection invites us to escape the confines of a "perfect life" and experience a "redeemed life" in which our scars become a part of our beauty. When Jesus heals our broken places and restores us, our scars gleam as if the pieces of our lives were put back together with liquid gold. By the grace of God, we are now beyond perfect. We are redeemed.

Come with me, meet some tea bowls who have been smashed to bits. You might even find yourself among them.

The Second Golden Thread

I love the Woman at the Well!

She runs into town after meeting Jesus. And without even considering that she might be mocked or discredited, she is eager to tell her fellow townspeople that she has just met the most amazing man...

"Come meet the One who knows everything about me!" she cries.

But the biggest miracle is that although He seems to know everything about her, he loves her anyway; in fact, He relates to her, and He seeks out a conversation with her.

She broadcasts to her Samaritan village that perhaps he is even the Messiah!

Doesn't she have some nerve? She, of all people; the woman of five ex-husbands and a live-in lover. This woman, of all women, was proclaiming that SHE met the Messiah.

Yet the town listened to her. And they all came running out to meet him.

Chapter 2

The Notorious Woman at the Local Watering Hole

HE SAW HER COMING A mile away. Her gait was easy and sensuous. Most women did their water run early in the day, but not her. She was taking her time and enjoying the sunshine warming her face as she ambled up.

He was tired from his long walk to this place, and thirsty. He saw that she was carrying a water bottle in hand and he asked her for a drink.

Now, this woman – who never finds herself at a loss for words – was suddenly at a loss for words. Who was this stranger asking her for a drink? Clearly, he was a man of the cloth, a Jew, and not of her social class. She was embarrassed that he asked her for water. They are not of the same race; she is a Samaritan, and Jews and Samaritans do not socialize. What was his deal? What angle was he playing?

She didn't trust him. Still, she observed him with no small amount of curiosity.

"Why are you asking me for water?" she said. "Why would one of your kind ask one of my kind for a favor? Especially for a drink of

water? Aren't you afraid that something about me might rub off on you and contaminate your drink?"

His answer was immediate and equally as odd as his question.

"If you knew the gift of God, and Who it is that asked you for a drink, you would be asking me for a drink," he replied. "I could have given you living water."

How arrogant. How Jewish. How male. What kind of an answer was that? She looked at his empty hands. He has no water cup, no bucket, no bowl, yet he offered her water. She saw nothing with which he could even serve a small cup of water.

"So, you think that your water is greater than the water my family has been drinking from this well from generation to generation?" She asked, finding this man to be outlandish and presumptuous.

"Everyone who drinks this water will thirst again, but whoever drinks the water I give will never thirst," He continued, ignoring her insults. "The water I give will become in them a well of water that bubbles up to eternal life."

The stranger talked in riddles, she mused. Then she took a step closer.

"Do you mean to say that I wouldn't have to trek down here every day just to get water? Well, then, give me some of your magic water," she said, setting down her heavy water jar.

This traveler certainly had his own agenda. He decided to change the subject.

"Go, get your husband and come back," he said.

"I don't have a husband," she replied.

"Well now, that's nicely put," he responded. "You certainly don't. You have already had five husbands, but the man you are living with now is not your husband."

Something about his look seemed to bore right through her. She saw no judgment in his eyes yet somehow felt emotionally naked before him, as if nothing about her past was hidden. She flinched; she felt a little afraid. But she was never one to run from conflict.

He now had her complete attention.

"Okay, sir; so, you know things about me I haven't told you. Are you a prophet?" she asked. "If you are a prophet, then answer me this: our fathers worshipped in this mountain, and your people look down on them for it and say that to be true worshippers, they must worship in Jerusalem. Which is it?"

He answered like a true rabbi.

"Woman, believe me. An hour is coming when neither on this mountain nor in Jerusalem will you worship the Father. An hour is coming, and in fact, is already here, when true worshippers will worship the Father in spirit and truth. These are the type of people the Father seeks to be His worshipers. God is a spirit, and those who worship Him must worship in spirit and truth."

Now she understood. This stranger was a Jewish Rabbi, speaking in riddles about religious concerns.

Well, this conversation was certainly different, but her interest was piqued. She decided to stick with it. Alright then, he apparently wanted to argue about worship.

"I know that the true Messiah is coming, and he will tell us of these things. He will make it clear to us," she said firmly.

Then the man who asked her for water paused and looked straight into her eyes.

"I am He," he said.

His words went through her like a bolt of lightning. In an instant, she knew it was true. Without thinking, she dropped her water jar and ran back into the village.

"Come! Come! There's a man at the well that told me everything I have ever done!" She cried out to everyone she met on the village streets. "This is not the Christ, is it? Come and see!"

Soon she returned to him with half of the village in tow. She met someone who said he was the Messiah, and she wanted everyone else to meet him, too. And though she had only just met him, he knew all her secrets, yet surprisingly did not judge her. Quite the opposite, she felt strangely and deeply accepted when he spoke to her. Why? The sense of shame that hung over her like a cloud vanished during their conversation, and in its place her heart felt strangely clean. Her heart trembled.

This event, which can be found in the fourth chapter of the Gospel of John, truly happened. It gave Jesus' disciples a sneak preview of how God handles things. Not confined by human stereotypes or tribal loyalties, Jesus struck up a conversation with a woman that went

outside the boundaries of his time yet was perfectly pure. Not only did he have a conversation with a woman, but she was a Samaritan woman, and a known sinner. But He talked to her anyway.

In the context of this conversation, the great I AM reached out to the human "I AM NOT" and redemption, not judgment, flowed.

Jesus calls us to be just like him.

If He were to talk to you or me this evening, would he not speak to us just like that? He would confront our limited and wrong ideas, but he would not accuse or blame us for our shortcomings. He would engage us in meaningful conversation. He would invite us to bring our friends and learn more. He would invite us to come in out of the storm of hobbled humanity, and into the warmth, safety, and wholeness of Himself. Does this excuse our bad behavior as irrelevant? Certainly not. In fact, He would tell us the truth and call us to repentance.

Christ is in the redemption game, not the blame game. God came to earth to heal us; to lift us up and away from the power and consequences of our own sins, and the sins others have committed against us. He offers forgiveness to us that is so complete it cuts the legs right out from under our shame.

But there is more to this story. As Jesus pointed out, the notorious woman at the local watering hole was thirsty for something that no water on earth can satisfy.

And so, do we all. What exactly are we thirsty for? Our hearts thirst for love and identity; we thirst to "belong." We thirst for meaning;

we ask "Why are we here? What is life about?" We thirst to be deeply connected; to be a part of something greater than ourselves.

The poet John Donne expressed it this way:

> "No man is an island,
>
> Entire of itself,
>
> Every man is a piece of the continent,
>
> A part of the main.
>
> If a clod be washed away by the sea,
>
> Europe is the less.
>
> As well as if a promontory were.
>
> As well as if a manor of thy friend's
>
> Or of thine own were:
>
> Any man's death diminishes me,
>
> Because I am involved in mankind,
>
> And therefore, never send to know for whom the bell tolls.
>
> It tolls for thee."
>
> ~ MEDITATION XVII, Devotions upon Emergent Occasions,
> by John Donne (Donne n.d.)

Within each of us this parched cry rings out. No man is an island, yet often we feel so utterly alone. How can this be? How can we fix this? Some try to fix this through relationships, both friendships and romantic love. Others try to satisfy this thirst through sharing food and conversation with their circle; or perhaps by delving into gossip about dating or marriage or sex or the social disasters of their

favorite celebrities. Still others look to satisfy their thirst through connectedness in work, measuring meaning by making money, or working hard to set themselves apart. I could go on for a thousand pages rehearsing the multitude of ways we try to satisfy this thirst, but the end is the same. We are all still thirsty. And thirst, like pain, is a driving force.

Yet in a few short sentences, Jesus shared the secret with the notorious woman, where she might finally satisfy the nagging thirst of her soul. The human soul is eternal, and it thirsts to be connected to its eternal spring. Made in the image of our Creator, our souls need to be watered continuously with His inexhaustible fountain of life and love to quench the thirst. Yes, John Donne, we thirst for connectedness; but the truth is that it is only the connectedness with our Creator that can satisfy us and the thirst that pushes us to find our completeness in all the wrong places.

My answer to a failed marriage was to try again.

Did I need affirmation as a woman to be regarded as desirable? How about security? Yes. Did I need that sense of connectedness that a great marriage can supply? Yes, that too. Did I need a father for my children? Most assuredly. But none of those needs were my driving force. I just could not bear the thought of being alone and not belonging.

Sadly, I discovered that great marriages are not born out of broken choices. And, news flash, almost every such choice, if made while broken, will only produce more brokenness. If I want a happy future, I must create a happy present. Healing is not an option. I am embarrassed to tell you that I am a dense student that would not

come to a full stop and allow the Lord to do Heaven's work in me. My slow learning was not the fault of Jesus. He told me loud and clear that I must allow healing. I just thought I could get it like one might pick up a burger at a drive-through joint. I was going to grab my solution, keep driving, and eat in the car! And, that kind of thinking handed me three divorces.

So, I have a lot of compassion for the woman at the well. She was not a Lolita, looking for a wild romp in the hay. She was a woman looking for a man to heal her broken heart. And no man can do that. No man, that is, except Jesus.

The Third Golden Thread

Where did I first learn the Language of Scars?

I first learned the Language of Scars in the most unlikely of places: I learned it in the same place that I was taught to "Expect a Miracle." Oral Roberts University.

How could this be? It is a long story, but if you will allow me, I would like to share a collection of tales that explain this complex journey. Perhaps you will even find parts and pieces of your own stories in these next few chapters. Each of our journeys through life are unique, but they wind their way down similar paths.

The Language of Scars began with my introduction to the amazing healing evangelist, Oral Roberts.

I met Oral when I arrived as a freshman in the very first class of his new college, Oral Roberts University. I was utterly devoted to Oral's dream of creating Oral Roberts University; it was to be a new type of Christian university that would change the world.

(continued)

Within a few short years, I married Richard Roberts and became Oral's daughter- in-law as well as the lead female singer for his television programs and ministry meetings. Seemingly overnight, my life transformed from student to Christian celebrity. What incredible opportunities Oral Roberts gave me, in such transformative ways!

Yet Oral also left deep scars on my life; scars created by the imprint of his ambitions and the fallout of his imperfections.

Even so, I am not here to throw stones. Instead, I am here to get rid of them. Would you like to get rid of some of your stones, too? Then stay with me on the journey, my friend.

We were born to change the world.

Chapter 3

Born to Change the World: Expecting Miracles with Oral Roberts

MAMA TOLD ME THAT THE driver of the old Ford pick-up truck did his best to miss the deep ruts that would cause her to cry out as the tires sank into the wet red mud and spun their way out back onto the gravel. Her sister Lorene was holding her hand and praying to beat the band as they drove as fast as possible through the pounding torrents. Poor Mama; she had me inside of her, banging on the walls and pushing my way out into the world. She was young, frightened and way too many miles from the safety of the county sanatorium that doubled as a hospital.

The driver pressed on with dogged focus, after all, this was his little wife in the truck, and his baby was about to enter the world.

Daddy was only recently returned from World War II, where he spent the last many months as a guest of the Third Reich as a prisoner of war. He was frail, excessively jittery, and still having flashbacks from shooting down enemy aircraft and being shot down himself and captured. In those days, no one knew that there was such a thing as Post Traumatic Stress Disorder (PTSD), but clearly, Daddy was suffering from it.

His hopes for a better future, one void of the horrors of war, were riding in that pick-up and at 3-minute intervals, were making his world spin. "Merciful Jesus, just get us there, oh great God, grant us thy peace," Aunt Lorene prayed. Mama just cried and yelled.

The tension broke with the cry of a baby. The nurse told Mama that she made it just in time. Daddy still didn't have the color back in his cheeks, and he could not seem to keep his legs from jiggling or his hands from wiggling, or so I was told. Poor Daddy.

It wasn't three months until the cows, pigs, and chickens were sold off to other farmers in the area and the drafty old farmhouse was up for sale, too. Daddy's strength to farm was gone. His body, though still so young and beautiful, was broken and could not be repaired. His very soul was also a purple mass of bruises. Killing people killed my daddy. What was not killed by war was killed by imprisonment. He was the walking dead. We just didn't know it, nor did he. It took another nineteen years for the war to do him in, but in the end, it did. But we Holcombes are patriotic folks who love their country. Our contribution to America was great, as it was for many American families. It cost us our father.

Oh, enough of the sad part. Let's move on to the happy part of the story, the part under the sway of new hope.

Granny and Grandpa Holcombe moved to Oregon four years earlier. Letters they placed in the mailbox on Hall Street, Sherwood, Oregon, somehow found their way over the mountains, deserts, and windy plains to our little farm in Yarnaby, Oklahoma. Each word that was formed by Granny's pencil spoke of lushness, love, and beauty. The news of rains that drenched the earth and nourished the

seeds into whopping crops of beans, corn, berries, and flowers of all sorts softly watered Mama and Daddy's parched hearts. These rains of hope watered-in seeds of new dreams, and soon enough, nothing could keep Mama and Daddy in the state of Oklahoma one minute longer. They were Oregon bound.

We four – Mama, Daddy, I, and my older brother Alan (a happy surprise conceived on their brief honeymoon) – were tucked into Daddy's 1939 Ford with all our earthly belongings and headed for the verdant promises of Oregon. Dirt farming was abandoned in favor of finding health and happiness in the great Northwest.

Several years ago, I visited Mama and we took a drive along Oregon's old 99 West Highway together, the road Mama and Daddy traveled on that endless journey. She showed me yet again the exact spot where she thought she simply could not continue driving, not even one more mile. But Granny's house was another two hours north. Daddy, Mama, and my brother and I had been driving for some sixty hours without stopping, save for gas. Alan and I slept on a pallet in the backseat most of the way across the West. We kids were doing fine, but Mama and Daddy were beyond exhausted – they never stopped, not for rest or hotel or hot food. A gas tank fill-up or a quick stop for the most meager of groceries were the only pauses they made on the long haul across the country. I asked mama why they didn't stop at a motel or hotel and get some rest? She said that there was only enough gas money to get to Oregon, so they made the trip as fast as possible. Hope was my parents' mainstay, their compass, their prayer and – except for a few bologna sandwiches – their primary nourishment.

But they made it.

Sadly, Daddy's health never improved. Yet, he too was a resolutely optimistic man. Even in his most weakened state of being, he still talked of the future, and reached out to offer help and hope to others. Although his body failed him, he managed to build a business that did not rely so much on physical strength. By tenacity, brain power, and cooperation within our little family, Daddy, with the help of Alan, my older brother, built a wholesale auto parts business.

While I do not think we had much money, I never felt the grinding shame of poverty. Love shielded us from such indignities. Poverty is more than a lack of money; poverty is a state of broken faith and grayed-out dreams. We still had each other, our vibrant faith, and abundant dreams.

So, while we surely did not have much money, we never knew a moment of true poverty. Daddy still gave money to others, to build churches, and to loan to those in need. His body was weak, but his heart was strong.

I heard my father say hundreds of times that it was impossible to out-give God. God could not become your debtor, Daddy taught us. So, Daddy gave freely and with much confidence in the reciprocity of God.

For eighteen years I lived in the heart of my family's optimism. Our faith gave us hope. Our home, our love, our friends, our new life were all evidence of my parents resolve to "keep on keeping on," believing that finally, a better day would dawn.

The day came when it was time for me to go off to college. The day in August of 1965 when I left my home in Oregon and headed to Tulsa, Oklahoma to attend Oral Roberts University was a strange

day indeed. Daddy was not happy with my schooling choice. By this time, he was seriously, chronically, ill and he must have sensed that his life was nearing completion. He wanted me close. Mama, however, wanted to see me learn and grow, she wanted to see me sprout wings and fly.

And I too wanted to be a part of a grand adventure. The grand adventure that captivated me at this crucial time in my life was the vision of evangelist Oral Roberts, who was building a Christian university unlike any that existed. Oral's infectious enthusiasm for the vision that God gave him thoroughly overcame me. With every fiber of my being, I knew that I simply must be there to play my part in the founding of this great institution, even though the great institution at the time was little more than a five hundred acre cow pasture with three buildings hastily erected.

And so, I waved goodbye to my family that day in August and traveled by train back to the state of my birth. Yes, this trip back to Oklahoma was better than lying on a pallet and driving for sixty hours straight. But it wasn't much better. Nevertheless, my youthful excitement made me oblivious to the difficulty of sitting upright for a four-day train ride. I was tingling with anticipation, walking right into the middle of this colossal vision to build God's university. I never felt more alive.

The morning I arrived in Tulsa was a typical Oklahoma late-summer morning. The methodical whir of the oil-well pumps which sprouted up on the west lawn of the school welcomed the university's first class of students to the rolling hills of south Tulsa. Soft winds played in the honeysuckle, releasing their sweet perfume. I really did not

know if I was smelling the fragrance of God or the wildflowers, but whatever it was, I, the starry-eyed dreamer, loved it all.

What an odd bunch we must have seemed, the pioneer class of ORU! We came from such diverse backgrounds and so many different states. The thread of commonality that bound us all together was the belief we shared that, with God's help, it was truly possible for us to change the world, and Oral Roberts University was the place to be trained to do it.

The year 1965 was smack dab in the middle of the hippie generation. Young women were burning their bras and declaring their freedom from constrictions of any sort. Young men were going off to die in Vietnam, and white America was reluctantly laying down some of its arrogance as it moved toward greater racial integration and equality, following Dr. Martin Luther King's lead. It was a time when people were magnetized to causes greater than themselves. A new nation, a different nation was being forged in the sixties.

Time itself seemed to be shifting gears.

And so it was with us students. The Alpha class of students that came to those first years of ORU were children of hope, lovers of Jesus, idealists, and dreamers. We came to ORU seeking an education that was not an end, but a beginning; knowledge gained for a greater purpose. To a person, it was more than a college education that we sought. We were, at heart, idealists and zealots, called to the highest cause.

I do believe we understood that from the get-go.

Even to this day, that spirit still permeates ORU. There is a sense of God being there. And that spirit of ORU, if embraced, becomes embedded in the outlook of alumni; it colors how we envision serving Jesus. It is a spirit that looks past human limitations and focuses on world-changing possibilities. When personal plans run up against the wall of limitation, God's pervasive Presence seems to meet many ORU alumni with a beckoning whisper, saying "Don't stop! Don't despair! There is still more; the well is yet deeper; the horizon of hope is still limitless. Only believe!"

Oral was troubled at the splinter between the sacred and secular in education, and his quest was to reunite education by educating the whole man: body, mind and spirit. The essence of the Whole-Man Education was to make a place where the very Spirit of God could wed knowledge and wisdom within the students, knowledge that came not just from books and lectures, but from their hearts, their minds, and their souls. The original university logo displayed a triangle of Whole-Man Education, showing the Spirit at the top, but included the mind and the body as the other two points of the triangle.

Bringing one's entire self into this construct was a fresh new idea to us students. All parts of our triune being were recognized, valued, sharpened, and trained for the service of God and mankind. The body was to be the servant of the spirit, and the mind was to be the laboratory for God's brilliance. It seemed a splendid vision: Christian excellence, on steroids.

For over 50 years, the university continued to operate at least basically within this paradigm. More than 40,000 alumni have passed through the front doors of Oral Roberts University, exploring their dreams.

Most have gotten their educations and headed out into the world, full of the purposes of God. Ministries have been established, companies have been started, universities have been built in far-flung countries. ORU-trained composers wrote much of the new worship music of the church. Other alumni built third-world orphanages, hospitals, and other great works of service to humanity around the globe. Those with less noticeable ministries have stories of powerful local impact in their communities as teachers, nurses, church goers and business owners.

Oral Roberts was a brilliant visionary, and it was truly breathtaking to watch him go after a vision. But watching Oral Roberts flesh out his visions could also be a painful experience, especially for those closest to him. Oral was human, a divinely gifted man with clay feet. As the years stretch out since his death on December 15, 2009, it is inevitable that the next generation leadership – student body and faculty included – can see what he accomplished but never knew the man Oral himself. To know the vision without knowing the visionary is, indeed, a loss.

If you find yourself wishing that somehow you could have known him personally, allow me the privilege of introducing you to the Oral that I knew. The Oral I knew was not only Oral the healing evangelist and university president, but also Oral my father-in-law, an extraordinary but very human man whom I grew to deeply love.

Oral was born in Pontotoc County, Oklahoma, on January 24, 1918. He and the soil from which he sprang shared common understanding, conflict, and traits. Let me explain.

When he was a child, the dirt onto which he put his tiny unshod feet was already saturated with needless bloodshed. The very air still rang

with the cries of our Native citizens who were pushed from their lush homelands of the Southeastern United States and marched into the dry prairies of the Oklahoma Territory. Sixteen thousand members of the Cherokee tribe were relocated from established homelands and forcefully marched West to a place that was not even a state, only a territory. The native lands of the Cherokee were then confiscated by the white man. Thousands died as they marched West on the orders of Andrew Jackson, president of the United States. Four men representing the Cherokees negotiated a treaty with President Jackson, which they conceived as a land swap for new lands in the Oklahoma Territory, plus a sum of 5 million dollars. But many of their tribe felt betrayed by these four men and refused to leave their lands. These Native American resistors were eventually forced out by military intervention and given little preparation time to make such an arduous journey. Government-forced marches soon spread to other tribes. The Choctaws and others made treaties under Jackson's government, with similar results. While the treaties were made in good faith, they often ended in forced marches, death, disease, and sorrow for the natives who signed them. (Cherokee Historical Association n.d.)

So, into the Oklahoma Territory marched a brutalized people, families seeking a new place to live in peace and security. Their route and their journey to the territory was so rugged that it was named 'The Trail of Tears' by the Native Americans. Oklahoma ultimately became a territory full of Native American tribes. The state today is called the home of the Five Civilized Tribes. But there are far more than five tribes represented in Oklahoma. There are at least 39 tribes that call Oklahoma their home. Still, only five tribes are considered indigenous. (Bentley 2003) These five tribes are the Creek, Cherokee, Seminole, Choctaw, and Chickasaw.

Further, in the spring of 1889, the government decided to extend some of the Oklahoma territory to non-native population and give two million acres of unassigned lands to anyone who could stake a claim. Thus, the Oklahoma Land Run was born. On April 22, 1889, over 50,000 people lined up their horses and wagons and waited for the starting gun shot at 12 o'clock noon. The frenzied chase for land that followed culminated at sunset, and by the end of the day the two million acres available for claim was snapped up by the new Oklahomans. In fact, by the end of 1889, 62,000 new Oklahomans, give or take a few, settled the lands that lay between the east and west sides of the state, the lands where the Native American tribes were promised and assigned property. It was a sandwich of humanity. (Hoig n.d.)

In the veins of Oral Roberts flowed the blood of both these vastly different cultures. His father Ellis M. Roberts was a poor white Pentecostal preacher man and his Choctaw Mama, Claudius Roberts, was a powerhouse of human will and mighty spiritual influence. The record books identify Oral as a member of the Choctaw tribe. Oral carried within his DNA a mixture of both the white man and the Native American in Oklahoma, and his attitudes and personal ambitions reflected them both. Oral's mixed-race background also uniquely qualified him to later build an international, mission-based university like ORU, but I will talk more about that later.

One hundred years after the Trail of Tears, another racial conflict emerged in Oklahoma that shed more blood and injustice on the Oklahoma soil. In the Tulsa Race Massacre, on May 31 and June 1, 1921, a white mob burned 35 city blocks of African American owned homes and businesses to the ground, killing as many as 300 people and leaving 800 more injured. The event, which de-

stroyed Tulsa's phenomenally successful "Black Wall Street" in the Greenwood District of the city, has been cited by some as the single worst incident of racial violence in American history. About 10,000 black people were left homeless, and property damage amounted to more than $1.5 million in real estate and $750,000 in personal property (equivalent to $32.25 million in 2019). Their property was never recovered. (tulsahistory.org n.d.)

This brings me to another thought. In the Biblical story of Cain and Abel, Abel's blood, spilled on the ground when he is murdered by his brother, cries out to heaven, pleading for justice, and God responds. If Abel's blood unjustly shed still cries out from the soil today, it would be hard to imagine how Oklahoma could escape God's attention.

I like to speculate that Oral's calling to build a university was part of God's answer to those blood-cries for justice from the Oklahoma soil. A healing place needed to be built, a place where injustices and ignorance could be healed AND remedied through education, mercy, love and strengthening the whole person. Oral Roberts was the perfect native son to build such an institution. He said he heard this call on his life while recovering from a near death encounter with tuberculosis.

Oral was a man of both genius and angst. He was raised poor and grew up hating the indignities of ignorance and poverty. He vowed to abolish them in his own life, and as far as was possible with him, and to also abolish them in the lives of others. Oral was mostly brilliant yet also hard-headed in a maddening way. Sometimes he accomplished God-sized visions in ways that inspired awe in everyone around him. Other times, Oral staggered clumsily through a room

with the walk of a young boy from an inelegant and impoverished background. Social grace and poise were not always evident. But always, he displayed the mind and heart of a deeply spiritual individual with a great faith in a good God.

Oral was a big and beautiful man. Oral's eyes were black; dancing with life yet fiercely capable of boring a hole right through solid steel if the piece of steel should happen to incur his ire. He possessed great self-control over his emotional reactions unless he felt he could better accentuate his point with a childish tantrum. Then, the tantrum would come, and folks would skitter. Despite a childhood affliction of stuttering – stammering as he called it – he could be eloquent to the point of being poetic when preaching. In those moments, by the sheer force of his personality and intellect, he could whisk his audience off to a land of thought heretofore untraveled. To say he was a master storyteller is to understate his abilities.

Prior to the mid-twentieth century it was common for Pentecostal religious folk to keep their mouths shut about secular worldly concerns – politics and financial markets included. Speaking into society about politics, international policy, or the world of finance was, in fact, a foreign idea not only to Pentecostals, but also to many evangelicals. Evangelicals were taught to be quiet believers, or missionaries, or pulpit ministers. Oral Roberts believed this should change. He envisioned a world where Holy Spirit-filled Christians would take their places at the tables of decision making and power in government, commerce, and education just as naturally and smoothly as they would take their places in Christian leadership. These well-trained Christians would become a force for positive change and a

strong voice for the Kingdom of God. These were the type of students Oral dreamed of launching from his university.

Oral taught ORU students and the partners in his ministry to "Expect a Miracle," and to believe that literally NOTHING is impossible with God. And, while he was somewhat sexist within his own family, he was not that way with his students. Oral encouraged young women as well as young men to let nothing stand in the way of their dreams. Oral well understood the Biblical injunction "the kingdom of heaven has suffered violence, and the violent take it by force." (Matt. 11:12). Using a little force to create change didn't bother him in the slightest.

When he set his mind to something, Oral Roberts was a sheer force of nature. Some associates said that he was also myopic, so focused on what was right in front of him that at times he failed to see the bigger picture, and that this contributed to the fact that not all his dreams became a successful reality. Several graduate schools opened at the university closed after a few years or were transferred to other universities, including the O.W. Coburn School of Law, a medical school, and a dental school. The City of Faith Hospital complex also failed to materialize after being surrounded by much controversy. That failure cut him so deeply that I am not sure he ever fully recovered from the humiliation of it all.

But long before he was an educator, Oral was a preacher and a faith healer. His public ministry began with evangelistic tent meetings, and countless people experienced real miracles when this man prayed for them at the altar. And such prayers! When Oral prayed for you, it was as if the sweet clouds of heaven parted and Jesus himself bent down to attend to your needs.

At the healing-prayer services I attended, I saw people healed in very visible ways, right before my eyes. Those healings were not fake. Those healings were not staged. Oral honestly believed what the Bible says about Jesus healing all manner of illnesses and casting out all manner of evil spirits. He found it curious that there were intellectual pundits who found the mix of prayer, healing, speaking in tongues, and other Pentecostal practices to be at odds with good sense and educated thinking. To Oral, good sense, educated thinking, medical practice and a Christian's spiritual gifts were all delivery systems for the same graces of God, sent to heal the world.

He was aware that some ministers were fakes and employed phony miracles. But, unlike them, Oral would never push someone down to claim that they "fell under the power of God" nor would he "blow healing" upon people lined up for prayer, or any other such silliness. He was a no-frills praying machine with no appetite for foolishness. In the healing prayer line, Oral rarely took time to hear the story of the person for whom he was praying. Because of this, some thought that he was insensitive; and, indeed, he could be. He could be a bit rough with people, too. More than once I saw him clap the ears of a deaf person. If they were not deaf to begin with, they surely could have been after such a mighty clapping on their ears. Yet even those folks were often miraculously healed, with their hearing coming back in perfect stereo.

Sometimes literally thousands of people lined up for prayer. Really, to pray for them all, one individual could not possibly stop and chat. The physical, emotional, and spiritual strength it took to wade into the desperate crowds who sought healing would drain the tank of most people, and sometimes they drained Oral as well. There were

times when Oral could barely walk or speak when he finally finished all that praying.

Once a woman brought her son, born without a hip socket, to one of Oral's meeting for prayer. The boy was unable to walk since birth. By the time the determined woman reached the stage, Oral was done for the night, exhausted, and was walking away. But as an act of faith the mother brought with her the first new pair of walking shoes the boy ever owned, so that he could wear them after Oral prayed. She was not about to let those shoes go home unused. She ran after Oral as he was leaving the building. Drenched in sweat and in a state of total exhaustion, Oral flatly refused the mother's prayer request. To his surprise, this mother, in turn, flatly refused to take no for an answer. Oral insisted that he was drained, and his faith was gone. She insisted right back that she was not drained, and her faith was strong enough for them both. Besides, she said, even if Oral were drained of energy, God was not too tired to hear heal her son if Oral would only pray. Finally, Oral acquiesced, laid his hand on the boy, and said a quick prayer.

Immediately after Oral's prayer, the woman's son sat down, put on his new shoes, and walked away with his mama, fully healed. The boy's first steps were taken in front of the tired eyes of a faith-healer who momentarily lost his faith. That night, it took the faith of a determined mother to remind Oral to expect miracles from God even when he could not expect much from himself.

Oral was human. But he was also an inspiration. Oral was a man dedicated to God and healing, and accomplishing that mission was his driving focus. Many of us in his orbit were transformed by that driving focus, as well.

The University: the dream years, the hard years, and the legacy

To be Oral Roberts daughter-in-law, to be a member of the Alpha Class at Oral Roberts University and throw my youthful energy into Oral's magnificent dream, was an extraordinary privilege. But after 55 years – as of this writing — what became of the university?

I am happy to say that after some tumultuous ups and downs, the university today is flourishing. The torch on top of the Prayer Tower at the center of the campus still burns white hot, and so do the hearts of the students who catch the vision of ORU's original healing mission. The continued existence of the university is a tribute to Oral Roberts and the strength of the vision that God planted in his soul. The command he sensed from God to "Build Me a University" became Oral's north star until the day he died.

The dream years

In the formative years of the university, ORU was a bit of a novelty and students were afforded the brilliance of several of the world's high achievers. Visiting professors, notable politicians, preachers, and people who distinguished themselves through great achievements regularly popped into our classrooms or spoke at chapel services. Some were world famous missionaries, some were talented innovators, others were rising political stars and presidential hopefuls. Oral was a driving luminary force in those years.

We students thought, of course, that these impressive people came to see us, because that is what Oral told us. But eventually it became clear that at least some of our elite visitors were more interested in tapping into the vast mailing list of Oral Roberts Ministries. The politicos were particularly interested in Oral's approval, for he owned a mailing list of

millions of potential voters. Oral Roberts handled the politicos well, however. He knew how to navigate between celebrity ambitions and the needs of his students. He was also well studied in the finer points of retaining his ministry's charitable tax status, the mighty 501C3.

As with many great persons, the gifts and brilliance of our beloved founder and university president were at times his weaknesses as well as his strengths. One fear that drove some of Oral's less fortunate decisions originated with his idea of legacy. He fervently believed the saying, "Success without a successor, is failure." In his view, having a successor meant raising up a son to carry on his work. In the first few years of my association with the Roberts family, it was assumed that the older son Ronald would be the great successor to Oral. Ronnie was a gifted scholar who possessed a formidable intellect. But he had some personal issues, not the least of which was his willingness to challenge his dad on just about anything. He was also gay, much to his father's dismay. He was also quite a progressive. Ronnie and his father could no doubt agree that he was not the one to succeed Oral as president of this university. So, Oral, believing that a successor must be from his own bloodline, chose his younger son, Richard. Sadly, he lived long enough to struggle with the results of this choice as well.

The hard years

When Oral Roberts eventually installed his son Richard as the university president in 1993, turmoil ensued. From the moment Oral stepped down, the presidency of the university seemed an awkward fit for Richard Roberts. In addition to Richard's basic personality differences and giftings from his father, the new president inherited terribly heavy loads of debt (in the millions). Attempting to retire that debt

while running the day-to-day operation of the university may have been a lost cause from the get-go. But to worried students, faculty, and the watching public, it appeared that Richard and his administration lacked the caution and frugality that was expected of them during such a major leadership change. Instead, it seemed the new administration burned through money as if it were toilet tissue. There was chatter about Richard's family using university assets for personal enjoyment, and stories of the company jet being used to ferry their children off to the Bahamas for vacations. This chatter caused discord and mistrust within the university community, and alumni donors.

Thousands of ORU alumni were no longer inclined to donate. They spoke privately of lacking trust in the university's integrity in how funds were handled. The dire financial straits of the school eventually produced a game-changing crisis for Richard Roberts: a negative vote of confidence from the faculty as the school marched quietly toward a hidden, but impending bankruptcy.

When the perfect storm of inherited debt, lavish spending, and financial shortfall finally came crashing down upon the school in the late fall of 2007, the school was merely hours away from financial-code-red status. It was later reported that the mid-year payroll was also unfunded, and the bill collectors at the school's door could not be assuaged any longer. A complete collapse of all that Oral Roberts dedicated his life to seemed imminent. Yet Oral himself, now retired and living in California, was totally unaware. He and Evelyn divested themselves of millions of dollars and gifted it to the university coffers years before. He had no idea that all they gave was now gone.

Professors filed lawsuits, and in short order, all the bad news was public. Everyone knew. The school was in crisis and currently en-

rolled students panicked at the thought that their hard-earned and expensive private-school degrees were on track to become potentially worthless.

Suddenly ORU outsiders stepped in to save the school. The Green family of Hobby Lobby Stores, Inc. intervened with an offer of financial rescue for the school, but it came with strings attached. At such a moment, how could ORU regents turn it down? The first no-nonsense requirement of their intervention was a requirement for new leadership; Richard Roberts, the president, would have to step down. In addition, an entirely new board to govern the school's affairs would be chosen, and the accounting books of the school would be audited.

ORU's new benefactors spotted the need to separate emotion, family ties, and personal loyalties from the school's business side. There would no longer to be a member of the Roberts family in the university leadership, although Oral's original vision was to be maintained.

With outright gifts from the Green family that began at $70 million (Associated Press 2008) and continued over the next several years, the tentative and frightening state of ORU's solvency, which was hanging by a slim financial thread, was now magnificently and miraculously remedied. Shared governance replaced top-down leadership under the new president Mark Rutland and the new board; financial transparency replaced less open fiscal dealings. The new board was given the mandate not to merely rubber stamp the wishes of any future president, but to hold in sacred trust the unique mission of the university. Dr. Rutland was president of ORU from 2009-2012.

Dr. William Wilson followed Dr. Rutland as the fourth president of ORU in 2013. It has been his aim to bring ORU fully into the digital age, which he has done through the launch of the Global Learning Center. ORU presently is operating around the world through digital learning.

Many loyal alumni over all these years cared more deeply than they showed as they beheld with horror the continuously unfolding drama of their alma mater. Many alumni now support the school, remarking that it is profoundly gratifying to know that the university is a safe place to invest both their money and their confidence. Those of us who were in the Alpha class of Oral's university dream, who traveled the ORU road from a muddy path in a cow pasture to today's beautiful campus and world-wide dreams, are especially grateful to all who stepped in to save the university.

The Legacy

Despite a few unsightly bruises on the soul of a great man, Oral Roberts accomplished many extraordinary endeavors, not the least of which was the university he built. It is a place where Christian young people can get a first-class education in the context of a Christian worldview. ORU offers its students a unique understanding that God heals and that He wants them to take that knowledge and healing power all around the world. The full work and gifting of the Holy Spirit is still taught as necessary to carry out Christ's mission. Today, ORU-trained students dot the globe. They have taken to heart the vision of Oral Roberts. And so, in the end, Oral's legacy was not without a successor; it has thousands of successors – all his spiritual children, the alumni of the Oral Roberts University.

The original mandate for the school is still held in great esteem, as is the founder.

As Oral repeated so often, God's commission to him was:

> *"Raise up your students to hear My voice, to go where My light is dim, where My voice is heard small, and My healing power is not known, even to the uttermost bounds of the Earth. Their work will exceed yours, and in this I am well pleased."*

To the present student body, I say, "If you are here, it is not by accident. You are now the keepers of the Flame. It is your turn to press into tomorrow's untapped wonders. You chose ORU, and you, in return, have been chosen. Nothing is random. Here you will gain an education and sprout the wide wingspan of your being; here too you will be trained to step into a healing ministry for the nations."

It was hard for Oral to release Oral Roberts University, but in his final days, he at last found peace in letting it all go. He released the university back into the hands of the One who called him to build it. And with his parting breath, Oral was gathered into the bosom of the Lord he loved and partnered with, committing his family and all his life's work back to God.

The Fourth Golden Thread

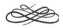

Why include Israel in a book about defeating shame?

Israel became an unexpected part of my journey;
my first trip to Israel altered my life forever ...

Throughout history, there has never been a people who have
survived so many injuries and scars, only to rebuild again,
as Israel. Whatever happens, they hold their head high and
start over — even when the bulk of their neighbors wish them
to be annihilated. Why do they persist like this? Are they
blessed because they are somehow perfect?

No, none are perfect. Israel continues to exist because of
God's divine constancy. He made a divine covenant with
Abraham, and the covenant of God lasts forever. He stands by
His covenant to Abraham to this day. This is personally a great
comfort to me.

Israel's resilient existence proves to me that even when
I fall or make terrible blunder, God's covenant with me,
written in the blood of his own son Jesus, carries on.
God does not let go of those who have come to Him.
He is faithful to me just as He is faithful to Israel.

Israel will one day turn to Him. And when they do,
He will receive them. He will receive them just like
he receives us: as long-lost children coming home.

Chapter 4

His Foot in My Sandal

It was 1968 and the world was a kinder, more trusting place. Our student group boarded a plane at Rome's Da Vinci International Airport. Things were different then. There were no stringent security measures, no TSA lines, no taking off shoes or jewelry.

I took my seat near the rear of the aircraft. My seatmate was the now famous and distinguished Dr. Terry Law. But in 1968, he was just another brilliant student who came from the plains of Canada to study at Oral Roberts University in Tulsa, Oklahoma. I, too, was a student at the time, and we both were members of the university's musical outreach team. "The Collegians." We were tasked with traveling Europe and the Middle East to spread the good news of the Gospel. Mixed in with our missional efforts was the slightly lesser job of advertising Oklahoma's newest university.

All fueled up by our passion for Jesus and our love of this new university, we were having the time of our lives. Those were exciting days, for so many of us were plucked out of relative obscurity and thrust into a world-wide mission. That was certainly the case for me, and for Terry Law, as well. It was the norm for Oral Roberts University students in those early days.

Rome was fabulous. In addition to seeing the popular sights of this glorious relic of history, we sang in several churches in Rome. The congregations were cordial and patient with us, although, culturally, we were worlds apart. The ladies of these churches still wore head coverings and no makeup. We, on the other hand, were bare armed, hair-sprayed modern women. For the sake of the Gospel and the Italian faithful, we ditched the lipstick, and covered our heads and arms. The Italian Christians were extremely conservative in comparison to the German Christians, whom we were with the week before. Germans thought nothing of offering a stiff and warming drink to us college students, some of us still underage by U.S. standards, before we boarded our bus and headed out. Learning of these cultural differences among Christians was a great lesson for me. What is thought to be holy behavior in one country ain't necessarily holy in another! Religious taboos vary from culture to culture, country to country. Of course, today, we are far less isolated as nations and the cultural norms are much more uniform. But, Germans, holy or not, still like their beer, and Italians, devout or not, still sip their wine. And until Millennials came of age in the church, Evangelicals sipped neither.

Terry and I were in deep discussion by the time the plane lifted off for the David Ben Gurion Airport in Tel Aviv, Israel. Even then, I was taken with his keen mind and spiritual depth. Mostly we discussed life as we understood it at our tender ages, including thoughtful discussions of faith along with more than a few conversations about my very lovely roommate, Jan D'Arpa. Jan was a beautiful young alto singer from Florida who recently captured Terry's fancy. Somehow, as her roommate – both at the university and on the singing tour – he saw me as her gatekeeper. Deeming Terry worthy of Jan's atten-

tion, I encouraged him to press on and ask her out. I do think he was already smitten, even before their first date.

But now, young love and all, we were heading to Israel. All I really knew about Israel was what I was taught as a child in Sunday School, and at my Mama's knee. Mama and Daddy on occasion gathered us up for an evening of Bible study, and Israel was often the topic of the lessons. Our Sunday School lessons were low-tech in those days. In addition to our quarterlies, there were visual aids. Visual aids were nothing more than a paper illustration cut-out stuck to a board covered in flannel fabric. This artsy presentation was called the "Flannel Graph." These small cut-outs of Moses, Miriam, Baby Jesus, the Red Sea, the Crucifixion of Christ, the Last Days, impacted me as much as if they were presented on the IMAX screen. But what I learned of the small and new nation of Israel was really limited to the Israel of the Bible and of the flannel-graph.

My parents did tell us stories of the Israel that was prophesied in the Bible. It was a land flowing with milk and honey. It was a land where grapes grew to the size of oranges, and oranges grew to the size of basketballs. As far as it seemed to me, everything in Israel was bigger than even everything in Texas, and that was big. I was taught that God himself would fight for and defend the children of Israel forever. We understood that the land was His, and that it would never belong to anyone else. He deeded the land to His chosen children, the Israelites, and that unchangeable contract would live on into eternity.

It was just one year after my birth that the nation of Israel was born anew. May 5, 1948, the United Nations proclaimed Israel as the earth's newest country. My father had not been home too long from World War II when the state of Israel was founded anew. He was

elated! My poor father came home from the war a broken young man, having been captured by the Germans and sent to prison camp. While in the prison camp, many of his flight mates died of beatings, starvation, and other inhumane treatments. Daddy's own body bore the scars of war on the outside, as well as on the inside. Having seen the horrors of the death camps of Germany, Daddy was jubilant, thankful, and awed by the news that the Jews were being granted a homeland. If ever there was a time in history, he felt the Israel deserved a country of its own, now was that time, in his mind.

Jewish Israel, the fulfillment of ancient prophecy, was a big topic in our home Bible studies. But, beyond that, I simply lived oblivious to the wonder of this thing God was doing in the Middle East. Somehow, I relegated the significance of the region to those paper cut-outs and flannel covered boards, and the zealous opinions of my parents. It never occurred to me that Israel was significant not only in the flannel-graph past but also in the very real and living present.

Thus, as we prepared to disembark our aircraft in Tel Aviv, I expected the stop in Israel to be nothing more than one more musical experience on our tour.

Carry-on luggage in hand, we made our way to the front of the aircraft. In those days, there were no jetways that smoothly glided up to the aircraft to ferry passengers from the aircraft to the terminal. Instead, a rolling metal stairway met us, positioned at the door. One just climbed down these simple and somewhat shaky metal stairs to get to the solid ground of the tarmac.

When my turn came, I made my way down to the tarmac with nothing more on my mind than not tripping on the steps. Beyond this, I

did have thoughts of getting safely to our hotel for a good hot bath and a comfy bed. But how was I to ever imagine what would happen to me when my feet touched the ground?

Who knew that my very body would begin to vibrate with the song of the ages? How could I have prepared for the flow of tears that poured from my eyes as my foot touched the tarmac? Without a forewarning of any sort, I immediately and strangely felt completely "one" with Israel, as if it were my own spiritual homeland. Yet I had never been in Israel a day in my life before that day.

I felt suddenly home. I was "home" in a land that I did not know. I was "home" in an ancient place to which I somehow belonged. Israel was me, and I was Israel. Tears flowed like a river; deep sobs of gratitude hit me in waves. It was the strangest experience of my life.

It was as if the Lord Jesus who lives within me placed his foot on the ground in my sandal. Truly, just as the old gospel song says, "I walked today where Jesus walked." Today, that song became my reality.

The sights, sounds, and smells of Israel immediately and continually transfixed me. I remember floating away on the plaintive notes of a shepherd's pipe played in the lobby of our modest hotel by some unknown musician. The hotel's high ceilings and stone floors caused the mystical sounds of the flute to fill the air, as well as my heart. The sound was something I imagined to be like the flute King David played. Its haunting melodies melded the lines between the ancient and the modern. I listened as of in an aura of timelessness.

The next day we arrived in the eternal city of Jerusalem and I could hardly contain my excitement. Truthfully, I was not hyped-up to walk where Jesus walked before I came on this trip. But unexpect-

edly, His presence seemed so real to me that I could almost feel His footsteps next to mine; I could almost hear the soft padding of His sandals. This, without a doubt, was His homeland. Again, the seams of time seemed to blur; the old and the new faded together, creating the Israel of today.

The famous Six-Day War was not even a year in the past as we walked into the broadly open area in front of the "Wailing Wall." This wall is sort of an obligatory tourist site, as it is a wall that remains from the ancient temple of Jesus' time. It was in the Arab sector of Jerusalem until the recent war. Jewish soldiers jubilantly tore down the restrictive wall that separated East and West Jerusalem. The whole of Jerusalem was once again under Israeli control. From now on, access to The Wall could never be restricted. Jews, as well as worshippers of all faiths, would always have a right to lean their heads against the ancient stones and offer prayers up to God. Wars, famine, and invasions could not tear down the wall that literally holds up the nation of Israel. It stands as a strong stone testament of the eternal tie the people of Israel have with their ancient land. It is on the site of King Solomon's original temple, which housed the Ark of the Covenant more than 2,000 years ago. The Wailing Wall is spiritual and emotional ground zero for all persons of the House of Israel, from age to age.

Since the Six Day War was just a year past, Israel Defense Force soldiers were stationed in the streets, just about everywhere. They were all nearly my own age and, to a person, the soldiers seemed beautiful to me. I was immensely proud of them.

Our musical team held several concerts for the soldiers. I remember one such concert we performed high up in the Golan where we sang and danced the Hora with these young heroes.

A week or so into our stay in the Land, Oral Roberts and "his darling wife, Evelyn" joined us. President Roberts was a longtime friend of the leaders of the country, and Teddy Kollek, the Mayor of Jerusalem, was a personal buddy of Oral's. The first Prime Minister of Israel was also a man with whom President Roberts shared a warm friendship. It is significant that long before it was fashionable in evangelical circles to embrace and support Israel, Oral Roberts forged a tight brotherly bond with the leaders of the land. He also forged strong ties with the Jewish community in Tulsa. It was a unique and valuable time, and his support of Israel and all Jewish concerns is still felt and honored at the university that bears his name.

On a particularly hot summer day, President and Mrs. Roberts and the musical team boarded a plane and headed south to the Negev Desert. There in Kibbutz Sde Boker stood the home of David Ben-Gurion and his family. The house, built in 1930, was the desert home where the venerable first Prime Minister of Israel lived, and later, died.

Born in Poland, Ben Gurion became the head of the World Zionist Organization in 1946 and proclaimed the establishment of the State of Israel on May 14, 1948. After the War of Independence, he was elected to be Prime Minister, a position he held until 1963.

Ben Gurion came out of his modest home and greeted his old friend, Oral Roberts, and the young students who were there with him and his wife. He sat down of the cool grass beneath the trees of his yard and chatted with us, much the same as a beloved old grandfather would do. His friend Oral launched into a beautiful speech about the origins of the Land. He spoke of the Creator flinging the stars from His fingertips out into the deep blue skies above us. And, that Jerusalem

sat "like a diamond on a velvet couch" of God's great making. Ben Gurion listened with respect and some delight. It was clear to him that Roberts and his young companions loved the land to which Ben Gurion dedicated his life's work. We then sang a full-throated version of "Jerusalem, the Golden" to this legendary Israeli leader.

There, sheltered in the shade of those beautiful trees, my heart was unalterably turned toward Israel and her people. My blood quaked with the significance of the moment. Every palm tree, stone and grain of sand were precious to me.

In my youth, there was much I did not understand about the schism in the heart of the nation of Israel that tears at its fiber. Just as with all nations, when Israel does not live up to the standards of behavior that God set for her, she suffers, and many times, the rest of the world suffers as well. Israel is not a perfect country with perfect leaders making perfect decisions. Yet Israel is uniquely chosen, according to the scriptures, and I will always believe that she is uniquely God's.

Among evangelical circles of the church in the past few decades there has arisen a sort of spiritual mandate about "Blessing Israel" that gives me some concern. I love Israel, and I want to always bless her, according to Gen. 12:3. But I am wary and watchful in parsing out what it means to "Bless Israel." I do not think blessing Israel equals a blank moral check that Israeli leaders can fill in with the expediency of the moment. This has never been God's way of dealing with Israel or any other nation. I do not see Israel's chosen status as an excuse for her to mistreat anyone, Palestinians and Christians included. Israel's ancient captivity of Babylon stands as a stark example that God will judge Israel (and every other nation) for her sins. God is no respecter of persons, scripture says.

Here is what blessing someone means to me. If I bless you, I am praying that you become exactly what God originally intended for you to become. May you behave as His regent and produce in action and attitude a reflection of God's glory, God's nature, and His purpose for your life. May you live continually in His revealed Presence. May you be blessed.

I certainly bless Israel in this way and expectantly pray for her to climb to her prophesied status. Prophecy says that one day Israel will be a blessing to all the families of the earth. That is what the big book says, and I lend my 'Amen' to that.

Years after my seminal encounter with the heart of Israel, I once again returned to the land. This time I was bringing home the feted Russian Refuseniks, Vladimir and Masha Slepak. I worked diligently against the Soviet government to win the release of these 'Prisoners of Zion' who were refused the right to emigrate from Russia to Israel. I was just one of thousands of people around the world that took up the cause of the Jews of Russia. The Slepaks were themselves battle-hardened warriors who fought hard, were imprisoned, persecuted, even tortured, and then denied on all their dozens of requests to emigrate to Israel. Still, for years they helped hundreds of other people gain the right to emigrate. Among those they helped were many Pentecostal Christians who shared similar persecutions as the Jews in Russia. It did not matter to the Slepaks that the Pentecostals were not Jewish. They helped them anyway.

Masha told me that there were many times when they would have people show up at their door, day or night, seeking help to emigrate. Sometimes these people traveled thousands of miles in difficult circumstances to get there. When they got to the Slepak's door they

would find hot food and a pallet on the living room floor where they could rest their tired bodies.

Now, it was the Slepaks turn to go to the homeland. The Slepaks, along with Jews from all over the world were making Aliyah. Aliyah is the official "Right of Return" afforded to all Jews, regardless of nationality, to return to their homeland. How ironic that it was Pentecostal Christians who were chosen to fly the Slepaks to their hero's reception in Israel.

It was October of 1987. The sky over my house in Nashville was as blue as it possibly could be. I sat out on the back deck and watched colorful hot air balloons float over my neighborhood. I was getting a wonderful show for which someone paid dearly. But for me, the view was free for the taking.

I could hear the phone in the kitchen ringing, so I hopped up to answer it.

This is where the adventure shifts into high gear. The call was from Alex Slepak, oldest son of Mr. and Mrs. Slepak. He and his brother immigrated to the United States a few years earlier. In those days, the Soviets liked to split up families who were trying to leave the Soviet Union. Sometimes children were given visas while the parents were denied theirs. And sometimes it was just the opposite. The point was to inflict emotional trauma on anyone who dared to resist the Soviet governmental order.

Alex helped us form a team of people in the Jewish and Christian communities of Nashville who shared a common goal. It was our shared desire to get the Soviets to allow Jews to leave the country. Our two distinct communities met from time to time to work on

our goal. This afforded us an opportunity to develop rich friendships and experience our strong commonalities, which were many.

For a year or so we worked. I also met weekly with my prayer group and we hit the heavens faithfully with requests for divine intervention. We rightly believed that Heaven was more powerful than the Soviet government. And boy, was it ever.

It was this group who stood behind me when I decided to go to Washington D.C. and protest in front of the Soviet Embassy. Protests of this sort were old hat in D.C., but not so for this woman. I got the appropriate permissions from the District of Columbia and set out with my pearls around my neck, my bail money in my purse, and my protest poster in hand. It was a given that I would be arrested if I got within 200 ft. of the embassy. And, of course, that was my intention.

The night before the protest, I was fit to be tied. I paced the floor, wearing a path into my hostesses' Persian carpet. I walked and prayed. "Dear Lord, what good is a protest if no one hears about it? And how am I going to get the Press interested in covering my "huge" protest – made up of just one Mama from Nashville?"

To make sure I was not utterly alone, my Jewish friends alerted a handful of rabbis who served congregations in the D.C. area, and my Christian friends did the same with their connections to local pastors. Kindly, at least a couple of dozen clergy showed up to support this one-woman show. From every angle, this protest seemed hugely insignificant. Even so, at least a dozen police showed up with paddy wagons, horses, helmets, and batons just in case I got out of hand.

But, on the night before the big event, I wrestled with God. Then, the phone rang. The caller was a woman who heard of me and my crazy plan. She asked if she could help. I told her that the only real help I needed was to somehow rally the press. She told me that perhaps 'someone' would call me. Minutes later a deep voice was on the other end of the line. This is what he said. "Patti, years ago I was at the end of my rope and sitting in a shabby hotel room ready to end my life. I turned on the television and there you were singing "The Old Rugged Cross." Something came through the TV screen and grabbed my heart. I began to weep and weep. I cried until all the sorrow was cried out of me and I lay peacefully on the floor, knowing that God visited me. At that time, I told God that if there was ever any way that I could help that woman who sang the song, I would do so. Tonight, I got a call and heard that you needed help." he said.

"Who are you?" was my first question.

"I am Cort Randall and I own a company called The Federal News Service," he said. "We broadcast a stream of what is happening in actual time in the Senate, the House, and other governmental agencies. We have feeds into most embassies around the world, not just American embassies, but all embassies. Also, the normal news agencies receive our feed."

Boom! Heaven heard my prayer.

He went on to ask me to write my own press release and he would put it on his wire the moment I began my protest.

I arrived at the Soviet Embassy a few moments before my scheduled civil disobedience.

Up until that moment, it did not cross my mind that I needed a plan to make the Soviets in the embassy notice me. I am sure by the time I arrived, some of them were peeking out of their shuttered windows to check the police presence and count the rabbis and religious ministers. But where were the protesters? Shouldn't there be hundreds, or perhaps even thousands, of protesters who were about to descend upon them with placards and annoying chants?

Just then, I extended my stiletto-shod foot out of a taxi door. I stood boldly to my full height and unrolled a banner. The banner read "Secretary General Gorbachev, allow Vladimir and Masha Slepak, as well as all Prisoners of Zion, to emigrate." It was a banner that previously hung across the front of my house in Nashville. The banner traveled with me to D.C. to do its good work in front of the Soviet embassy.

A very tall policeman came up to me and stated, "You are free to speak your mind, but you are not free to cross this line." He pointed to the ground a couple of feet in front of me.

I thanked him politely and walked across the line. It occurred to me that I had no microphone, no megaphone, no sound equipment. But I am a singer and I know the power of a strong singing voice. To the tune of the Hallelujah Chorus, I began to belt out: "Vladimir Slepak; Masha Slepak; Let them go!" I chose to sing my protests to Handel's "Hallelujah Chorus" because of the height and very loud notes that could be reached using this tune. I repeated these simple lyrics again and again.

Yes, it was crazy. Yes, it was weird. Yes, it was foolhardy. But it worked.

The policeman let me sing my version of Handel's Messiah for a few moments and then stepped in front of me and told me that I had my

say and it was time for me to quit, or he would have to arrest me. I did not quit.

He let me go on for another 10 minutes or so, just so I could thoroughly humiliate myself. Then he told me again to stop.

"Sir, it is your job to enforce the law, I realize this, and I understand," I said. "But do you see where your feet are standing? It is this very soil that people like my father fought for in the last great war. It was these streets for which many gave their lives so that you could do your job, and I could do mine. Today, my job is to let the Soviets know that the plight of Soviet Jews is not just a matter that concerns Jewish communities around the world, but their voices have reached into the American South, and I have heard their cries for help. I am standing on the ground that my own daddy fought for, and I am doing what a Christian woman must do. So, arrest me, if you choose."

He told his fellow officers to fold up my sign while he personally handcuffed me and put me in an awaiting paddy wagon. Patti Roberts Thompson was now handcuffed inside of the police vehicle. It struck me funny, in the strangest way, that I now sat handcuffed in my very own "Patti" wagon.

But as I rode down the streets of America's capital in my Patti-wagon, I unexpectedly began crying tears of joy. It was an honor to have sung my song for the freedom of God's people to immigrate to Israel.

To my surprise, I was welcomed at the central police station by several policemen and policewomen who watched me on TV! They knew my name and were glad to see me. So, rather than a fearful experience, it turned out to be sort of a sweet time. I was booked and released after I gave them the bail money.

Within hours the Soviets called Cort Randall and told him to "Tell your girl that we are not going to release the Slepaks. Her efforts were futile."

But, in short order, for some reason, they released the Slepaks. Within a few weeks we were on a private jet, sharing our stories with them as we flew to Israel where they were to be honored as heroes of the Refusenik Movement. These humble children of Israel had served their people at great sacrifice to themselves and now the Prime Minister and Knesset members were gathering to welcome them to their homeland.

Oh my! Such a God thing! Again, I cried.

Years later, I returned to Israel with a handful of my girlfriends from Nashville, Tennessee. By this time, we had in tow a crop of teenagers. It was 1996 when I returned with these friends. It had been nine years since I was last there. Much had changed in the skylines of Tel Aviv and Jerusalem. But the spirit, the essence, of the land felt the same.

On a beautiful day, canopied by the deep blue of the Israeli sky, I once again went to pray at the Wall. I made notes to God and stuffed them into the cracks where thousands, perhaps millions of similar requests were placed. When my friends and I retreated from the Wall, a fellow traveler and I decided to ascend the long flight of stairs that hugs the stone wall that is off to the right of the Wailing Wall. These steps lead up to the Dome of the Rock and the Al-Aqsa Mosque. There are not many days in the year that one cannot find news of a violent outbreak of some sort that occurs on the large courtyard that surrounds the mosque. It has been the scene of con-

flict for hundreds of years, and this day was to be no different for me and my friend.

The Dome of the Rock was built by the Umayyad Caliph Abd al-Malik. It was finished sometime around 691 A.D. as a shrine for pilgrims. According to tradition, the Dome of the Rock was built to commemorate Muhammad's ascension into heaven after his night journey to Jerusalem. (Qur'an 17). It is built atop of the Roman temple to Jupiter Capitolinus, which itself was built over the ruins of the Second Jewish Temple. The Second Jewish temple was destroyed in the Roman Siege of Jerusalem in 70 A.D. So, the conflict over who has the spiritual right to the real estate has historical roots in what once stood there. Both Jews and Muslims claim the territory as being historically theirs. Rome's claims died with the death of the Roman Empire. (Tesch 2011)

Many Christians and Jews alike share the belief that the Dome of the Rock was built on the very rock upon which the Ark of The Covenant sat. That would mean that the Dome of the Rock is sitting squarely atop the most Holy of Holies, or the holiest place in the Jewish faith.

So, one begins to see how deep the roots of conflict between the Jews and the Muslims are. Will there be a Solomon who will have the wisdom to suggest cutting the baby in two halves so that both mamas can have their claims met?

On the day we visited, I was dressed in modest long shorts that were declared to be immodest by those that guard the entrance of the vast courtyard on which the Dome of the Rock stands. I was told by the temple guards that my legs must be covered. No problem, I thought.

I was wearing around my neck a large piece of thin fabric that one uses to wrap themselves after taking a swim. It seemed enough that I could wrap it around my waist and be well within the temple dress code. Well, after wrapping it around me I noticed that there was a slit up one of my legs, but it was not a nasty slit. So off I strolled, inching nearer and nearer to the Dome of the Rock.

Even I knew that infidels were no longer allowed to enter the Dome. Years before, I entered the building freely and took a long look around. But laws were passed since then, and now non-Muslims could not enter. So, I contented myself with a general look-about on the large stone covered courtyard.

Friday prayers were finishing, and men began streaming out of the nearby mosque. Without any warning, my friend and I were suddenly encircled by a crowd of angry men.

Someone began to scream in English, telling us to leave the Temple Mount. Before I could even clear my head, the entire crowd of men began yelling and shaking their fists at us! I finally said that I was sorry to have offended them and would certainly leave. But I was NOT going to leave unless I had an Israeli police escort off the mountain. They found that to be outrageous! Great. Now they were not just angry with us, they were furious.

Why did I ask such a thing? In the pressure of the moment, all I could think of was, "Who is ultimately in charge here? Who actually owns this land?" I would submit to and obey only the deed-holder of the land. In my mind, the proper deed-holder of the mount was Israel. So, in the moment of greatest pressure, all I could think of was to insist on an Israeli police escort.

In hindsight, there may have been all kinds of safety reasons – good reasons indeed – that made requesting Israeli police to escort me a good move. But at the time, my thinking was not that shrewd. It was quite simple.

Sure enough, in 20 or 30 minutes, the Israeli police arrived. Still encircled by furious, if devout, Muslim men, we were deeply relieved when the two Israeli officers came on the scene. The officers asked me if I would like to come along with them. I said yes that I would be absolutely delighted to do so, and off we strolled. As we walked away, I glanced back at our detractors who were now angrier at the conditions under which I agreed to leave than they had been at my sinful attire. But there was not an ice cube's chance in hell that I would have left under any other circumstances. I just could not do it.

Just one week later the prime minister of Israel, Ariel Sharon, went up to the Temple Mount. His presence caused such massive outrage among the Muslims that the Intifada officially began as a backlash to his entering that same space! Only then did I realize what true mortal danger we had been in that day!

I honestly did not go to the Temple Mount that morning with anything other than respect in my heart. I had no intention to defy tradition, culture, or the Muslim faith. But things escalated so unexpectedly and so quickly, all I could think of was that these angry men did not have the ultimate authority to demand that I leave the temple grounds. They had a cultural right to ask me to leave. But I suddenly had a sense that the very land upon which the Dome of the Rock is built belongs only to God, and He decides the rightful property manager. So, my gut-level response, intense and immediate, zoomed past current politics, or mandates of the United

Nations. The fierce will that roared up from deep within me simply could not be moved. I do not know where that force came from. I did not put it inside of me, nor did I have any idea how to make it go away. I do not know if it will rear its head again, or why. But having experienced the sheer power of this force, I do know that it will continue in me as long as I live, because it cannot be removed without my heart stopping and becoming cold and silent.

Israel has a long, long history of scars. From its beginnings, Israel was uniquely charged by God to speak the redemptive Language of Scars to all peoples of the world. All lovers of God and lovers of peace must pray that Israel will rise to her eternal destiny, and that her people will realize that they do not belong to themselves, but to God alone. And, that they will hear His voice and be able to give themselves fully to their long-prophesied purposes. It is not enough to claim the land. The people that are claiming the land must also claim the destiny that accompanies it. May God protect His true Israel and help them find their way.

Lord hear our prayer.

The Fifth Golden Thread

Did you know that Iran was once America's friend?

*Just as my heart bonded deeply with Israel, God also
gave me deep bonds of ministry and friendship with
some dear people and leaders in Iran.*

*At the time the doors opened to my Iranian friendships,
it seemed just like one more grand adventure in ORU ministry.*

*But as the years have passed, I realized these friendships were
more than coincidence. These relationships with Iranians
became for me like a window of understanding into God's heart.*

*During the season that I was ministering to Iranians, I was
not in a great place personally, either emotionally or spiritually.
In fact, I was a terribly broken woman. Things may have looked
normal on the outside, but my inner world was crumbling.*

*Yet God honored my feeble efforts to glorify Him,
opened amazing doors, and used me to bring
His Love to these Iranian friends.*

How healing it was to be used by Him even when I wasn't perfect!

*When I think about this today, it reminds me that
our experiences are never just about us, are they?*

*At an extremely low point in my life, God lifted me up by using
me to share His great love with some Iranian acquaintances that
needed His help. I am so grateful He chose me share
His love with them.*

Chapter 5

⤙⟶⟶⟶⟵

When Iran was a Friend

IN 1976 THE WORLD WAS abuzz with change.

On the national and international scene, the U.S.A. was enjoying a year-long party in celebration of our 200th birthday of independence from British rule. The weird two-dollar bill was issued, forever unseating the saying "phony as a two-dollar bill" – now there really was such a thing, compliments of the U.S. Treasury. Jimmy Carter unseated President Gerald Ford in the presidential election. Maria Perón was deposed in Argentina, Mao died in China, and Fidel Castro took up the power as president of Cuba. The world was watching the unfolding events of the Palestinian terrorist who hijacked an Air France jet, flying it and 246 passengers plus crew off to Entebbe, Uganda. Later, the Israelis stormed the airport and set the passengers free, just as they did earlier with a Sabena Airlines jet and 100 passengers. Yay for the Israelis. They were counted on at that time to do the bravest, most impossible, and unpopular tasks of the day.

In my personal world, I was married to Richard Roberts, son of famed evangelist, Oral Roberts. Life in Oklahoma was pretty much status quo, at least as much as it can be for a member of one of

America's leading religious television celebrity families. We taped 52 half-hour television shows and several highly rated hour-long seasonal specials in 1976. It was not odd to fly off on our private jet to Alaska or Beverly Hills or Italy to do God's work, or mostly God's, that is. I was working full-time as a television performer and rearing my two little girls. My life was just sort of rocking along at a peaceful-breakneck pace. My religious-show-biz job kept me flying from coast-to-coast and sometimes across the pond. I sang and sang and sang. For the most part, my work was enjoyable and even somewhat exciting. There were always new people to meet, new places to go and new challenges of life to be met.

My girls, Christi and Juli, were in preschool and kindergarten, and were well looked after by my nanny, Mrs. Idella Canoy. When I was away, Idella held down the fort with great love and finesse. My children adored her, and I trusted her. Even so, we all cried when my suitcase was taken out the door to an awaiting car. My being away was difficult on our emotions, but I rested in the fact that Idella was entirely capable and loving.

Idella was a strong woman with even stronger beliefs. Her Christian faith was unshakable, but so was her belief that if John Wayne should ever appear at her door, she would allow him to put his boots under her bed. He never happened by, so we thankfully did not have to see her face the issues of faith versus temptation. But since John Wayne was the only man that held out the possibility of infidelity to her strongly held faith, her bountiful love was spent instead on my two young girls. Idella has long since passed on to her reward, but we still speak of her and cherish the memories of her many kindnesses.

I had some recording business to do in London and flew over for a week. While there I enjoyed the lovely summer weather and walks in the numerous parks. Hyde Park was one of interest to me because of its famous Speaker's Corner. This little corner of verbal liberty still exists in that park, where it hosts a colorful array of people, each spouting off about off about politics, religion, the royals, the economy, and a host of lesser-known topics.

I strolled through the park admiring the perfectly manicured flower beds and long stretches of emerald lawn. The wet and foggy climate of England wins its justification in what it does for the gardens of the UK – lovely, all. Whatever sunshine the Brits sacrifice to rainy weather is handsomely rewarded in the glory of their gardens.

It was not long before I began to hear the noise of the speakers down on the corner. Curiosity drew me closer. Laughter and a good bit of mockery seemed to be well in order, if one did not agree with what was being shouted from atop the soap boxes. The man I was listening to could be more properly identified as a political malcontent. He was roasting his parliament and speaking derisively about his sovereign. Such passion. I noticed a young man heckling him. I watched as the speaker delighted in returning the verbal ping-pong ball. When it was over, I complimented the young heckler on his ability to hold his own with the speaker. He thanked me and introduced himself as Michael Molovani, of Iran.

With that, I met my first Iranian. He had several pals in the audience, and I was introduced and invited to sit with them for a while. These young Iranians, who proudly referred to themselves as Persians, were in England on educational visas, each pursuing his future. They were bright, personable, and fun. One young man asked me if I could

help him get a visa for the States. He wanted to join his girlfriend in Norman, Oklahoma, and complete his pediatric medical studies at the University of Oklahoma. But for this he would need a visa from our Department of State, and, during those days it was difficult to get one of those prized visas.

Abe Bayani told me that his family owned property on the Caspian Sea and that he was going to build a children's clinic there, near the sea. Each summer there was an epidemic of sorts that claimed the lives of many children in Iran. Intestinal disease, parasites, and dysentery were the issues he was planning to address. He sounded entirely serious and it seemed that his goals merited my support and help. So, without really knowing what this might entail, I told him I would indeed help him.

When I arrived back in Tulsa, I began to make calls on behalf of the young Persian doctor. I called my senator and congressmen. They showed little interest, but I continued to barrage them with calls and discussions of the benefits of helping this idealistic medical student. I wanted them to help me by recommending to the Department of State an educational visa for this young man. After much effort and quite a bit of expense on my part, the young doctor was granted his visa. He came to the United States a grateful young man and joined his girlfriend at the University of Oklahoma.

This was the year that I started to notice that God was granting me some pretty weird little miracles, and I quickly learned to put away my doubts regarding his interest in guiding and facilitating things that can happen well off the beaten path of normal evangelism.

While on a missionary trip to Taiwan, I decided that I would try to go home to Oklahoma using a different route. Instead of retracing my flights from Taiwan back to Korea, Hawaii, California and finally to Tulsa, I decided to keep on going. I was going to fly home via Hong Kong, Delhi, Iran, Rome, London, New York City and finally, Tulsa. And so, it was. For whatever reason, my geography lessons left my reasoning chambers and I assumed that it would be just as close to get home via London as it would be via Hawaii. Call it a blonde moment if you will. But I possessed one of those lovely green American Express cards and nothing was impossible. In those days, American Express cards only came in green, by the way.

My young Iranian friends in Oklahoma needed a Bible in their native language of Farsi. For that I needed to go to Tehran and secure one. Just a little errand to run while in route home. I left Taiwan for Hong Kong. While at a travel office in the wildly wonderful city of Hong Kong, I happened to read a brochure issued by Iran stating that one could travel there without a visa if he or she had an emergency visit or emergency business in the country. Those without visas would be interviewed and granted entry to the country on a case-by-case basis, according to the nature of their emergency.

That seemed to be enough for me to board a Pan American jet and head that direction. Granted, my emergency was that I needed to pick up a Bible in Farsi. But to me, this was a valid emergency. I arrived at the Mehrabad International Airport at around 4 a.m. Those with visas were going through the process of being questioned and were granted entry one by one. All those without visas were being put directly back on the plane and were being sent to London. I stood in line, alone and somewhat concerned. After all, I was a young American woman,

not accompanied by a male family member, arriving without proper papers. It was not long before I found out just how the authorities felt about such an issue. The immigration authorities ordered me back on the plane, with such a stern command that it left absolutely no room for argument. These guys carried automatic weapons and were not disposed to cordial chit-chat. I spoke up anyway. I told them that while I was extremely sorry to have inconvenienced them so early in the morning, I indeed had an emergency and needed to have them give me a temporary visa. They flatly refused. So, again, I stated that while I would like to go on to London, I simply could not do so for to irresponsibly address my emergency would be unthinkable. Again, they ordered me on to the aircraft.

Well, this was a tug of wills, wasn't it?

When I did not turn around and head out of the terminal to the waiting aircraft, they yelled at me with the assumption that I must not have understood their orders. I asked to speak to the supervisor. I was not allowed to, but the person directly in command would do so on my behalf.

He returned and brusquely told me that I must leave. Again, I asked to speak to the most senior officer. And this time I was put into a small room and heard the door lock behind the officer.

After some time, a man entered the room and said, "Madame, you have no visa. We have been clear with you that you have no right to enter Iran and you simply have to leave the country and go to London immediately."

I studied his face for any signs of softening.

There were none.

I was female, I was blonde, I was Christian, and I was American. None of these attributes were thought to be of great value to these Iranians.

Finally, I took a stab at what I knew was my only chance.

"Do you mean to tell me that after all of my efforts to help one of your young doctors enter the United States to finish his pediatric studies," I said, "That this is the gratitude you are going to show to me? Is this how you treat those who spend their own time and resources to help your young countrymen? Is this the kind of people that you Iranians are? You will take the good that another person will provide to people of your country, but you will not grant them a simple and very brief stay in your country? If that is who you are, so be it."

Angrily, he took my passport and stamped it.

"You have three days," he said, never asking what my emergency was. "Make sure that you leave the country by then, or you will be arrested."

And with that, I launched out on a search for the Hilton hotel and one Persian language Bible. And that was how my first visit to Iran began, with this weird little miracle of winning a temporary visa.

That day I met the young Iranians in Hyde Park was a day that changed my life. Before that day, I was a busy young woman raising my children, working in television, and singing full-time. Due to my intense work schedule, along with being a Mama and wife, I dropped out of Oral Roberts University. International studies, including their cultural, political, and religious concerns, did not hold

much interest for me. And taking Christ to a Muslim nation was not big on my list. I am quite sure that I thought Iran to be a place of earthquakes and unwashed masses. But these young sons of Persia indicated to me that my perceptions were wildly misguided. Instead of unwashed masses, I encountered a group of beautiful souls, astute politicos, artists, poets, fashionistas, and intellectuals.

When I returned to Tulsa, I spent time at the Oral Roberts University library researching Iran and her people. I checked out every book in the library about Iran and/or Islam. I felt an urgency to learn; to understand. I cross-referenced historical and current events with the biblical accounts of Persia and Persian kings. There I found Daniel, Esther, Mordechai, and others interacting with Persian royalty just as surely as I interacted with the young Persians in London. It was intriguing. I often asked myself why these encounters happened, and why I was so taken with it all?

Over the course of the next two years I visited Iran four more times. Each time I visited, I became more and more aware and caring about the issues this country faced. The people I knew were among the well-educated and wealthy. It was not so, however, with the bulk of the Iranian population. The ruling leader, the Shah of Iran, held an iron grip over his nation. He brought this country from a Third World antiquity, screaming and kicking, into the 20th century. Unfortunately, his massive efforts were accompanied by strong-arm measures, repressed liberties of his people, and the brutal secret service known as SAVAK. SAVAK stood for *Sāzemān-e Ettelā'āt va Amniyat-e Keshvar*, which translates literally to 'Organization of National Intelligence and Security of the Nation.' The organization served as secret police, central intelligence, and domestic security

during the Pahlavi dynasty, all rolled into one. The royal family included the Shah's twin sister, Ashraf, his wife, Farah Diba, and his children. In addition, there were plenty of political cronies who did the bidding of the Shah. I think the Shah may have been both Iran's worst news and best news all wrapped up into one person. While he clearly advanced Iran into the contemporary world, the progress was sometimes accompanied by graft, incarcerations, and death to his enemies, along with a certain repression of individual civil liberties.

Yet, under the Pahlavi dynasty, women's rights flourished, as did religious liberties, education, and the general economy. Consequently, the Shah became hated by the more militant Islamic clerics. To advance his causes, he took the mantle of leadership from them and placed it upon himself, just as surely as he did his jeweled crown, stripping the clerics of their most repressive powers.

The Pahlavi dynasty was oil-rich, Western-educated, and smartly stylish. Their friends were among the *literati*, film makers and stars of the world; they were themselves consumers of whatever was lovely and lavish. They were the beautiful people of the 1970s. One could as easily have found them in Switzerland skiing as one could find them in London, Beverly Hills, Paris, or New York City – shopping and doing business. They were massively wealthy, with a distinct cachet about them that seemed to dull the world's understanding of the brutalities it took to maintain their privileged lifestyle.

The Shah was a bona-fide dictator but defied the stereotype. He was a man with a great deal of intelligence, style, and personal beauty. These desired attributes, along with massive oil reserves, opened the doors for him to the rich and powerful of the world, most especially

Downing Street and 1600 Pennsylvania Avenue. The Pahlavis were a handsome bunch to look at, to boot. The Pahlavi dynasty had entrée.

Royal events under the Shah – whether staged at home or abroad – were lavish, lovely, and extravagant. President and Mrs. Carter invited the Royal Pahlavi family to Washington for an extravagant State dinner, and a side trip to Williamsburg. The Shah, in return, invited the Carters to Iran for political reasons but also to bask in the fading sunset of the world-stopping party he held in 1971 when, in celebration of Iran's 2,500 year of the Persian Empire, the Shah held a state celebration to top all other such occasions.

That celebration, even years later, was still the talk of the royal party circuit. It was glory, it was glamour; it was an event of unparalleled exquisiteness. The setting for this event was near ancient Persepolis, out in the Iranian desert. There in the desert, the Shah created a fantasy tent city. Chandeliers of enormous value, Persian carpets of unimaginable worth, and the finest furnishings filled the guest tents. These tents, ancient and pristine, were the visible skin that surrounded luxury guest quarters. Outside it looked like a fanciful and colorful tent city, but inside each tent were the latest and most advanced mechanical systems to ensure comfort and cool air along with opulent furnishings. The paparazzi gave the rest of the world an inside view of the Shah's vision of restoring Persia's glory. The tent city in glittering Persepolis redefined what a royal Iranian event should look like.

For all intents and purposes, it looked as if the Shah and his royal brood were best friends with all things American. Even our ambassador in Iran at the time, Richard Helm, was the former head of the

CIA. Politically, this brought no small amount of criticism to the Shah, and to our government as well. We stationed thousands of troops in Iran as "consultants." The CIA had a large presence there as well, as did American oil industries. There were sections of Tehran that mirrored Beverly Hills, complete with top designer shops. It was a wonderful time for Americans to visit Iran.

Sad to say, the adage "If you're going to dance, you must pay the fiddler" came true, and all too suddenly. But I am rushing the story a bit, so let me back up for a moment.

As a fair warning to all who desire such adventures, please know that in traveling to a foreign country and engaging with their people, one runs the risk of beginning to genuinely care for them. After meeting my Iranian friends in London and making several trips to their lovely country, those 'unwashed masses,' seemingly without faces, became individual persons to me, with very human faces. Whereas once I had no feeling for any other people group but my own and the Israelis, with an affection for the Brits, now I began to deeply care about Iranians. Maybe it was God tugging at my heart to share the grace of Jesus with this Muslim nation. Or maybe it was the golden glitter of the empire that pulled me in. Maybe it was just the wonderful people I met in London. Only God knows for sure.

But I did care, deeply. Honestly.

I remember that during this period of my life, while I was working in the Ministry of Oral Roberts, and while I was shuttling back and forth to Los Angeles, Palm Springs, England, Taiwan, India and Iran, I had a conversation with God. I told him that while I thought the ministry was fulfilling, I did not really care for masses of people.

The surge of people that surrounded us everywhere we went was somewhat unnerving to me. And they always seemed to have such urgent needs.

I was overwhelmed by their needs, and under-loving.

We in the televangelism ministry became a strange mix of show-business and God-business, and my feelings for the needs of humanity were blunted by the demands of "doing" the ministry. So, I admitted to God that I had a real problem and that I was aware that loving the ministry yet not loving people was pretty messed up. I wanted God to change me. And over time and at the price of great personal loss, He did.

While there in Tehran I was invited to sing at an Assembly of God church. I remember a gentleman coming up to me and saying that for years he prayed that Oral Roberts would come to Iran.

He looked at me with great disappointment and said, "But it is you who came here, instead."

Suddenly, I felt small and wholly inadequate. I gave my songs, my love and caring, and my prayers for these people that night. But to this gentleman, it was not good enough.

In such times I learned to call to mind that although we give to people, we are always ministering to the Lord. Whether or not it is appreciated by the people we serve, it still counts for something. Whatever is sown in love to the Lord will have a positive outcome, even if we do not see the fruit of our efforts. A couple of years later I was told that the pastor of that very church where I sang that night was beheaded during the revolution of 1979. The revolution

produced unthinkable violence aimed at Christian leaders of Iran, among others. Who could have predicted this awful outcome? I am in awe to think that God sent us, along with many others, to strengthen these Christians before their time of testing.

As I watched the revolution unfold two years later, safely back in Tulsa, I a deep sadness overcame me. Lower, deeper resounding strings of my soul began to sing in a minor key. Here I was, the girl who privately admitted to God that I did not really care for the masses I ministered to, becoming a woman who felt the heart of Jesus breaking in her own chest.

The most significant thing that Iran gave to me was the ability to feel the suffering of another culture. I began to feel the pain of that which was beyond myself. I suffered with the people of Iran. The yearning for them to know Jesus as someone other than a Western religious figure took deep root in me. I wanted them to feel Jesus, to receive His Spirit, His guidance, His comfort, His purposes, and His salvation. I wanted them to know Him. It was this shared suffering that forever changed me. It forever changed my worldview. It abolished my ability to live in splendid religious fame, unaware that outside my walls was a deeply suffering world.

On my final visit to Iran, I took a team of singers and musicians from Oral Roberts University with me. We sang wherever our performances were allowed. One of the highlights of the last tour was singing on the National Iranian Radio and Television Network. I look back now at the photos of myself, dressed in a long white cocktail-type gown with frothy feathery trim and wonder what in the world those Iranians must have thought of the blonde Christian woman from the United States. I am embarrassed today at my lack

of understanding or sensitivity to their culture. There I was, singing soft, non-offensive gospel music to a nation seething with rage at their own monarchy – and at the United States and its political machine.

Ignorance may be bliss, but it can sometimes be a dangerous bliss. Our little team from ORU was blissfully ignorant of the sorrows and frustrations that the people of our host country were feeling. Our Muslim hosts, though hospitable, were not ignorant of this seething struggle. They told us in no uncertain terms how dangerous our message was and even how dangerous our presence was in their country.

Friends at the American Embassy were kind enough to introduce me to the leader of our armed forces in the country. Gen. Philip Gast graciously received me and my team into his office and briefed us on what was happening between the U.S. and Iran. He presented a sunny report of partnership, of fidelity between our two countries. Ironically, just a few weeks after this rosy pep talk President Carter turned his back on the Shah and did not help him when he truly needed us. Carter did nothing to influence the outcome of the Iranian Revolution on our former ally's behalf. He just let him fall.

Yes, the Shah was a known human-rights abuser, but the U.S. cheerfully did business with him right up to the moment he went into exile and the Ayatollah Khomeini came into power. Our behavior begs the question: is it okay to deal with a dictator if things run smoothly and money is being made? We sold the Shah a country full of sophisticated military equipment, ostensibly because he was one of the peacekeepers in the region. And, truly, his regime did keep a lid on militant Islam and the various regional wars. The Shah had a non-aggressive relationship with the Israelis and his presence on

the Middle Eastern scene kept Israel from being a target of destruction by Islamists who wished to see Israel destroyed. Yes, Israel faced its various wars in those days, but the Iranians did not take part in them. It was more expedient for most of the Arab states to keep wars at bay while the oil was freely flowing. OPEC had some serious clout regarding that subject.

Then of course there were the Israelis and the Egyptians and the Camp David Accords. This was all going on at nearly the same time as the revolution in Iran was brewing. While President Carter was ignoring the Shah, he was busily working for peace between Israel and Egypt. Anwar Sadat and Menachem Begin were close to shaking hands in the sweet soft light of the White House Rose Garden. While it is admirable that President Carter facilitated a working relationship between Israel and Egypt, how could he ignore the foment in Iran as it reached critical mass? How could he not see what would change in the Middle East if this erupted?

The Christian media at the time was exultant in their joy over the situation between Israel and Egypt. And indeed it was such good news for the region. However, it proved to be Sadat's death warrant. He was soon assassinated. Hosni Mubarak would step into his shoes and lead Egypt into a dark time that resulted in the crippling of many personal freedoms.

Amid these events, I was asked to be a guest on Pat Robertson's CBN show. I accepted with the hope that I could speak about supporting prayer for the people of Iran. End-time prophecies were the popular chatter on Christian media at the time, and U.S. Christians largely ignored Iran as irrelevant to their understanding of last-day prophecy stages.

While I was treated very kindly by Mr. Robertson, he seemed to find my passion for praying for Iran to be naively ill-timed. Egypt and Israel and other Middle Eastern happenings were all he could see at the time. In fact, he told me that the Bible says Russia will one day swoop down and politically align itself with Iran against Israel. Since this was sure to happen, what use would there be to pray for Iran's peace, anyway?

This view of Iran seemed strategically flawed to me, but it was, nevertheless, not only Pat Robertson's view, but also the view of many other U.S. Christian leaders at the time. By contrast, my perspective was that if Iran – who stabilized the region – became unstable, God only knows what would happen. This could become a problem of epic proportion both to the U.S. and to Israel. And certainly, my instincts proved to be accurate in the end. Following the revolution, Iran soon was a major threat to Israel's existence. And today, Iran, which was once ruled by a "Hollywood-perfect" dictator, favorable to the West and at peace with Israel, is now antagonistic to both countries, with weapon potential of a nuclear Armageddon.

With my whole heart I wished that President Carter would have used his great power to intervene on behalf of the Iranian people! And I also wish to this day that Pat Robertson and his evangelical colleagues could have seen where their end-time theology was leading us politically; a road that ended with Israel and the rest of the world in peril. Don't you wish there could have been another alternative? Don't you wonder how the outcome today might have been different if Christians dedicated themselves to praying for Iran's peace?

When the Pahlavi dynasty collapsed because of the Islamist uprisings of 1978 and 1979, the Shah flew out of Mehrabad Airport in Tehran,

never to return to the land of his birth. He shuffled from country to country looking for a place of respite and safety. For the most part, he and his family were turned away. He was a hot potato that nobody wanted. Eventually, he landed in Egypt and accepted the hospitality of President Anwar Sadat. Koubbeh Palace on the outskirts of Cairo became the last place the beleaguered dictator rested.

The next year, in 1980, I got a call from the dear soul, Harold Bredeson. He regularly visited the heads of nations and awarded many of them the prestigious "Prince of Peace Award," if he deemed them as having done something significant to move peace forward. It was arranged for him to take a delegation to Cairo to present President Anwar Sadat with this award. While the Shah was not on the list to receive the award, Bredeson was deeply compassionate for this very frail and sick man, now living in a bedroom on the second floor of a borrowed palace. Harold asked me to join him in going to Egypt to see Anwar Sadat and to pray for the Shah.

Arrangements and appointments were made for both events. Sadat received the award graciously. And the Shah, even while suffering from cancer, agreed to receive prayer from our small delegation. There were about a dozen others that Bredeson assembled for this mission, and we all flew into Cairo from various parts of the world. We were all Christians that were well-schooled in the current events of the region, including the details of the Iranian Revolution, and the ramifications that spiraled out of that bloody vortex. Many of us personally knew Christians who were now martyred because of it. So here we were – an odd assortment of believers gathered to speak life-giving and encouraging words and prayers to a terminally ill king without a country.

When we arrived at Koubbeh Palace, we were led into an opulent receiving room. Soon, a man appeared and told us that his Majesty was too ill to leave his bedroom. We were asked to come into his bedroom for our audience with the Shah. I remember climbing the wide white marble staircase and wondering how it is that one finds oneself headed to the bedroom of a dying monarch? This very event is proof positive of the great mercy of God, and the lengths to which He goes to reach out to all lowly souls. No one is beyond His compassionate reach.

The light was dimmed in the royal bedchamber. I found it odd and sad that there were open suitcases on the table, not even 10 feet from the bed. This was on purpose, a preparation. If a quick getaway were necessary, they were ready. A box of Kleenex, a container of Johnson's Baby Powder, and other common items sat on the nightstand. The Shah lay in bed while Her Highness the Queen, sat on a chair beside her husband. She thanked us for coming to visit them. Mr. Bredeson told them of our concern for their personal and spiritual health and well-being. We prayed for them in general, and we prayed for the Shah to be healed.

Farah Diba Pahlavi, her majesty, said that she prayed that light would overcome the darkness in her country. How odd it seemed to me, at the time, for a Muslim to pray that the darkness of militant Islam would be overcome by the light. What light? What was she referring to? I was not sure, but I knew that this was a good prayer. Her prayer rang in my ears for years.

I felt sad that, though, that when it was my turn to speak personally to the Shah and his wife, I was not a brave Christian. I held his fevered hand and told him that I was sorry that he was not in his country. He asked me if I knew of his country, I answered that indeed

I visited Iran on many occasions. My heart wanted to tell him about the Light of Jesus, but at no time in my conversation with him did I mention Jesus Christ. Timidity and political correctness stilled my tongue and hid my fervor for the ultimate well-being of his soul. A grief for the loss of such a momentous opportunity lived in my heart and memory until such time as I could address and somewhat correct my behavior. The Shah died on July 27, 1980, a few weeks after we left Egypt. The great moment to tell him of my Lord was forever lost.

His wife, her Imperial Highness the Shahbanou Farah Diba, was another matter. Nearly 15 years later, now divorced and living in Spring Hill, Tennessee, a door unexpectedly opened in 1994 for me to meet with her. This time, I was resolute; I would speak to her of the deeper things of my faith. The queen owned homes in Paris and in Connecticut, and I was invited to her home in Connecticut. At that time, I had little money, and certainly not enough to buy a next-day plane ticket to Connecticut. Nor did I have proper clothing to meet a queen. Years earlier I traveled to Iran with several suitcases packed full of exquisite clothing just in case I needed to meet with the Pahlavis. But those days were gone.

In my many years of ministry I never directly asked anyone for money to do a mission. In fact, the very idea of doing so was repugnant to me. My years of being with the Oral Roberts ministry, sitting through fundraising effort after fundraising effort, expunged whatever desire I might have to get someone to empty their billfold or purse into a Patti-allocated offering plate. The doctrine of "Seed-Faith" so widely promoted by Oral Roberts was not something with which I wholly agreed. It was not the scriptural references about giving that were problem to me. The emphasis of giving to God

and expecting him to pay back ten times more was. The "If you give money, you'll get money" gospel, although the hottest deal in town, simply was not supported by the full counsel of scripture, or so I thought.

The constant need to raise funds for the university or proposed hospital using the Seed Faith message totally wrung me out. I left the Oral Roberts ministry ultimately because of this – I could not justify the "give to get" method of fundraising. To this day, I hate that pet doctrine because I saw it preached in a way that manipulated people into giving money. Is it true that God honors our gifts of money, love, prayer, and kindness? Yes, He does. But the way Seed Faith was preached in those days reduced a holy sacrifice to an unholy slot machine. God became an evangelical Santa, and the faithful giver became one who can access God's treasury by putting money in the plate. It was sad to me, also, because it changed the emphasis of man being the servant of God to God being the servant of man.

But here I was, now truly in need of funds for ministry. And, I was going to have to ask for it. What was I to do?

A wonderful couple by the names of Joseph and Karalyn Schuchert came to mind. Joseph once mentioned to me that if I ever needed anything, I should call him, years passed since that conversation. I never picked up the phone to tell him about any need before now. Now however, I saw this as an opportunity to address my mistake of not giving the raw gospel to the Shah. Granted, he was gone, but his wife and family were still alive. I needed to lay aside my pride and ask for help. Sure enough, I barely requested the help, and a plane ticket was in my possession with a next-day departure time. I shall always appreciate Joseph Schuchert's generosity and prescient un-

derstanding of what I needed to do. On October 31, 1994, Joseph afforded me the honor to visit with her Majesty Fara Diba.

I arrived in Greenwich, Connecticut, on Halloween evening. I was totally unaware that this holiday might conflict with my arrangements to arrive at her Majesty's house at a specific time. From my hotel room, I called for a taxi to take me to her address. I was informed that due to the many trick-or-treaters, there were no taxis to be found. I guess I never thought that certain kids used taxis to get around from neighborhood to neighborhood in Halloween. When I was growing up, we walked from house to house.

I fretted as I watched my appointment time come and go. I called the front desk of the hotel so often and so urgently that they took my emergency personally. The clerk told me that he would take me to my appointment as soon as his shift ended. I called the home of the Shahbanu and asked if a late arrival would be acceptable. It was. When the young man finished his shift, he called for me to meet him at the front door of the hotel. When the glass doors popped open so did my eyes. My chariot awaited there in front of me.

The rain was torrential, and the old rag top of his dented car leaked a bit, but I was thankful for the ride. When we pulled up into the circle drive of her Majesty's home. I saw a female figure eyeing me from the second-floor window. I assumed it was her. How funny I must have looked, getting out of that leaky old convertible, and running to the door.

I was welcomed at the door by the butler who was, I assume, also a security person. He led me into a large living room to the right of the entry foyer. A gigantic dog sauntered into the well-furnished

room and gave me a sniff and a look over. I guess I passed inspection, for within five minutes, Farah Diba entered the room. For an hour or so we chatted and sipped tea. I will not disclose the subject matter of that visit except to say that I told her of Jesus, and I prayed, and she listened. She said that once while skiing in Switzerland, a young Christian man approached her and talked to her about Christ the same way.

Admittedly, I felt very humble coming to this woman's home in a beat-up old car with rain pouring in the front passenger seat. But, as you know, it just takes what it takes to get things done, and one must be grateful for the chances God gives us to share his magnificence. How I got there will certainly not matter in eternity. It only bruised my ego for a moment. What matters is that we remain vigilant to the miracle of open doors. Never think that there is any closed door that cannot be quietly opened by God if you are intent upon doing His work. He opens doors; we have but to walk through them and carry out our mission.

Some years later, I went to Paris and sang a parlor concert for Farah Diba Pahlavi and several of her former royal court that lived in the area. Again, she graciously listened as I poured out Jesus in every song. While there, I was also invited to sing the same concert at the France Amerique-Society, where I was billed as "An American Woman Sings Her Soul." And I did. In fact, I left it all right there in their laps.

French audiences appear extremely bored and unimpassioned to me and this audience was no different. At the halfway mark of the concert I took a break and seriously considered taking a taxi back to the hotel and just leaving them sit there. They seemed to be merely

enduring my presentation. They acted as if they somehow found themselves in a situation that they were too polite to abandon. Their contempt hit me in the face with each new song. Toward the end of the concert I simply gave up on them and sang my heart out to Jesus. They could enjoy it or not, their stone faces caused me to not care any longer.

Standing in the receiving line following the concert, I was flabbergasted at their responses. Person after person took my hand and told me how my songs "took them up to heaven." They shared the intimate reaction of their hearts. How could the people in this line possibly be the same people who sat there like stone gargoyles just a few moments earlier?

Never underestimate the work of the Holy Spirit in the lives of those you reach out to touch! Expect Him to do great things, abandon yourself to the mission, and leave the results in God's hands. It is not about us, or whether we are adored, or conversely, perhaps not liked at all. As I look back over my interactions with the Pahlavi family, I realize that only God knows what may have been accomplished. I have no way of measuring it. My only mandate was to be obedient to the moment of opportunity.

Allow me to tell one more story about my Iran experiences. During each of my four visits to Iran, I met people I considered to be highly significant. There were also those who seem to be incidental to a greater scheme of things. One such incidental person was a man with the first name of Tony. Tony is obviously not his Iranian name but for the purposes of this story, Tony will do. I met Tony at a Bible study in Iran. I went to sing for a few people who gathered to see what in the world I might be doing in Tehran. Tony told me that

long before that night he became a believer in Christ. He was born Muslim, but Christ visited him and won his heart. He asked me if I could help him get into Oral Roberts University to study and prepare for the ministry.

It was an easy request and one that I was happy to carry out, back in Oklahoma. Not long after I returned home, Tony arrived and enrolled as a student at ORU. While a student, he worked for my brother's company to make ends meet. I never really kept up with his day-to-day life but would see him at university events from time to time. He met a lovely woman from Canada and eventually married her. The last time I saw Tony was at my brother Ron Holcombe's wedding. Ron and Tony became close friends, and he was there to wish the bride and groom nuptial bliss.

In 1985, Tony somehow got a copy of and read my first book, *Ashes to Gold*. (Word Publishing, 1985). In the book I stated that I felt like I was a complete failure at accomplishing anything of lasting, eternal value in Iran. Tony and his wife disagreed with me about the value of my work in their country. Soon after they acquired my book, they wrote me a letter of love and encouragement. Tony said that my efforts to reach out on his behalf at ORU gave him the chance he needed to grow the roots of his faith down deep into Jesus Christ.

For many years Tony preached the gospel to Iranians via shortwave radio. And he further stated that thousands of people heard the message of Christ and indicated that they were now believers. He has continued to preach the gospel by every conceivable means to Iranians around the world. In fact, so famous is he for his faith and his moving sermons, that a death warrant was issued over his life by

the Ayatollahs! He moved from country to country to keep his family safe. Still and yet, he preaches on.

What I never could have done because of not knowing the language or how to reach into the Muslim mind, Tony and his wife were, and still are, doing with eternal and bountiful fruit.

It is God who is at the helm, and He is doing His own will, using whomever He desires and in whatever measure they allow. Again, it is not about you or me, it is just about being obedient.

If you knew me in those days, you would not have seen a faith giant or a gleaming example of grace. You would have seen a woman with many contradictions within herself. You would have known me as a woman who struggled to be obedient, and sometimes one who wondered if my life had any meaning at all. You would have seen a woman who was still trying to "fix herself." You would have seen lots and lots of cracks in the tea bowl. But God just went ahead and used me anyway. God was practicing the beautiful art of Kintsugi in my life, even though I was unaware. Amazing. I branded myself as a hot mess -- because it was the truth. My life was in shambles. My marriage was deeply troubled and headed for divorce. I was a part of the Oral Roberts Ministry, but it no longer ministered to me. The differences in how we practiced our faith were becoming evident. I believed that if I just did all the right things that good little Christian girls were supposed to do, that my life would be brilliantly blessed and unflawed. Sadly, I discovered that I could not measure up to my own standards of goodness, nor could any of us in my TV family measure up to the high standard of morality and goodness of the Christ we preached.

Before the divorce, I remember sitting on stage in chapel at ORU having just returned from one of my trips to Iran. On the outside, in that stage, I looked successful – as one who had achieved the life of success that our formulaic gospel suggested was easily available to everyone who would only believe and apply the formula. But I couldn't stop crying.

I remember crying off my perfectly made-up face, aware that tears were staining my Brioni suit. I must have looked like I was having a deep spiritual experience. But honestly, I was crying because I had seen a world that existed completely outside the matrix of our U.S. theology, and that world – by its very existence – had proven to me that our "formula gospel" was insufficient to effect real change in societies not so materially blessed as ours. I cried because I thought of the story of Jesus passing the fig tree and cursing it because there were no figs on it. He was hungry and the tree denied him nourishment. The tree was covered in big, bold, and beautiful green leaves. It was a magnificent tree of green leaves. Had Christ been looking for a place to sit and get some shade, it would have been perfect. But he was looking for more; he was looking for life-giving nourishment. For all its leaves, it bore no fruit. He cursed that tree.

I cried because we were like that big tree, full of lovely leaves but little to no fruit; my TV family put on a great show but lacked the true nourishment that would sustain the spiritually hungry. I cried because I realized that I, too, was a big green tree with no fruit. I cried because I suddenly realized that what I was, and what they were, was not enough. We needed to be more Christ-like and less celebrity-like. We needed to live among the real people with their real problems and their real hungers. In the guise of the people in

the crowds, Jesus was asking to be fed. But the "give to get" gospel was never going to feed Jesus, because it was designed to feed us.

This "give to get" doctrine went on to taint a good portion of the young preachers who wanted to be a success in the evangelical world. This gospel was errant. It was harmful. It removed both the discipler and the discipled from the reality that we were to be producing figs. We did not need Brioni suits. We did not need private jets. We did not need the country club. We needed Jesus, and we needed Him just as much as the unwashed masses of Iran or any other country.

The gospel that Christ himself put forth was the gospel that we needed to live and preach. Nothing more. For this pure gospel, I cried.

The Sixth Golden Thread

When I think of the Middle East, I think of three ancient mothers. These mamas were just as real as your best friend or mine. They were ordinary girls, just living their lives. Yet more than any other trio in history, between them, they left a legacy that changed the history of the world.

The first two women bore children to the great patriarch Abraham, and each was told by angels that they would become mothers of great nations. What a promise!

But being the mother of a great nation was not quite enough for them.

You see, they were rivals. Through uninvited circumstances in their lives, they ended up competing for the same man's love and legacy. There was jealousy, there was bitterness, and there were between them words and actions that left deep scars.

Unfortunately, these hurtful attitudes did not stop with the mothers. Through the ages, their sons and their sons' sons carried the rivalry forward; it seemed it was in their very blood. This generational bitterness became the source of wars, tears, and scars through the ages, and even down to our day.

But the third woman had a different impact. Born centuries later, descended from the same ancient patriarch, this young mother carried within her womb a bridge-builder. Her son was sent to unite the family of Abraham. In fact, He was sent to unite the entire human family. His legacy ran as deep as blood also, but instead of blood that boiled with rivalry and war, the blood of the third son brought peace.

Chapter 6

The Three Most Influential Women in the World: Thoughts on Legacy

THROUGH MY EXPERIENCES IN ISRAEL and Iran, a part of my heart now lives in the Middle East. I began to see that the gospel could not be presented in power as an Americanized product. The Middle East helped me to realize that the gospel I love and dedicated my life to spreading was highly culturized. To the people of the Middle East, we must have seemed like the leafy green shade tree mentioned in the last chapter; beautiful, perhaps even refreshing, but without real fruit to offer, without substance. If we were going to offer the truly transformative gospel of Jesus Christ, the gift of the very Life of Heaven to save the people of the world, we would have to reach deeper. We would need the real deal, the pure gospel of Jesus Christ, not a "shade tree" version.

But where could I find this pure gospel of Christ? This question sent me back to our roots – to God's promises to the patriarch Abraham. I needed to delve deep into Abraham's story until the central characters became real to me. As I re-read the account of it in Genesis 12-15, the characters began to come alive and I was transported back in time in the desert, in a place so real it was as if I could hear their very human conversations. Care to join me there? Here we go …

Abram gave out a big sigh. Why were things so difficult these days? Sarai had been in a sour mood recently, which was not like her at all. She was usually joyful, hopeful, and eager to awaken to a new day. But that now seemed to be a thing of the past. Of late, she was quiet, snappish, perhaps even moody.

Abram was getting weary of trying to prop up her faith, and sometimes even his own. After all, it had been a great many years since the Almighty spoke to him about a son. Yahweh talked to him then of great promises and a great legacy. Abram was to be "the father of many nations." And, every night before sleeping, he would go out of the tent and just sit beneath the stars. God talked to Abram about the stars, once. The Almighty said that Abram and Sarai would give birth to a son, and that through their son would come a great and long line of descendants. Abram was to become the Father of Nations with descendants so numerous that they would be like the stars. But now, even that nightly ritual of remembering the Word, and the promise of God, was stale and brittle. The millions of stars, the uncountable numbers of stars, seemed to mock him. How silly it all sounded now. After all, he was going to be 86 on his next birthday, and Sarai was just a few years younger. How can a child be born to an old man and old woman? Especially when that old woman's womb never bore a child, even when she was young and of the age to get pregnant? God knows, it was not for a lack of opportunity. She and Abram loved each other deeply and often. Yet no baby was conceived.

Sarai found Abram with his head in his hands. She once laughed out loud when God said she would bear a child. Even in those earlier days she was regarded as an old lady. But now, neither of them laughed, not these days. Her husband's sad face brought tears to her eyes.

"Abram, are you sure He said that you and I would be the parents of the Promised Child, the Covenant Child? Could He have meant that we would raise a child and call him our own, but perhaps we would not be the ones to give birth?" She reasoned, "I know that you might still be able to father a child. Well, with a little miracle or two, you could. But there is just no chance of my being able to even get pregnant, much less have the strength to carry a baby to term. And, then there is the matter of giving birth. Could this old body of mine withstand the rigors of giving birth? What were we thinking? We must have misheard The Great I Am. We certainly cannot have a baby of our own."

And with that, Sarai went into her own tent, snuffed out the lamp, and quietly wept until sleep overcame her.

Poor Abram, he had his own doubts with which to wrestle, and Sarai's doubts pushed him to the brink. Perhaps Sarai was right. Perhaps they had not done their part; perhaps there was another way that this child is supposed to come to us, he thought.

The next morning, he was awakened by singing. Could it be that Sarai was singing? Yes, it was her voice all right.

"Good morning, my husband. I hope you slept well. Here, I have fixed your favorite foods. Now sit and take nourishment."

What on earth could have changed last night's brooding Sarai to this morning's singing nightingale?

"Abram, my husband. I have the answer," she said.

"The answer to what?"

"My dearest husband, we have been patient, we have kept the faith. But we must face the fact that nothing has happened. You were 75 years old when the Lord spoke about our son, and now you are about to turn 86. All these years of waiting, and we still have no son. We must not have understood the Lord correctly. The Almighty, bless his holy name, could not lie. So, the problem must be with us. Abram, we wanted a child so much. We were so desperate. We stood strong, month after childless month, and year after childless year. We made love. We watched. We waited. We did everything humanly possible, but still, nothing.

"But in the night, it came to me! How could we have missed it? There has been a solution right in front of us all along! My beautiful handmaiden, Hagar, is young and strong. She has never once disobeyed me, nor has she ever done one thing that I could hold against her. She has a sweet temperament, and a gentle manner. My dear husband, please take my maiden to your chamber and give me a son through her. Just think, in nine short months we could be holding a little baby boy. "

Abram was stunned. "Sarai! How can you even say such a thing? I cannot. I will not."

"Abram, we have an obligation to the Almighty to do our best to have a son," Sarai reasoned. "How else will the words he gave you come to pass?"

And, so, Abram did as Sarai suggested. And, sure enough, it was not long before Hagar told her mistress that she was with child.

Together, the three of them looked forward to the day of the child's birth. There were only a few times when other emotions came up be-

tween Sarai and Hagar. Sarai often chided herself for thinking that Hagar's attitude was disdainful, perhaps somewhat entitled. It was foolish for her to think that the handmaiden somehow now gained an upper hand. Why should she be jealous? After all, this plan was her idea to begin with. She must dismiss these thoughts immediately. But the beautiful Egyptian handmaiden's eyes told a story that Sarai could not seem to discount.

There was a brief time when Sarai grew so impatient and negative about Hagar's attitude that she demanded that the girl must leave the camp. And, so, Hagar was sent to live outside of the confines of the camp. An angel was sent from God to comfort the frightened handmaiden as she shivered in the cold, hidden near a spring out in the desert.

"Go back to your mistress and submit to her," the angel instructed Hagar. "God hears your cries."

The thought of going back to Sarai was not a pleasant one. But when her emotions calmed down, Hagar did as the angel said and returned to her mistress. When times became hard for her, she recalled the promises and prophecies the angel spoke to her.

Soon, a beautiful boy with deep dark eyes and hair was born. Hagar named him Ishmael. His smooth skin was soft as a cloud and was the color of newly tanned goat skin. A baby at last! He was loved and celebrated in the great household of Abram.

Even the little boy's name was a testimony. 'Ishmael' means 'God hears'. Hagar named him that because of the message of comfort the angel gave to her.

Surely, now, Abram thought, *the promises of the Almighty would go forward just as he said so many decades ago.*

Abram and Sarai were happy. Hagar was joyous and deeply proud of the son she brought into this world. Once again, harmony returned to the tents of Abram.

All was well on the plains of Canaan.

Years passed. Abram's wealth increased, even as he increased in age. His son grew to be a beautiful young boy, the delight of his father's eyes.

Then, the Lord came again to Abram. Then, as now, when God shows up to speak to a human being, the body loses all its strength and crumples to the ground. Abram fell face down before the voice of the Almighty. He was now 99 years old, but even had he been a strapping young man, his physical response would have been the same. Mortal flesh is no match for the power that comes from the presence of God.

"Abram, I am God Almighty; walk before me faithfully and be blameless. Then, I will make my covenant between me and you and will greatly increase your numbers," said the Voice who called forth all creation.

God spoke again. "No longer shall your name be called Abram, but your name shall be Abraham, for I have made you the father of a multitude of nations. I will make you exceedingly fruitful, and I will make you into nations, and kings shall come from you. And I will establish my covenant between me and you and your offspring after you throughout their generations, for an everlasting covenant, to be God to you and to your offspring after you. And I will give to

you and to your offspring after you the land of your sojourning, all the land of Canaan, for an everlasting possession, and I will be their God." (Gen. 17:5-8)

Abraham could not even lift his head from the ground to which he fell. The weight of the Presence of God pinned him down.

God continued speaking. "As for you, you shall keep my covenant, you and your offspring after you throughout their generations. This is my covenant, which you shall keep, between me and you and your offspring after you: every male among you shall be circumcised. You shall be circumcised in the flesh of your foreskins, and it shall be a sign of the covenant between me and you. He who is eight days old among you shall be circumcised. Every male throughout your generations, whether born in your house or bought with your money from any foreigner who is not of your offspring, both he who is born in your house and he who is bought with your money, shall surely be circumcised. So shall my covenant be in your flesh an everlasting covenant. Any uncircumcised male who is not circumcised in the flesh of his foreskin shall be cut off from his people; he has broken my covenant." (Gen. 17:9-14)

Then, God addressed the matter of Sarai. "As for Sarai your wife, you shall not call her name Sarai, but Sarah shall be her name. I will bless her, and moreover, I will give you a son by her. I will bless her, and she shall become nations; kings of peoples shall come from her." (Gen.17:15-16)

Abraham, who began to raise himself up off the earthen floor, fell again. But, this time, he was overcome not by God, but by hysterical

laughter. Abraham literally laughed out loud at the pronouncement of God. He laughed until tears streamed down his face.

Finally, catching his breath, he said, "How in the world," he gasped, "Can a son be born to a woman of 90 and a man of 100 years? Will my Sarah still bear a child – at the age of 90?"

Now, here comes a big lesson in legacy for all of us who are reading this improbable story. I am interrupting the narrative because there is something so important here to consider. Remember, God appeared to Abraham a decade or so earlier and told him the same story. But then, Abraham and his wife stopped believing that they would conceive a child themselves and decided to go ahead and have the child by other means. And thus, Ishmael was born.

Because Abraham loved his first-born son, he cried out to God: "If only Ishmael might live under your blessing!"

How often do we ask God to bless something that we have made on our own because we could not wait for God to do things His way? Or how often have we created our own answers to prayer, instead of giving God enough time to put a better plan in motion for us?

By this definition, I must admit that I have created many 'Ishmaels' over my lifetime. These were not bad things, necessarily. I am just saying that they were not necessarily "God" things. I am as human as Abraham and Sarah. Like them, I had a vision, or a need that I had brought to the Lord and felt He would answer. But I also grew discouraged, and eventually impatient. So, I fixed it, my way, just as Abram and Sarai did. And thus, my limitations became part of my legacy. Later, I too bargained with God and asked him to bless my fleshly efforts.

"Isn't this good enough, God?" I prayed. "See how successful it is? Other people are now involved. It's fine if you want to do a more supernatural work, but could you bless this too?"

Tell me honestly, haven't you done the same thing, at one time or another?

After all, Ishmael was a beautiful little boy, and he *was* Abraham's first-born son; his daddy loved him as deeply as any man loves his son. Of course Abraham asked God to bless Ishmael, even if there was to be another child of the covenant.

The amazing thing that God said next nearly renders me speechless. God said "YES."

God did not strike Abraham down; He did not judge Abraham and Sarah, nor did he blast Ishmael to smithereens. God did not even lecture, "Because you didn't do things my way, in my timing, trusting me alone, I will NOT bless the son of your human efforts to fulfill my heavenly plan."

No, the *God of All There Is* simply says yes to Abraham's request. Yes, He will bless Ishmael.

Please carefully read God's full response to his servant of little faith:

> "... but Sarah your wife shall bear you a son, and you shall call his name Isaac. I will establish my covenant with him as an everlasting covenant for his offspring after him. As for Ishmael, I have heard you; behold, I have blessed him and will make him fruitful and multiply him greatly. He shall father twelve princes, and I will make him into a great nation.

But I will establish my covenant with Isaac, whom Sarah shall bear to you at this time next year." (Gen. 17:19-21)

Then God took his leave. An astonished Abraham looked up as a trail of light extended deep into the blue skies of Canaan, then disappeared. God had spoken. God had vanished.

It was God's moment to fulfill His promises in His own way.

The story of Abraham and Sarah gives me of the hope that no matter how much I mess things up, God has not forgotten me, nor has He cancelled His original calling and plan for my life. I have offered up my Ishmaels and He has not struck me down, nor did he kill my Ishmaels. Instead, he agreed to bless the results of my willful efforts. But he stands before me and declares that He will yet do in me, and through me, that which he declared to me in my youth.

God does not forget us. God also does not forget His promises. God has not changed his mind about me. If I bring my life to Him, He will take me, broken as I am, and repair me with gold. He is the Kintsugi Master. And in that repaired state, I will be an honor to him, more beautiful than before. I will yet declare the works of God and his great glory. My road may be long and take many detours, but I will arrive at my intended and holy destination. And you will too if you put your trust in Abraham's God and his son, Yeshua.

So, let's take a deep breath and head back to Canaan.

No one could have known what was about to happen for indeed, pregnancy in a couples' "90s" was a physical impossibility. It could not happen. The laws of nature forbade it. Yet it did happen.

The God who created the Laws of Nature can transcend them whenever He wishes.

Sarah awakened one morning with a sick feeling. Had the delicious lamb that Hagar prepared for last night's feast gone bad before being served? She hoped that she wouldn't arise to find the whole household sick and vomiting.

She felt a little better by noon but was still not able to eat without losing it all. Surely, this would soon pass. Thankfully, she seemed to be the only person who ate something bad.

Day after day, she continued to have sudden episodes of feeling ill. Was it her time to die? Was this some strange disease that would kill her? She simply could not bring herself to eat much and feared that if this continued, she would become skin and bones. It was bad enough that she was old and dried up. But to be an old bag of bones was something she could not bear thinking about. She felt every hour of her 90 years of life.

Her husband was a kind man and still seemed devoted to her. But there was Hagar to look at, the Mama of Abraham's only son. And Hagar was a beautiful, and much younger, woman. Her thick black hair flowed down her back like a mysterious dark river shining in the light of the moon. And her skin...not a wrinkle in sight. Sometimes Sarah was afraid of Hagar's beauty. Maybe she was even a little jealous of her sultry Egyptian handmaiden. Even at 100 years of age, Abraham was still a man's man. She wouldn't blame him if he looked at Hagar with desire. Hagar seemed to sense this, and that made Sarah feel even worse. Since Ishmael came along, Hagar's self-confidence soared. Her importance in the home was greatly elevated after

she bore Abraham a son. There were times when she even seemed to give Sarah a look of pure mockery.

Abraham was the first to notice that his wife's breasts were getting larger and her stomach, always taunt and firm, was softening and getting quite round.

"Sarah, you are with child." He announced.

You could have heard a bird thinking. The tent went silent, and no one moved.

Then Sarah's deep laughter broke the tension. "Abraham, my man of faith, have you missed the fact that I am just about to celebrate my 90th birthday?" Sarah laughed. Even with the changes happening in her body, at this point she did not give pregnancy a passing thought.

"No, my dear," Abraham said slowly. "God said that YOU would give birth to our child. And even though it has been nearly 25 years since He said it, it will come to pass. Sarah, you are going to have a baby and that baby will be a son, just as The Almighty said."

Suddenly it was all too much, and her emotions swung wildly the other direction. Sarah began to weep. Abraham wrapped his arms around his wife and held her as he never held her before. Suddenly, it all made sense. Sarah being sick nearly every morning, her breasts swelling, and her usually calm, mature emotions swinging wildly up and down, like a branch in the wind. Sarah was pregnant.

Pregnant.

Sarah was with child.

The news spread quickly through the household. Hagar was preparing food when a young maiden burst into her tent with the news. She slowly put her chopping knife down as her world ground to a standstill. How would this change her life? What would happen to her? Would Abraham still give her favor? Would he still love their son?

She chilled; and for one long moment that seemed to stretch into eternity, Hagar felt as if the very oxygen was sucked out of her lungs.

Yet life carried on. And the old lady Sarah grew.

A few months passed and one day Abraham's tent was once again filled with the sounds of a woman giving birth and the small shrill cries of a baby. Sarah's baby was born; it too was a boy. They named him Isaac. Ishmael looked on from the shadows of the room.

"Father, will you love Isaac as much as you love me?" asked Abraham's 14-year-old son, Ishmael.

"Ishmael," Abraham said. "I will always love you, just as I have since you were born." He held his son's head close to his cheek and his body close to his own. He could smell the sun and the wind in Ishmael's thick ebony hair. It pained Abraham to see Ishmael's young brow furrowed with worry.

Time passed again, and soon little Isaac was the light of his father's life. Abraham was glad that they named this child Isaac, for just as his name suggests, the boy brought laughter into their tents. Abraham could never have dreamed that at 100 years of age he would be holding the love child of he and Sarah on his knee, telling him how God promised this day would come. The Almighty had always been a

promise-giver. Isaac was evidence that the Almighty is also a promise-keeper. And the Almighty is also a covenant-maker.

And Abraham knew that it was Isaac that was the covenant child. It was through Isaac God would somehow fulfill his promise to Abraham to bless "all the families of the earth." (Gen. 15:12-21) Isaac, the covenant child, would carry the blessing forward. He knew this because God Himself told him.

But how would he ever explain this to Ishmael, his first-born son?

Ishmael could feel his father's shift in priorities. Before, Ishmael was the one and the only son. But now there was a new baby that held his dad's rapt attention.

"Mama, I don't like Isaac," Ishmael confided in Hagar. "Father dotes on him and tells him the promises of God. Those promises are supposed to be for the first-born son, and I am the first born. But Father acts like Isaac is first-born, too. Mama, my heart hurts and I am afraid."

"Ishmael, my son, come and let your mama comfort you," Hagar said. "You are the first-born son of your father and nothing can change that."

But deep inside, a great and terrible desert storm was brewing in Hagar's heart. Meanwhile, a storm was brewing within Sarah, too. She heard Ishmael and his mama making fun of Isaac and even belittling him. She simply would not stand for her son being mocked.

Sarah and Hagar became so hostile towards each other that Sarah finally pulled rank. She insisted that her husband Abraham send the servant woman Hagar and her son out of the camp.

Exile. Sarah demanded exile for her handmaiden, along with Abraham's first-born son, knowing that sending them out in exile would mean danger and even death.

How this must have ripped apart Abraham's heart! He was forced to choose between Ishmael, his beloved first-born son, and Isaac, the covenant son of his wife Sarah, also his beloved son of the long-awaited promise.

In the end, Hagar was cast out. Yet the *God Who Hears* did not forget Hagar. Once again, He was so moved with compassion toward her and her son that He sent an angelic messenger. The angel found Hagar and her son alone in the wilderness and he proclaimed God's love for them and brought them the same message he gave Abraham, that God promised to make of Ishmael a great nation as well. Both sons would produce great nations. Both sons had God's full attention. But, their mission, their spiritual assignments, were different. And, from God's point of view, "different" did not mean "lesser." It just meant different. Each people group was to play a different role in the drama of the ages. And, to this day, their descendants are stumbling in their efforts to attain God's true purposes – a very human reaction to Divine intent; one that is not limited to these two people groups. Though Isaac bore the covenant blessing and the responsibility to produce a nation of people for God alone, Ishmael's assignment had its own significance in the walk of mankind from earth to heaven. But, alas, both, and all, have sinned and fallen short of the glory of God. (Rom. 3:23)

Both mamas claimed the "covenant son" status for their boys. The boys claimed the coveted status, as well. And, neither son has ever let go of his claim. The spiritual and physical DNA of their descen-

dants is tainted with enmity; an enmity that seems hopelessly and continues to roll down, to generation after generation. It still causes wars that seem to have no solutions.

In thinking about Sarah and Hagar, I sometimes wonder how much of a role the two women's rivalries played in their family's dysfunction? If Sarah and Hagar realized that their bitter heart attitudes toward each other (and each other's sons) would filter all the way down through history and spill into the bloodshed of endless wars today, would they have changed? Again, the word "Legacy" comes to mind. Perhaps if these women could have seen the ultimate sorrow this bitter rivalry would bring, they would have felt an urgency to make peace within their family, somehow. Our Legacy can be both positive and negative, and surely, we all leave a little of both in our wake.

Just as surely as these women's attitudes rolled forward through time, so will our attitudes, as we raise our children. If DNA testing has taught us anything, it has shown that what I am will be passed down to my children and even to my children's children. We must become mamas of peace, while holding fast to the Prince of Peace.

But back to the Biblical story. Seasons came and seasons went. Abraham, Sarah, and many generations of their children have gone to sleep within the earth. God indeed made mighty nations of both Ishmael and Isaac. Ishmael's lineage took to the deserts of the Arabian Peninsula and Egypt. Isaac's children became a great nation in the small sliver of land called Israel. In time, however, the House of Israel, the children of Sarah and Abraham were scattered all over the world. Presently we have no way of knowing the headcount of the families of the 10 lost tribes. (of the 12 original tribes, excluding the tribes of Judah and Benjamin.)

So, indeed, Sarah and Hagar became two of the most influential women in the world, by virtue of the two great people groups and religions that sprang from their descendants. Yet, there is a third woman. The third woman belonged to the future; she was herself a descendant of Abraham's seed. Yet it was the third woman's son who held the keys to unite the family, and to multiply Abraham's children until they outnumbered the stars.

The third most influential woman in the world stepped onto the pages of history as a young teenage girl, shy and quiet. Her name is Mary. Although she began her journey in obscurity, today, 2,000 years later, her name is known on every continent of the earth, alongside the name and influence of her son. Yet her part of the story began humbly. She was a frightened, engaged teenage girl in a small town, caught in an out-of-wedlock pregnancy with the father of the baby in question.

With such a situation, Mary needed to get out of town, and she chose to go see her cousin Elizabeth, who lived about 81 miles away. Elizabeth just finished milking the goats when Mary arrived. Lately, the mama goats were full of milk, come milking time. They made their sweet cries of relief as Elizabeth gently took their milk. And oh, what milk those nanny goats produced! It was luscious milk, with lots of heavy cream rising to the top of her wooden bucket. She carefully carried the full bucket back into her home. She and her husband, Zechariah, lived happily in their simple home. The longer they were married, the bigger the flocks became and the more milk she was able to make into lovely soft curds of goodness. She was extra mindful these days to drink plenty of the life-giving liquid that the goats gave them. After all, a little miracle baby was growing inside of her. She and her baby needed the extra nourishment.

She heard footsteps before she could even turn to see her cousin entering the door. "Elizabeth, my kinswoman!" Mary called out in greeting to her cousin.

The baby inside of Elizabeth's womb instantly jumped with joy at Mary's greeting, sending an electric shock through her from head to toe. Elizabeth gave out an involuntary yelp.

"Oh my, Mary!" Elizabeth laughed. "THAT was quite a surprise! We didn't know you were coming! Come, let me hug you! My goodness! Look at you! Why do you have such a glow? You are even more beautiful than last time we visited!"

"But oh! Mary!" she said, letting her go from the long embrace. "Before I say anything else, I must tell you that God has given me a great surprise that will make you smile. I, an old woman, am now six months with child! And when you walked in, my baby leaped in my womb! Come here! Feel him move!" Elizabeth grabbed Mary's hand and placed it on the big round bulge below her breasts.

"Thanks be to God for this wonderful sign," Elizabeth continued. "I felt the baby move before, of course; his little flutters. But today was different. When he heard your voice, I literally felt my baby jump for joy. Mary, can you feel him moving now in my belly?"

How strange this is, Elizabeth thought.

But it was not so strange for Mary. Mary had even stranger things to talk about. She had so much to tell Elizabeth, the things, in fact, that might explain her cousin's baby's sudden leap for joy. So, Mary began to tell her story of the night an angel visited her.

"Elizabeth! Congratulations! I am so happy for you!" Mary laughed and hugged her. "But nothing seems strange to me anymore, I came to tell you that I had a very strange thing happen to me, too! I was visited by an angel! Imagine, Elizabeth! Talking to an angel! He said to me, 'Don't be afraid, Mary, I bring you good news of great joy that will be for all people.'

Then Mary took a deep breath and looked down for a moment. She hesitated before she began speaking again.

"I had no idea why he said these things. Then angel said: "You are highly favored among women," she blushed again recounting the message to her cousin. "He told me I would bear a son who would become great, and that he would even be called 'the Son of the Most High God!'

"I asked him how this could be, since I am a virgin and have not known a man. He said that the Holy Spirit would come upon me and I would become pregnant, and that the child I would carry would inherit the throne of his father, David. His name is to be Jesus.

"Elizabeth, it was all so confusing, and so strange," she continued. "But a calm descended upon me and I knew I must say yes. 'Let it be done to me according to your words,' I said. The angel looked tenderly toward me, and then he left."

At this point, Elizabeth was wide-eyed and incredulous. She could scarcely comprehend what Mary was saying.

"Then suddenly I thought of Joseph," Mary went on, breathlessly speaking faster and faster. "Oh, dear God, what would I tell Joseph? I was soon to be pregnant, but not with his child.

"When I told Joseph, as you might imagine, he was angry, terribly angry. After that he was sad, and then later he was hurt and confused and mad, all at the same time. Joseph ran out of my house in a rush and I was completely sure that we were done.

"But the next day he returned to me like a different man. He said he still wanted to marry me, and that he was not going to humiliate me or 'put me away.' He said an angel came to him in the night, too! The angel told him that this thing which happened to me was from God. My cousin, can you even imagine what would have happened to me if that angel had not visited my Joseph also? So for now, can I stay here with you? Can I stay and help you prepare for your baby's birth?"

Elizabeth reached out and touched Mary's arm.

"Slow down and breathe Mary," Elizabeth laughed. "Sit down. Take some milk. You are talking so fast that I can hardly understand you! And what you are saying is hard to grasp! In fact, it would be impossible to believe all of this if I had not just felt my own baby leap! But my baby leapt when you entered! My baby recognizes the One you are carrying! Surely God himself is visiting our family!"

Soon the two pregnant cousins embraced and danced and wept for joy together, then talked some more. Tradition has it that Mary stayed there for three months, helping Elizabeth prepare for the birth of her child, and growing her own baby bump as well.

And so it was, that in the hill country of Judea, the plan of the ages unfolded in humble, human form. Elizabeth and Mary, the mothers of John the Baptist and Jesus, Yeshua the Christ, marveled together at their extraordinary pregnancies. Neither mamas knew of the great sadness in store for them both. They did not know, of course, that

one day Elizabeth's boy would be beheaded for speaking truth to power, nor that Mary's son would die like a common criminal on a Roman cross, due to political and religious jealousies.

But today, of course, there was only joy. Together they shared the joy of two expectant mothers, overflowing with hope.

I like to imagine that as Mary and Elizabeth shared these precious, private moments, two other women were also watching, from far, far away. Looking over the rim of eternity, did Sarah and Hagar also share the hope and joy of Mary and Elizabeth, but for different reasons? Did they regret their jealousy and pride that led to irreconcilable differences between them while on earth? Were they interceding in prayers for their legacy? Did they see from eternity's side that God was sending a peace child to end the terrible feuds that continued between their sons?

The spiritual descendants of Abraham today make up the three largest religious groups in the world, whose adherents total more than half of the world's population, or just over four billion people on the planet, according to a study done in 2017 by the Pew Research Center. Christians make up 2.3 billion people on the planet, followers of Islam make up 1.8 billion, and those identified as Jewish number about 15 million, with the lost tribes uncountable. (Conrad Hackett 2007) And, Mary's son, Yeshua (Jesus, in the Greek), is imprinted in the spiritual literature of both the Jew and the Muslim. Yeshua the Messiah can be found in the holy scriptures of Israel and is also found in over ninety verses, in fifteen surahs of the Qur'an. (NAMB March) And so, with over four billion living descendants linked by common elements of faith and bloodlines, these three

Middle Eastern women, Sarah, Hagar, and Mary, stand side-by-side as the most influential mothers in the history of the world.

Mary carried in her womb the Prince of Peace, 'The Way, The Truth, and The Life.' (John 14:6) The hands of mankind remain helplessly bloody, and wars still seem endless, even 2,000 years after Christ's birth. Yet the promise of redemption for all who believe in Christ, and the promise of His imminent return to this planet, holds forth the hope that one day the "lion will lay down with the lamb" (Isaiah 11:6;), when the "Root of Jesse" once again rules with compassion and justice, and peace, and righteousness fill the earth like the waters fill the seas. (Habakkuk 2:14)

The prophetic psalm states "Ask me, and I will make the nations your heritage, and the ends of the earth your possession." (Ps. 2:8) Christ not only asked, but he also came. He initiated a New Covenant, signed with his own blood, a covenant of peace and salvation for all peoples of the earth. And, by so doing, He also takes the hands of both his warring Semitic brothers and joins them together under his banner of Love.

The Seventh Golden Thread

*And so ... this limping, nearly defeated soldier
finally retreated to the home of her youth.*

*There, amid flowers, trees, clean rivers and
loving family, God heals her.*

*Why did it take so many decades for her red and ugly
scars to feel the transforming love of Jesus?*

*Because the old soldier finally stopped running
from the stillness He required.*

*She finally laid down in a bed of daffodils, roses, lilacs, and peo-
nies and let the lover of her soul restore her life.*

Chapter 7

Re-inventing the Future

It was March 1980. My marriage to Richard Roberts was over. Richard remarried in January, and I felt as if I might suffocate living in the shadow of the Prayer Tower at ORU. There was nothing to do but move away and begin a new life. So, I and my girls began readying ourselves for a new and uncertain future.

As if in slow motion, I packed china, silver, mirrors, sofas, clothing, pots and pans and other evidence of the life I lived in Tulsa but was now leaving. Before me were little boxes of mementos of a dreamy life from which I was so violently awakened. Surely, it must have seemed that I was walking about in a type of zombie stupor as I sorted, boxed, and labeled my life.

Sometimes we are blessed to find a friend with whom we can embrace our true selves in times like these. Throughout my lifetime I have had many such friends. Only with the help of such friends was I able to pack up the big moving van hired to take the remnants of my Tulsa life and drive them off to Tennessee.

To this day, whenever I pass a big U-Haul, Penske, or National Van Lines moving van on the highway, I still cannot help but wonder just what fragments of life the owners managed to rescue from their

former homes and their former lives. One hopes that all these trucks are hauling the evidence of beautiful lives that have simply received a better offer and are on the road to the next step of a great life plan. Surely, in a following car or a jet overhead, there is a family happily traveling alongside, looking forward to what is around the next corner. We could hope the moving vans represent a family that is collectively on a grand adventure, with possessions, cats, and dogs in tow.

But experience tells me that moves are not always so idealistic. Many of those moving vans merely haul off what is left of a life, and what is left of the family. In 1980, brave faces intact, my girls and I headed eastward, with that more somber type of moving truck traveling somewhere behind us.

In the next twenty or thirty years, I found myself packing and moving again many times. I moved for all sorts of reasons: a new job, a new adventure, a new opportunity. And, always, there was hope for a better life ahead tucked into each packing box, each time. I lived in Oklahoma, Tennessee, New York City, North Carolina, Wyoming, California, Oregon and then moved back again to Oklahoma. I truly traveled in a broad and interesting circle, only to find myself back in Tulsa, within blocks of where I once lived. How funny, and how ironic. It was a big surprise to me to end up back in Tulsa – but more about that later.

On the positive side, my travels and many moves brought my children and I much more than an understanding of different local cultures, sights, and sounds. They brought some practical skills into our lives as well. For example, my girls, and later my son, Canon Gray Thompson, certainly learned how to pack a box, switch gears, flex, and embrace change. But what in the world was I looking for in all

those moves? The easiest and truest answer would be that I was looking for a place to belong.

When I left Tulsa in 1980, I was leaving my home, my job, my city, my marriage, and my self-esteem. I went from being a well-respected singer and woman of God to the "ex-wife" of Oral Roberts' son. It felt like I was obsolete by the age of 30. My former family was gone, and I fell from international religious fame into obscurity. Would I ever feel a sense of belonging again? It was lonely out of the limelight, but I found a certain quietness about it that I did appreciate.

My belief system was no small part of why I was schlumping away to Tennessee. As I said earlier, I had serious theological differences with my boss and father-in-law, Oral Roberts, when it came to the promotion of his flagship teaching, "Seed Faith." As you may recall, it seemed to me that it painted God as one's personal vending machine. Just put in the money (to the Roberts' ministry) and receive a miracle necessary to your life. Granted, the principle was clothed in much silkier garments than this stripped-bare version. But the difference in my biblical understanding of giving and the pet fund-raising doctrine of Oral Roberts became a chasm between us so large that finally no bridge could cross it. Ultimately, I believed that Seed Faith was a lie, perhaps even a heresy. The greater tragedy is that Oral Roberts' pure and powerful teachings on the magnificence of the Holy Spirit and God's ability to heal today were later subjugated to the fund-raising genie of Seed Faith. Almost no one in the rest of my religious universe agreed with me at that time. And I, myself, would have changed my mind, had it been possible. But my understanding of the truth on the matter was very deeply ingrained in my soul. To have abandoned that truth would have been to abandon all that held me upright.

Oh the drama. So much drama.

Yet the drama was real, and it was scarring to me and to my children. The odd thing about scarring events in one's life is that while the wound is happening, one does not really feel the depth of the knife. It takes years and years to rightly assess what has happened to one's soul in the throes of that trauma. And usually by that time, we have already built an edifice of survival on the faulty foundation of pain and wounding. And so, mistakes are bound to be repeated. And repeated. We struggle to return to normalcy long months before we are even slightly normal. And so, we hurriedly build, only to find we cannot successfully live in the structures of our "new normal."

In 1995, my son and I temporarily moved back to Tulsa to be near my two adult daughters. Christi, my oldest, was married with one child and another one on the way. Juli was finishing up her Bachelor of Arts degree at Oral Roberts University and would be graduating in the spring. I was happy just to be near them, even though being in Tulsa felt somewhat akin to having my skin peeled away by a vegetable peeler. I was persona non grata at Oral Roberts University, not allowed to even step foot on the grounds. But I still managed to live a little life of some merit. I sang often at First United Methodist Church in downtown Tulsa, where my old friend Dr. James Buskirk was the pastor. I worked a day job with no sensational dazzle. In other words, I was just another single-mom-worker-bee of no renown.

My apartment was wonderful on the inside and not so wonderful on the outside. It was an old complex, chosen for its fireplace and rather large rooms. It worked for me and perfectly matched my unexceptional circumstances. My son Canon was trying to adjust to

our new surroundings. I can tell you that he did not fare too well. His behavior became so self-destructive that he frightened me.

I searched for and found a group of men that I thought could speak into my son's life. I found a ministry in Houston, Texas, called Youth Reach. I thought that it might be a place that could help my son refocus his life. Canon reluctantly decided that he would get into the YR program. He was not quite expecting that he would be mentored by a cadre of male staff members. Think: discipline, structure, order, work, and no trash-mouth. It was a godsend. Our story might have been become another tragic tale of a single mom losing her son to self-violence, but for God's intervention and that great group of guys. Thankfully, Youth Reach gave us a better ending.

Canon would tell you himself that at that time he was rebellious, depressed, angry at God, and terribly angry with his parents. He was eaten up with self-loathing. He weighed well over 250 pounds and was not yet 14 years old. I hurt for my son, just as surely as he hurt for himself. At that time, he was diagnosed with ADD and later, Asperger's syndrome. However, the medications the doctors gave him offered no relief.

When he arrived at Youth Reach, Canon's mentors embraced him, accepted him, and loved him too much to allow him to continue his slide downhill. They weaned him off his meds and put him to work on his studies and his house and farm chores. It was amazing to see what a little work could do for him. Canon began to lean-up and clean up. The guys were strict with him, but he needed that structure. It took five adult males to help my son get back on track and stay there. He hated the discipline but loved the results.

I eventually moved to Houston and took a job with Continental Airlines. Initially, I worked at minimum wage (which should never be confused with a living wage). Minimum wage meant that there was just never enough money to make ends meet up properly. I lived on Yorktown Street, just down from the famous Galleria shopping center. I cannot recall shopping there, even once, for obvious reasons. But I was too busy to care much. After six weeks of training, I was given a position as a reservation agent. My shift ended at 2 a.m., at which time I hauled my tired body back to the apartment to sleep. More than once in those wee morning hours, I would sit at a stop sign and wait for it to turn green. Notice I did not say "stop light," I said, "stop sign." You know, the red octagon on the right side of the road? After waiting at the intersection for a bit, it would finally dawn on me that the stop sign was never going to change colors; so, I would ease my foot off the brake and bumble on home.

Canon was several miles away at Youth Reach and we met up on weekends. We stayed in Houston for a year and a half. He left the program a svelte 165 pounds and as an "A" student. Kudos and praise to the men of Youth Reach. All of them earned multiple gold stars in their crowns. Now that Canon is older, he views his friendships with his mentors at Youth Reach as having been beneficial. But in the immediate weeks after leaving Youth Reach, he again expressed his independence in less than brilliant terms.

I was offered a job in beautiful Wyoming at double my salary, complete with housing. It was a step in the right direction toward financial well-being, and I thought the environment would be excellent for my son. Canon and I moved to Big Horn, Wyoming, population 259. Polo Ranch is the jewel of the valley below the Big Horn

Mountains. Oliver Wallop, father of Wyoming Senator Malcolm Wallop (1933-2011), carved out the ranch of note in 1883. It was 6,000 acres of breathtakingly beautiful land, tucked up under the breast of the rugged mountains. It was on that land that it is said that the senior Wallop built America's first polo field, used to test horses sold to the British during the Boer War (1899-1902), while he also founded America's first polo team, composed of cowhands. Upon seeing a polo field, legend has it, the cowboys were intrigued and wanted to learn to play. In the decades that followed, the ranch was bought and sold only a couple of times, and lucky for me, my friends Joseph and Karalyn Schuchert were the present owners. To this already magnificent ranch they made complementary improvements and additions. When I first saw the ranch with its long roads bounded by pristine white fences and cottonwood trees, I could hardly contain my awe. The main house was a wonder of architecture and design. There, set in the middle of old apple orchards, was a home of great beauty, owned by this wonderful couple.

The ranch boasted beautiful barns, more like horse mansions than lodging for animals. The farm was the home of a collection of cutting horses of great value and national importance. Even their poop fell quietly into little perfumed bags that floated on out to a pile somewhere way out of sight. Ok, not really. That might be a bit of an exaggeration, but you get the point. There was systematic elegance in every building, barn, garden, and greenhouse. The ranch's elegance was accentuated by its juxtaposition to the tough, rugged beauty of the State of Wyoming.

My office was in the main barn. It was beautifully appointed, with both furnishings and all the absolute best equipment. From my desk,

I was in contact with the whole civilized world. It was not unusual to have senators, congressmen, horse breeders, and every sort of luminary call my office wishing to speak to Mr. or Mrs. Schuchert. I would refer them to the main house or the main office to carry on their business. It was a delightful work atmosphere.

Canon and I both enjoyed the adventures of ranch life. He could not bring himself to wear the tight cowboy jeans that were the uniform of choice for the ranch guys. Starched jeans, a fine belt, custom boots, and a well-starched shirt were the unofficial cowboy uniform daily, not saved just for rodeo days. Recently I opened an old packing box labeled "Patti's Wyoming clothing" and found Western dresses and shirts, vests, and jeans. Seeing them again brought a smile to my face. I remember well the cattle-branding days when we would all go out to the pasture across the road from the main house and pitch in to help the cowboys. The air was nippy cold, and merriment permeated our chores. A few of my ranch hand pals liked to sing out, "Here comes Cow-Patti!"

Was I offended? Not even slightly.

While working at the ranch, I received an invitation to return to Tulsa to sing in the Christmas concert with the Chancel Choir of First United Methodist Church. Joseph Baez, the minister of music, extended the invitation to me, and I was thrilled to oblige. I arranged for Canon to stay the weekend with the ranch cook and his son, at the cookhouse. Everything seemed to be falling into place for me to be able to slip away for a few days. So, with great peace of mind, I flew off to Tulsa to be a part of this most wonderful Christmas concert.

When I returned, the ground in Big Horn was frozen and covered with ice and snow. When it snows in Wyoming, it looks as if every field and every meadow have been baptized in little white diamonds. They shimmer and dazzle and seem quite unreal under the dome of the big blue sky. It is a winter wonderland that everyone should see at least once before departing the Earth. I returned from Tulsa to this dreamy winter wonderland, only to discover that my son had summarily ignored my weekend instructions and created a parent's nightmare while I was gone. He had never once gone to stay at the cook's house. Instead, Canon and some ill-mannered, ill-educated, and ill-brained boys had stayed at *my* little house instead.

Horrors.

Little Red Shutters, the name for my home, was transformed into "Teenage Boy Mayhem Headquarters" for the weekend. My car, which was to have remained in the garage while I was gone, was used for midnight joyrides on the ice. It made a fairly good sled for the whole bunch of them, slipping and sliding down frozen country roads. Canon told me that they even found a whole herd of deer to chase down the icy streets. Oh joy.

He was excited; I was appalled. Visions of mutilated teenage arms and legs flooded my mind along with visions of insurance nightmares, lawsuits, and tragedies of all sorts. My head was close to popping right off my neck as I listened to his tale. All this mayhem was going on while I was serenely and joyfully celebrating the arrival of baby Jesus, singing my little heart out, hundreds of miles away.

What a difference that one weekend made in our lives!

Sadly, and suddenly, I realized that I was *not* doing a good job raising my son. He did not want to obey me or his teachers at school. He was still mad at God because his life, his mind, and his existence were not what he wanted them to be. I called his father and asked for help. His dad suggested that I send Canon to live with him for a while. I took him up on the offer and hoped for the best. I saw Canon off at the Sheridan, Wyoming airport. We were both depressed and defeated. I will never be able to forget his eyes and his funny little wave as he turned and looked at me for the last time.

It was originally intended for Canon to spend just the next several weeks with his dad. But the weeks eventually turned into years. While living with his father, Canon dabbled in all sorts of drugs and, by his own account, debauchery. He quit school and got his GED. My beautiful son with the brilliant mind and the charming heart was on a bullet train to hell.

Years passed, and soon he was young adult, living with his girlfriend.

I was living and working in Washington, D.C., before my son finally came back home to me again. His scruffy sweet self came to my door with several bad habits and a young woman in tow. She was his drug buddy, and they had no place else to go.

They promised that they would get jobs and get free of drugs. And to their credit, they did. Well, they may not have given up smoking weed, but at least they did it secretly and away from my house and nose if they did it at all. It is well documented among those who know me that my ability to detect a whiff of weed is irrefutable.

In time, Canon and his girlfriend grew weary of my house rules, and wanted to move away, so they did. This was all happening in

the fall of 2008. About that time, in the D.C. area where I lived, the economy was beginning to shake, rattle, and roll. I was the manager at a "to-the-trade-only" interior design house, which specialized in sourcing the very finest fabrics, hardware, upholstery, and bespoke draperies for some of the D.C. area's top designers. We offered the finest that money could buy. Our drapery designs and fabrications were the stuff of legends, and a good many of our designers worked for major home builders up and down the Eastern seaboard.

But in September of 2008, there came a trumpet blast, a financial wake-up call, that sliced through the pleasant dreams of our booming economy. Fraudulent dealings fell apart and a full-scale recession slammed the United States. Almost overnight, thousands of jobs evaporated, and the housing market just died. Suddenly, no one needed our beautiful bounty of decorating treasures, and those bountiful clients who created the luxe interiors of model homes vanished. We opened our studio one bright and clear fall morning to a thundering silence. No one came all day. This sad day recurred, with devastating regularity. It was soon clear to me that I and my colleagues were going to lose our jobs.

Mama was worrying herself into a tizzy about whether I could survive in our nation's capital without a well-paying job. My expenses were heavy, and my savings were, shall we say, humble. There were very few job prospects to be mined. It was clear that I needed to pull up stakes and leave town. Mama suggested that I come home to Oregon, buy a house, and settle down like all the other old girls my age. She said that I had been a gypsy for long enough.

Gulp. What a drag.

I always considered going home as a coward's retreat. It was repugnant to me, and not part of my big game plan. If at that point I was blessed with means, I would have gone to Paris or Tel Aviv, for those were the last two cities on my list of places where I hoped to live in my lifetime but had not yet actually taken up residence. But those sorts of moves would have required a massive reinvention of myself and my skill set. I simply was too old to muster up that kind of imagination and strength. And I was alone.

Truthfully, the idea of going back to the place of my raising – home to my brother, cousins, aunts and uncles – was sort of frightening to me. More than once I queried God about what this move meant. Was I going home to die, or was I going home to begin again (again)? I really did not know. I put on that big old overcoat called "trust," as much as it pained me to do so. But Westward Ho! Yee-Haw doggies, in the end, back home is exactly where I went.

In the dimming light of late fall, 2008, I moved into an apartment in Lebanon, Oregon. My brother Alan Holcombe and sister-in-law Aleita were kind enough to let me bunk in with them until the apartment was ready. Eventually the time came to move into that little apartment and try to make it a comfortable home. I was on the search for a house to purchase but was not yet successful.

In every home I have occupied, I planted flowers if there was a patch of dirt large enough to hold even a single bulb. The tired old plot at this apartment had been neglected and the earth fought me a bit while I dug out weeds and dead bushes. But finally, the ground became soft and welcoming for my lily bulbs, daffodils, and a few other pretties. I live by a hard and fast rule that commands me to create beauty wherever I am and wherever I go. The beauty is not always

in planting flowers or painting up the house. Many times, it means planting loving kindness in the lives of neighbors. Whether planting flowers or painting a worn fence or sharing a meal, creating beauty is my way of giving away the heart of Jesus by whatever means I can.

And in my new home, it meant all these things and more.

And so, I moved into the 12-unit complex and began to create beauty and meet the neighbors. Across the parking lot was "Bobby, the Watcher." Bobby hung out of the second-floor window, watching the other apartments pretty much night and day. I found him to be creepy – really creepy. He watched to see if my curtains ruffled in the wind, checking to see if my windows were open. He watched me when I left the apartment and when I returned. Always, Bobby was at his window, watching.

Next to Bobby's apartment lived a widow, her daughter and grand-baby, and next to them, was one of the local hookers, who also dealt drugs. Suffice it to say that an amazing string of visitors visited her at all hours of the night. And boy, did they party. I would love to tell you that I enfolded the hooker in the arms of Christian love and helped her out of her tawdry existence and into the life of godliness. But I called the police instead. I called the police lots of times. And I complained so much to the owner of the complex, who happened to be my brother Alan, that he finally told her to find another place to live. She broke law upon law with happy abandon, without even a smidge of respectable shame. On top of this, she had a baby, who – poor thing – lived in the chaos along with her.

Next to the hooker lived a woman whose adult son piled in on her. He and his buddies frequently hosted beer drinking binges out on

her front stoop. The son did not work but he did collect his government money, as did several people in the complex. Believe me, the local police were on my speed dial.

Lebanon, a once prospering little town, endured the harsh economic downturn of 2008 in its local economy as well. Both the town and its citizens suffered greatly. A population full of hard-working and productive citizens was now peppered with people who could not find any sort of work. And here I was, among them. When I left Washington, D.C. for Oregon, it never occurred to me that finding gainful employment might be a challenge. But I soon found out that an economically depressed community has little need for an interior decorator. Nor did the adjoining towns need someone who loved and specialized in billowy silk draperies or fine room settings.

As owner of this small complex where I lived, my brother Alan was kind enough to offer me the apartment at no cost. He was like that; he is like that. He is generous and warm; Ok, at times He can be crotchety. But he is always adorable. Everyone who knows him would add their own affectionate (and perhaps a few irreverent) adjectives to the string of traits I just named, I am sure. You might ask me why my respectable brother would own a complex where some of the more unfortunate of our local society lived? It started with the fact that several of those people lived there when he bought the units. At first, he planned to renovate and upgrade the whole complex, but in the end, he did not dislodge even one occupant, except for the hooker. Instead, he transitioned to looking after his tenants as if they were family.

As my first Oregon spring unfolded, I invited all the ladies of the apartment complex over for tea. I set up two tables on the walkway

in front of my apartment door. We had cakes and cookies, tea sandwiches and pots of tea. I brought out my silver and china and my best linens. Tea parties were not really the norm in this neighborhood, but it was my pleasure to give them the best of what I had, just so they could enjoy a fine spring day and a little bit of girl time.

My neighbor next door was a woman of about 30 years of age. She was striking in her appearance, with long, thick red hair and a fair, creamy complexion that goes best with ginger manes. Her eyes were brilliant blue, and all her children were possessed of angelic Irish features as well. Her husband was a hard worker, usually coming in late and remaining noticeably quiet. One Saturday afternoon he set up his barbecue and grilled burgers for the whole neighborhood. I was surprised when he knocked on my door and invited me to join them for 'Burgers Alfresco.' He was always so private and so quiet that I thought he didn't like people or any sort of socializing. But it turned out he worked so hard that he had little time left for such fun. Despite his long work week, he and his family attended church faithfully. Each Sunday and Wednesday night, the parents and all the freshly washed and dressed children hopped in their car and off they went to worship.

At my tea party, my red-haired neighbor proudly told me that her husband was their pastor's "armor bearer," and that this was why he was so often gone in the evenings. His "job" as armor bearer meant that he attended to a long list of things this pastor needed. As near as I could figure out, it sounded like her husband was tapped to serve as a butler of sorts for that preacher. He was at the pastor's beck and call.

This whole arrangement disturbed me, so I felt compelled to dig a little and find where the origin of this "armor bearer" was in scrip-

ture. The Old Testament reveals that the "armor bearer" in ancient times carried the king's shield, extra armaments, helmet and anything else that the king might need during *war times* when they went into battle, and was available to help dress the king in the heavy battle gear.

While King Saul, King David and a few other Old Testament kings might have needed someone to carry their stuff into battle, I was quite sure the local pastor was in no such need. The title, or post, of "armor bearer" was now just a ceremonial post. Wrapped in biblical language, it seemed noticeably clear to me that "armor bearer" was, in fact, the post of an unpaid servant. This really struck me as wrong. Here was this sweet little family, needing a good amount of help themselves, and the dad was now tasked with carrying out the preacher's list of whims.

What does a small village preacher need with a butler anyway? Where was the pastor's desire to serve? Why was he asking, instead, to be waited on?

I voiced my dismay to the wife.

My indignation was met with sort of a confused, blank stare. My sweet neighbor thought that her husband was greatly honored to be called on to serve in this manner. I know that the goodness in their hearts will be rewarded in heaven, but sadly, probably not on Earth. I hurt for them. This using of people by a pastor — someone who is himself called to serve — honestly hurt my feelings. It is quite likely that as my neighbor and her husband mature, they will not see her husband's role as "armor bearer" with such glamour. Unfortunately, this sort of usury and abuse of pastoral authority often ends with

someone being hurt, wounded, and yes scarred, all in the name of Christ.

The "armor bearer" mentality in Christian leadership is antithetical to the leadership style of Christ. Some parishioners have high needs to feel included and valued by someone important, and voluntary servitude appeals to this need. Occasionally, the role might be accepted by a parishioner who truly has a servant's heart, like my neighbor.

But to pastors, I would say, what on earth are you doing? How are you being like Christ? Remember that Christ even washed the feet of his followers. Jesus clearly taught that an authentic leader must be the servant of all. Servants by nature do not seek to be coddled or fawned over by those they serve; did Jesus name even one disciple to be his armor-bearer? Of course not.

So, dear reader, if you have a pastor that insists on this type of service from you, please run. Run quickly. If your pastor's nature is this self-serving, then his teaching is bound to be skewed as well. Besides, Jesus said that his yoke is easy, and his burden is light. (Matt.11:30) Christ invited us to roll our burdens upon his shoulders, not vice-versa. He says that He will give us rest. Pastors should serve like Jesus; He gives the true leadership model.

Eventually, I bought a little yellow house in the verdant bucolic Willamette Valley of Oregon. The valley is long and wide. It boasts of being home to the finest farms and vineyards. Along the coastal highway I-5, one can see acres of tulips, dahlias, and Iris in the valley, along with trees of all varieties being cultivated for market. Along the southern slopes of every little mountain are luscious vineyards that produce Oregon's famous Pinot Noirs, Pinot Grigios, and oth-

ers. Farther south are grass seed farms and orchards of hazelnuts. Sheep graze in the field under the watchful eye of the ancient volcanoes of the Cascade mountain range, which hedge in the valley on the east side. On the west side, the coastal mountain range keeps the Pacific Ocean from rolling in on top of the farms.

The university town of Corvallis is to the west side of highway I-5. My brother, Alan, lives with his wife Aleita and their son Jacob on the west side of the valley. Their home is high above the lovely town of Corvallis, a white house with perfect gardens and lawns. On any given day, you might find my brother in the basement garage where he houses his antique cars. His hobby has been restoring these beautiful pieces of practical machinery to their showroom shine. He patiently and lovingly coaxes old English roadsters back to their glory. Every inch of one of his perfectly restored cars has his unique and exacting touch. Every part, down to the smallest gasket, and the smallest screw, has been privy to his austere scrutiny. Not only do these cars start up, get up and go, they purr along the roadways, flaunting their pedigrees as if they have peacock plumage. They glide; he smiles.

As the valley begins to narrow in the southern region, one will find the village of Lebanon. At one time, it was a thriving mill town that pumped out lumber to build houses across America. Sadly, the mills were gradually sold off, consolidated, or closed. By the time I arrived, the town was sleepy and quiet. My little house, on the corner of Grove Street and Vine, was a mucky chipped green mess when I first saw it. As houses go, she looked like a fine woman who had been abused. The architectural skeleton was beautiful but terribly neglected. Yet one could see that it must have been a beauty back

in 1936 when it was built. I walked around it in late February and could see that the Earth wanted to yield up the vestiges of what must have been a beautiful garden. Snow Bells by the millions spread so profusely that they needed a good corralling. Daffodils were just beginning to unbend their pretty necks and point their faces toward the late winter sun. The yard was unkempt, but I could tell she had great possibilities. I was smitten.

My brother and I bought the house jointly. He did that for me out of the goodness of his heart. In the weeks over the spring and early summer, he transformed the house, while I coaxed the willing soil into a proper English garden, complete with picket fences and pergolas. Alan and my talented nephew Jacob took three weeks to sand and refinish the old fir floors that gleamed with renewed beauty. They also ripped out the old gas furnace and put in a new efficient gas stove, a miniature version of the previous one. They painted, plumbed, and rewired the house. The kitchen, which had been an old grease stained prison with little comfort, needed a fresh start. Out it went, and in came a new gas cooktop, dishwasher, fridge, and a sparkling black floor. Our new countertops were black granite, while the old cupboards received a beautiful coat of shiny white enamel and new hardware. At the end of the kitchen was an alcove with a window facing the back garden. We built in shelves on one side and shoved a small toile covered sofa under the window. The space was exactly right to hang up some black-and-white portieres on either side of the alcove, thus creating a cozy little reading or napping corner. It was odd how that small corner was where company always ended up. We would have to pull up some slipper chairs so everyone could fit in. It became the knee-knocking place of camaraderie. And, of course, coffee was always within reach.

He painted the exterior of the house the most beautiful yellow with bright glossy white trim. In the yard I planted a Honeycrisp apple tree, maple trees, and loads of flowers.

In the backyard, I put in a raised bed for tomatoes, cucumbers, herbs, peppers, and salad greens. The lot was much wider than it was deep. So, my garden spread mostly to the east and on down to the garage. A white picket fence connected the garage to the house. Within the fence grew a flurry of old lilacs, snowball trees, and butterfly bushes that made up a tall hedge, which separated my place from the neighbors behind me. A wild red climbing rose somehow made its way into the mix and bloomed profusely in early summer, right along with those beautiful old bushes. Yellow roses, coral roses, and hydrangea grew happily alongside each other. Calla lilies, delphiniums, Astilbe, Asiatic lilies, and baskets of geraniums, red and coral, all joined in the flower choir and waved as if they were on parade. My poppies were dramatic and dark, stunning me with colors that I never attributed to poppies before. A great number of rhododendrons edged my house. They were old and stalwart. When they bloomed, they bloomed as if the reputation of all flowers rested solely on their shoulders. They were vigorous and showy as if to win the approving eye of all passersby. It was a blissful life that I lived there in Lebanon, Oregon, in my Little Rose Cottage.

At Little Rose Cottage, I served tea to my neighbor ladies, cooked meals for friends and wrote volumes of emails. I directed the choir at my church and visited regularly with my brother and sister-in-law in Corvallis. Each time I drove back home I was treated with long stretches of emerald green grass dotted with grazing sheep. In places, the road brought me up high enough to see the tops of five mountain out to the east.

There were those blissful times when cousins and their spouses, kids, grandkids, and dogs flooded my yard. When Mama came from California for a visit, we would have impromptu family re-unions. Alan would cook a monster ham or a plump and succulent roast beef. The rest of the family would bring pies, casseroles, veggie plates, mac and cheese, drinks, dinner rolls, and good conversation. My family excels in cooking and conversation. We would haul every chair out of the house to the garden, set up and decorate tables, and feast. Mama and her two sisters, all well into their nineties, would sit in adjoining chairs and hold court under a big old tree. They were known to my brothers and me as 'the holy trinity,' and they adjudicated the family while dogs barked, and cousins caught up on all the latest news. Around dusk everyone would load up their cars and head back home. Alan would take down the tables, and anyone still present would put all the garden chairs back in place and take the dining room chairs back inside the house.

I cannot tell you how the healing love of my family washed over me, cleansing away years of feeling lost and homeless. Going home was one of the best decisions of my life. I always managed to have a nice house and wonderful friends wherever I ended up living. But I had no idea how bereft I was of the wider and deeper joys that one's own extended family provides. Those gatherings were pure bliss.

My brother owns property down in Newport, Oregon also. One of his properties is a small beach cabin just up the hill from the sand and surf. There were days when I put the dogs in the car and drove over to the coast. I welcomed the cold wet sand between my toes while my dogs played in the surf and chased seagulls. Those days of contemplation were full of quiet joys.

My sweet little house always welcomed me back, whether I was away for half an hour or days at a time.

The cottage and gardens were truly magical. The very walls of the house held my weary soul, while each bulb, bush, or veggie I planted seemed to pour new life into me. God walked with me in my garden and Jesus whispered me to sleep each night. My times with the Holy Spirit deepened and widened me with newfound wonders. I once again found creating beauty to be a healing venture. I vowed that someday before I get certifiably old, I would learn to paint. I needed to capture beauty in some more refined and passionate way than I could with a photograph. I needed to learn to paint.

My dogs, Sassy and Charlie, and I reveled in this new life.

One day the phone rang, and Canon announced to me that he was flying home. Could he live with me, he questioned? Even though he and I experienced rough differences in faith and philosophy of living, we did love each other. So, my answer was yes! He could come home and live with me. Besides, I needed his strong back. There were flowerbeds to dig up, and more things to plant. A win-win situation, if ever I heard of one.

I am especially pleased for the year or so I shared with my son there in Lebanon. He was still pretty messed up with drugs, but I sensed in him a deep searching for God. Over the months, the Lord gave me that big Jesus kind of love for this beautiful young man. I loved him with a heart full of hope and faith. And so, it came to pass. Canon grew, changed, matured, and began to be a great joy to me and to himself.

And our flowerbeds were lovely.

Before Chris Thompson became the love of my life, Canon moved to Hawaii. He so wanted to be a hippie. He has succeeded wildly at this, and he loved his life on the big Island. He is still sincerely on his journey to truth, as am I. Hopefully, you are as well. It is a beautiful and never-ending path. To always yearn for more light, more understanding, and more Truth is a good thing. And the magnificent thing about God, in all his glorious colors and in all His multi-dimensionality, is that He cannot be grasped wholly by us poor mortals. We search and we find, we look, and we see, and yet, there is still an unfathomable sea of God's wonder to discover. The advent of Jesus coming to Earth gave us a truly clear picture of what God is like. Thanks to the work of Jesus, we now have a pathway to God that allows us to experience His inexhaustible greatness, up close and personal.

Now to be sure, my journey into knowing God is different from my son's. But still, he is on the journey. And to those who sincerely desire to find and know God, He will not hide Himself. Canon would boast himself to be a New Ager, a flower child of the universe. I am an Old Ager. I am not a flower child. I believe in Jesus and His cross, but I do applaud my son's diligence in his search. To my way of believing, he has run down a few dead-end paths. But I know that Jesus loves him and will safely help him make it home to the Father. I have this hope. Jesus is there to be fully found by my son, and the more sincere the search, the greater the find will be.

Today, Canon and I were conversing via computer. He was telling me that he was experiencing a deep healing. I asked him of what he was being healed. "Fear," was his answer. We agreed that fear is merely the devil all dressed up in his costume-ball finery. Strip away

the mask and you find evil. And, as faith pushes fear out the door and down the street and out of town and to hell where fear belongs, the heart blooms with lively hope. These deep healings seem to happen over time, along with the help of unique circumstances. As we walk closer and closer to the Lord, healing continues to overtake us. To the open heart and the eager soul, the road to healing always motions us forward into God's heart and purposes.

In August of 2011, I married Chris Thompson. We met 40 or so years earlier while students at ORU. When we met up again, we compared our scars, our victories, our marriages, our kids, and our dreams. We discovered that we could cultivate a different type of garden, together. We began planting sweet joy into each other's lives, and those plantings eventually produced a most satisfying and wonderful marriage. Chris, a life-long Oklahoman, packed me up and moved me back to Tulsa. Tulsa, it seems, is my inescapable city of destiny. It is a good thing that I love this good man because trading my little house and beautiful gardens for the stubborn clay soil of Oklahoma was a sacrifice that only love would allow.

The Eighth Golden Thread

*The Patriotic Prophet: that's how Jonah might be known
if his book were written today. Jonah was fiercely patriotic to
Israel and fiercely committed to his role as a prophet of God.*

He also had some fierce scars on his soul to prove it.

*The Language of Scars became a bitter language for Jonah,
as it can if we are not careful. As Jonah became more and
more scarred, he also spoke with more judgment,
more defensiveness, and more self-righteousness.*

*In the most famous episode of Jonah's life, Jonah decided that
his own plan was wiser than God's and literally ran from
God's call. When he ended up in the belly of a huge fish
for three days, he had time to reconsider who was boss.*

*But why did he run? Jonah ran because he hated Israel's enemies
— especially the very people he was being sent to preach to in
hopes they would be saved. Hate always scars most deeply the soul
of the hater.*

*Jonah's story reminds us that, when we nurse hate and bitterness
in our hearts, even if we are devoutly religious or in church
leadership, the roots of unforgiveness can send us running in the
wrong direction.*

*Christ calls us to his more excellent way; to overcome evil with
good; to choose light over darkness; to choose love over hate.*

Love never fails.

Chapter 8

When is Anger More than an Emotion?

JONAH HAD A THING FOR God. He was known by his friends as a nice guy and a fabulous prophet. Jonah was handsome, smart, and unusually spiritual. It was not unusual for Jonah to stop right in the middle of his workday and find a quiet room in which to contemplate the Almighty. He gained a reputation as a man of diligence, fair-mindedness and boldness when preaching the prophetic messages of God. He could also have made a great judge or perhaps even a military professional because he always aided those who were treated poorly. He especially felt compassion for his countrymen when they were mercilessly attacked by their northern neighbor, Assyria. Jonah longed for revenge against Assyria, and justice for God's people. He wanted those who attacked his country to get what they so richly deserved.

But on a less violent, balmy summer afternoon he stepped away from his work bench and went outside to sit under a tree and take a break. While sitting in the gentle breeze he suddenly heard a familiar voice.

"Jonah, I have a job for you," said the voice of the Almighty.

Jonah was quick to answer. "Lord, I am your servant. What would you have me do?"

Jonah loved working for the Big Guy. There was a prestige, a sense of purpose, and a good feeling he always got upon completing a God-mission. It had been awhile, and he was eager to hear the new assignment.

"Jonah, I want you to go preach repentance to the people of Nineveh. Their sins stink in my nostrils, and I am going to destroy them if they do not change their evil ways," said God.

Jonah heard the words, but he did not believe what he heard. "*God wants me to preach to Nineveh?*" He asked himself. "*To the Assyrians? What must the Big Guy be thinking? Surely, God doesn't plan to be merciful to these monsters?*"

Jonah much preferred the immediate destruction of the enemies of Israel. He would have much preferred the justice of God on Nineveh, rather than a second chance with the mercy of God. But the decision was above Jonah's pay grade. The most he could hope for was that Nineveh would not be repentant and turn from its wickedness, so they would get the punishment they deserved.

How many decades has Nineveh been attacking Israel? Nineveh deserved divine destruction How long can God let this go on, he wondered. But now the Big Guy wanted him to preach to them?

Then his eyes suddenly lit up with delight.

Maybe there is a way around this, he thought.

He hatched a plan that would ensure their destruction.

I will help God out by NOT doing the thing he asks of me. This will ful-fill God's ultimate purposes, thought the jubilant prophet, who suddenly felt quite clever. By refusing to obey God, he could further Heaven's justice! How clever was that?

His plan went like this: Jonah would NOT go to Nineveh, in fact, he would go the other way by heading out to Joppa and catching a ship to Tarshish! He was sure he knew how God thought about these things, and he would stake his life on the higher power of God's special love for Israel. No longer would God have to tolerate the hatred and aggression of Assyria toward the apple of his eye, Israel. Israel was special to God; she was his beloved, his own nation.

No amount of repentance would be enough to rid Assyria of her guilt. It was unthinkable to Jonah that enemies of God's beloved Israel would get off scot-free! God surely hated them as much as Jonah did. Perhaps he could let God off the hook with his clever plan.

In truth, Jonah's plan was just the same old, ancient rationalizing that began in the original temptation of our first parents in the Garden of Eden. It begins with the serpent's question, "Hath God said? Are you *sure?*"

Oh, surely God did not mean *exactly* what He said, did He? Of course not. It might even be a test.

With this reasoned confidence, off Jonah went on his merry way, anticipating a wonderful cruise, perhaps even enjoying one of those bountiful buffets that seem to be onboard every decent ship. Bon Voyage, Jonah.

Meanwhile, way out in the sea was a great whale that was having tummy troubles. It must be something he was eating that caused nausea and subsequent vomiting. He would try something new in his diet.

Little did the whale know, but a ship was headed his way. And the passengers of the ship were in for a terrifying ride. A storm blew up over the Mediterranean Sea and tossed the ship to and fro with violent motion. Every timber groaned as the waves beat mercilessly against the sides of the ship. The captain could not understand how he could have put his ship and passengers in harm's way. This was not the season of storms. This was not in his forecast. This monster of a storm seemed almost sinister and would surely tear his sturdy little ship into toothpicks.

The captain began to think that someone on his ship must be truly evil and the gods were going to destroy them all, just to get to the culprit. So, he questioned his passengers. Here is the original account:

> So, the captain came and said to him, "What do you mean, you sleeper? Arise, call out to your god! Perhaps the god will give a thought to us, that we may not perish."
>
> And they said to one another, "Come, let us cast lots, that we may know on whose account this evil has come upon us."
>
> So, they cast lots, and the lot fell on Jonah.
>
> Then they said to him, "Tell us on whose account this evil has come upon us. What is your occupation? And where do you come from? What is your country? And of what people are you?"
>
> And he said to them, "I am a Hebrew, and I fear the Lord, the God of heaven, who made the sea and the dry land."

Then the men were exceedingly afraid and said to him, "What is this that you have done!" For the men knew that he was fleeing from the presence of the Lord, because he told them.

Then they said to him, "What shall we do to you, that the sea may quiet down for us?" For the sea grew more and more tempestuous.

He said to them, "Pick me up and hurl me into the sea; then the sea will quiet down for you, for I know it is because of me that this great tempest has come upon you."

Nevertheless, the men rowed hard to get back to dry land, but they could not, for the sea grew more and more tempestuous against them.

Therefore, they called out to the Lord, "O Lord, let us not perish for this man's life, and lay not on us innocent blood, for you, O Lord, have done as it pleased you."

So, they picked up Jonah and hurled him into the sea, and the sea ceased from its raging. Then the men feared the Lord exceedingly, and they offered a sacrifice to the Lord and made vows." (Jonah 1:6-14)

Jonah hit the cold water with a force that should have broken his face. Down he plunged into the blue-green abyss. He felt the fish just seconds before he was engulfed into its mouth and swallowed into the gut of the huge sea creature. Was he dead? Was this a dream? What was that awful smell? Do dead men smell rotting vomit? One thought out-raced another to get to the front of his brain. It took him a long time, perhaps hours, to figure out where he was and

what happened. After all, there were no stories or examples of a man being swallowed whole and surviving in the belly of a sea creature. He needed to really think about this one. But as bits and pieces of seaweed, ocean flora, and other awful things with no names floating around his head, he surmised that, indeed, he was alive and in the belly of a whale.

Three days passed with Jonah praying and the whale suffering with a terribly bad case of nausea. By now, Jonah was fully repentant for his arrogance, his disobedience to the Voice, and his cock-eyed, vain reasonings that he could somehow out-smart God. He realized that he was so used to being successful with God's messages that he exchanged his own voice for that of God's.

This sometimes happens with the "God Professionals." In fact, this transference seems to be an occupational hazard.

After what seemed like an eternity, a mighty churning and heaving commenced in the belly of that whale. Completely enrobed in slimy, decaying plant life, Jonah, too, began to vomit, right along with the whale. In just a few seconds he was thrust out upon an awaiting shoreline. Realizing he survived, Jonah waded out into the shallows and swished himself off in the sea to rid his body of the rotting filth of badly digested whale food.

Now Jonah re-thought his plans. Yes, he would now obey the exact words of God and he would preach repentance to the people of Nineveh. Off he went with a renewed determination to obey God. Yet even still, he secretly hoped that the supremely wicked citizens of Nineveh would ignore his fine preaching.

But they did not.

Nineveh was a big city. Really big. It would take an average, healthy person a good three days to walk from one end to the other. So, from one end to the other, an obedient Jonah walked and preached his heart out. And, to his surprise, the people listened. Even the king of the city listened to the message and believed that he and his people must repent. The King ordered every person and animal to wear sackcloth and ashes as a sign to God of their heartfelt sorrow for the sins they committed against Him and His people.

What can we say? God is compassionate. As Nineveh turned from their sin, God turned from his anger. In fact, he relented and accepted their sin offerings, and thus did not destroy the city – Exactly what Jonah feared.

Jonah became deeply upset over God's compassion. His conversation with God went something like this: "I knew you would do this. I just knew that you would go all soft and squishy when you heard their cries of sorrow and repentance."

Then he got mad. He got so mad that he put himself into self-exile.

Jonah was a runner. Again, He ran off rather than deal with something. But this time he ran out into the desert and literally prayed to die.

"Please God, take my life from me," Jonah moaned. "It is better for me to die than to live!"

Then God said right out loud, so Jonah could hear him: "Is it right for you to be angry?"

The hot sun beat came beating down on pitiful Jonah, so compassionate God caused a plant to grow up and provide shade over him. The shade from the hot sun made Jonah feel only slightly better.

Then God did a funny. He caused a worm to attack the plant, and it withered right up. God followed that with a mighty eastern wind that fairly burned the skin right off the suffering prophet! Jonah felt like his brain was baking. In fact, Jonah fainted.

Again, Jonah cried out for God to kill someone, but this time the person was him!

"My plant! My plant! I am so angry that my plant died that I wish I too were dead." whimpered Jonah.

God chuckled. "Jonah, you are so concerned about this plant, though you did not plant it or cause it to grow. It sprang up overnight and died overnight. And should I not have concern about the great city of Nineveh, in which there are more than 120,000 people and their animals?"

And that is it. That is exactly where the Bible story ends, with a God-size question, and no answer.

We will never know if Jonah settled his score with God. But we do know that when the book ends the prophet was stuck in his anger. Jonah's anger became more than an emotion. It hardened into a position of hate, fed by a savage thirst for revenge. It caused him to rage at God. And his attitude towards God's seemingly ill-directed compassion even separated him from God and resulted in a deep depression, a depression that completely overtook the angry prophet.

This story reveals the power of rage, (un)righteous judgments, and even the mental illness that awaits those who allow anger to become weaponized. The book of Jonah is in the Bible. It is only four chapters long, and it ends with the reader not being sure if Jonah, the

man and prophet, will ever have a happy ending again. Consider what happens when anger has its way.

Let me tell you another little story. This one is out of my own life and cannot be found in the big black book on the coffee table.

It starts with this:

Sometimes I feel as if I have no inspiration, nothing fresh to say or think. It seems to help me if I go into my room and strip back the covers and lie down on cool fresh linens. I lie there with my head cradled on the pillow and my ankles crossed. And I think, and I pray. It is not unusual for me to seek the Holy Spirit's advice on what He would like me to think about.

Today is Saturday, and it was just such a day. I went to my room pulled back the covers and lay down. I suppose it seems lazy to some folks that I would just shut down the outer world and the inner world of my home and close the door on all activity. My dogs must stay in their beds in the laundry room, my stepson must be quiet, and the phones must be silenced. If I am tired, I drift off for a few moments. But not usually. My husband is off work, but still, he works. He always has a list of projects in mind, and he ticks them off with rapidity He is one of those rare and productive persons who thinks sitting down is a waste of time.

But I am flat on my bed doing what I call 'pray-think.' This is my way of collecting my mind and making it be obedient. I usually pop-up in a few moments and write down my thoughts.

One morning, several years ago, was such a time. I was in my pray-think mode for an hour or so. I heard the dogs getting restless and

wanting to go out, so I knew it was time to get back into the groove of the day. After I let them out, I decided to do a little light reading. I opened my computer, and there was my daughter's blog staring back at me. Juli Roberts Sensintaffer has become known for her writing. If she takes the time to write, she usually has something worthy to offer. As per usual, her blog was filled with love and humor.

Both of my daughters, Juli and Christi, are strong and beautiful women and my son, Canon Thompson, is a fabulously creative young man. They all three have known far more than their share of suffering. They have scars, most of which have been placed on them by others, and they have also had to deal with terribly flawed parents. Their father and mother have made blatant mistakes that could have permanently disabled most human beings, yet my children continue to be givers of grace to themselves and to others. This includes their parents.

But this morning, the title of the blog that Juli posted truly caught my attention.

Juli's Blog: "A Question of Mercy"

"I have a question: we want God to have mercy on us when we screw up, right? Why don't we want Him to have mercy on others, especially those who hurt us? Why do we want bad things to come to them?

What we refuse to see is that God loves those people the same as He loves us, and He is not willing that any should perish. Why can't we see this? (2 Peter 3:9).

Revenge is human nature, and it is exceedingly difficult to break free from the desire to see it land on the head of our enemy. But somehow, we think we are God's favorites, and he will spare us the results of our sins, instead gathering us up into His loving arms when we lose our way. We are sure of His forgiveness for ourselves, but we are not as sold on the idea that He is as loving to others, especially those who have wronged us. We put those offenders in a quite different category.

The reasoning might go something like this: I know that God loves me. How then can he love those who have tormented and abused me? Doesn't it lessen His love for me if He also loves those persons with that same everlasting love?

Surely our understanding of love versus justice is incomplete and dimmed by our human nature. If I try to count all the times I have messed up, this will end up being an awfully long blog. Do you know how many times God has forgiven me? He forgave me every time I asked him to do so. Each time I have repented and asked for forgiveness, that is exactly what I've gotten. I know that God's goodness and mercy have followed me around cleaning up my messes, Psalms 23:6 promises me that. So why do we find it hard to imagine God forgives others, too?

God loves his children, all of them, all the time. He is rich in mercy and loving kindness.

Recently, I stumbled upon an online forum where people were talking about a shared experience from years ago. It

was obvious that all these people in this forum went to Oral Roberts University, which was founded by my grandfather, Oral Roberts. The forum could have been a place where they would reminisce about funny things and easier times, but sadly the forum gave many the opportunity to simply prove themselves to be bitter and stuck in the past.

God isn't in the business of going backwards. God is always in forward motion. He has plans for us, He has a future and a hope for us. (Jer. 29:11). He doesn't live in the past; his mercies are new every morning. (Lam. 3:23).

I mean, how can we fulfill God's plans for our own future if we cannot get out of our past? We must accept God's mercy for ourselves, and then we must show God's mercy to others, and get on with life."

As soon as I finished reading Juli's blog post, I picked up the phone and called her to find out what was going on and who hurt her.

She informed me that, no problem mom, the blog post was a reprint from nearly a year before. My Mama Bear roar began to slowly quiet itself. As a Mama Bear, I assumed someone was just mean to my little girl and she took the opportunity to be sweet and exercise grace and forgiveness. I was not so inclined to be sweet. My ire was up, and someone was about to stand down, and it wasn't going to be me or Juli.

As it turned out, Juli wrote that blog post as a thoughtful response to a news article she saw. The article toasted and roasted her father, Richard Roberts. Oral Roberts University, and Richard, as its president, was caught up in a conflict that was well-covered by the local press. Her father's leadership as president of Oral Roberts University

was assaulted publicly. As I mentioned in chapter three, three professors took him to court. His leadership was in question and the lid was finally coming off. People who remained quiet while their anger and frustration simmered were quiet no more. Richard Roberts was forced out of his position at the university because the school become totally insolvent during his tenure as president. What began as a court battle widened online to include complaints about her dad's management style. Many people loudly agreed that it was time for the beleaguered president to go, since he backed himself into an impossible situation from which there was no graceful escape. Much to his total surprise, his own board voted him out.

Once the board acted, the local media declared open season on all things "Roberts." Every student who ever had a hurt or a gripe about the administration of ORU found this to be their long-awaited opportunity to vent their frustrations. Past students vented quite publicly, in social media, for all to read. It was a crap-storm of dirty laundry, hung out on display. A 30 to 40 year build-up of angry feelings toward the Roberts family spilled out in harsh detail, and since it was online, everything said was very sharable. Juli's father and his wife, Lindsay, took the brunt of the hatred.

Juli followed the articles and attending comments online until she could take no more. She was hurt by it all and responded to that hurt by writing her blog. Juli and Christi were hidden on the sidelines, but still, the wounds of the father were visited on the children's hearts. They grieved at the sight of his public disemboweling. Every critical word not only cut Richard, the intended target, like a sharp knife, but also his daughters as well. So Juli watched the father she loved eaten up, like easy prey. Some bites were taken by people with

legitimate complaints. But there was plenty of evidence that others simply took the opportunity to kick her daddy while he was down. She wanted and needed to move past the controversy. She wanted others to move past it as well. She wanted these few but loud disenchanted former students to forget it, to get over it. Much time has passed. For heaven's sake, she appealed, let it go. She wished she could just tell them all to "Get a life!"

Now that I knew what the catalyst for her blog was, I realized that I also had some unfinished business. But I was suddenly faced with a choice. This same batch of online comments affected me, too, but in a different way than Juli. To be perfectly honest, it gave me some satisfaction to see Richard getting a whippin.' I was feeling a little bit vindicated in the deep, old wounds that I still occasionally licked. In a flash that seemed to come out of nowhere, I felt a sort of glee that he was finally getting his due.

My divorce from Richard Roberts happened decades before this public humiliation, and over the years I worked ridiculously hard to find a place of peace that only forgiveness grants. But deep anger is hard to root out.

There it was again, a flash of fresh anger. Juli felt it for one reason, but I felt it for two reasons. First, I was protective of my daughter's heart, but second, I was protective of my own heart as well. The incident popped the lid off an old, simmering desire for revenge hidden deep within my soul. I was faced with a choice. Would I choose to indulge this anger and rehash the details, until the pain resurrected, and we all re-lived our worst days? Or would I once and for all put a nail into it?

It is natural for a Mama Bear to be angry when someone is hurting her children, and perhaps in that context, anger is useful. When danger is near, a Mama bear protects her cubs. The emotion of anger can be a bright red flag of danger or even a warning we should heed to protect ourselves and those we love.

But when does anger become more than a protective emotion?

Anger is more than an emotion when it moves away from the normal, healthy expression of one's feelings and hardens into a position of hatred or revenge. Anger is more than an emotion when it is weaponized. When anger is weaponized it spawns a great many other emotions and deeds that eventually kill all possibility of living with a healthy heart. Love and life are snuffed out in a heart filled with weaponized anger.

So, at the time of this public conflict, I decided again (and again) that I was not going to let anger rule me. Instead, I laid down the weapons of war and gave in to the salve of forgiveness and peace. Weaponized anger was not going to be a part of my growth pattern. I thought that I was well beyond having weaponized anger rise to the surface of my heart again. But those hurt feelings and desires for revenge still lived, hidden in stealth, waiting for a time when they could infect me once again. It took a strong act of my will to intentionally starve them to death, to smother them with God's love. The time for anger to be a natural expression of good mental health was long passed.

Each of us have near-daily opportunities to let our anger become weaponized. Things happen in our private lives that render us just one hand-grenade away from an explosion. We face betrayals by those we trust. We face lies being told to us, or about us. We face

humiliations that strip us and leave us naked. It is not just individuals who must face these things. It happens at a national and international level in politics, between countries; it happens in single proprietor businesses and in huge corporations. The whole world boils in the stew of its own anger.

I am a news junkie. I flip on the news as I am sipping my first cup of coffee. I usually hang around and watch it until I have s l o w l y finished my second cup. Then I will press the TV off-button and get on with my day.

Around 5:30 p.m. I flip the telly back on and catch up on what has happened around the world since I put my morning coffee cup into the dishwasher. Usually around bedtime, I look at the news one more time, just to make sure nothing blew up while I wasn't watching.

Blow-ups of all sorts are reported (with copious commentary) on the all-news stations. Events are watched and re-watched, dissected, trisected and quad-sected. But now, what used to be a straight-up, forward reporting of the news has degraded into a blood sport, a partisan slug fest. The "news" seems to be as much opinion as it is hard facts. I wish it were not so, but it is, and it is not likely to change.

With every flip of the channel, one can see the close-up pictures of human failure and abject carnage, and everywhere, there is anger. Lots and lots of anger.

The conflicts in the Middle East are seemingly unending and are just a sampling of world-wide upheavals. Palestinians versus Israelis. Kurds versus Iraq. Iran versus the Saudis and Israel. With every rocket that is launched and met with a return volley from the opposite side, one can see what happens when anger is weaponized.

Anger in the Middle East has been weaponized, whether anger over land disputes, anger over a two-state solution or a lack thereof, anger over who holds the rights to visit certain holy sites. Anger is weaponized and launched over the walls on a volley of bombs and missiles. Somebody throws a rock and hits a soldier. Then that rock-thrower gets shot. The rock-thrower's mother is seen wailing and draped over the coffin of her child, then more shots are fired, then, missiles are lobed into a school, then bombs are dropped in neighborhoods. Endless, self-perpetuating anger, weaponized.

Anger is highly contagious. You can get the disease from your friend, your spouse, your neighbor, or your family member. Does an answer or a solution come from weaponized anger? No. Not usually, not hardly, not ever.

Weaponized anger kills rationality and thoughtful discussion. Weaponized anger kills meaningful resolution to conflict. Anger, when weaponized, becomes the enemy of all peace-loving and peace-seeking souls. This type of anger does not play nice and sends us down a road from which there will come no good ending, because weaponized anger is the neighborhood bully. But anger is the human response when we have been deeply hurt, disenfranchised, or dismissed as insignificant. It is impossible not to feel anger when faced with injustice.

The Bible tells us, "Be angry and do not sin; do not let the sun go down on your anger, give no opportunity to the devil." (Eph. 4:26-27) Wait - be angry, but sin NOT? How is that possible?

This is a command to not allow our anger progress to a lethal stage. Instead, we must face it, deal with it, and even pray for those who have

provoked it. Individuals must resist weaponizing anger. Communities must resist it. Countries must resist it, because whatever weaponized anger touches will eventually blow-up, and people will die.

And we all must resist, with everything within us, the temptation to exercise revenge. Love must become a greater motivation to us than revenge because weaponized anger is a wildfire that can only be smothered by love.

I am now going to tell you about the wonderful man I married. He was hurt by his first wife in a way that would send most men into their arsenal to arm themselves for battle. Yet, he chose to have the raging wildfires of his anger snuffed out by the power of love.

After he experienced a heart-breaking divorce, Dr. T. Christopher Thompson did something stunning. Every year on the anniversary of their wedding, he called his former wife and asked for a meeting. They met again and again for sessions of forgiveness and mercy. After some time, forgiveness was finally freely given, and the cup of mercy and kindness was extended. Were they able to restore the marriage? No, his former spouse moved on and he accepted that. His goal was to be healed and to be a "repairer of the breach." (Isaiah 58:12) Chris told me that his promise to "love until death do us part" was still a serious oath to him. It meant a commitment to a lifestyle of Christ-like compassion, decency, and kindness toward the other, in Chris's mind, even though the marriage was gone. And, amazingly enough, they were indeed able to restore respect and kindness to each other.

How I wish that this were the norm for divorced couples! I especially wish this for divorced Christian couples. Never have I seen such a raw hatred and meanness as I have seen in Christian divorces!

Everyone seems to be touting their innocence rather than dealing with their own sins of commission or omission. Thus, new wounds from the divorce itself are heaped upon the older wounds. The whole group of us who have gone through this become a scarred and ugly bunch, save for the few who manage to let the power of love and mercy tend to their wounds.

Chris and I dated in college, but when I met him again, 46 years later, never had I met a man so whole as he. His scars show the grace of Jesus. They became redemptive signs that Chris used his pain to develop a habit of mercy. How did he achieve this? Chris's wholeness grew because of his courage and willingness to look at the breakdown of the marriage and ask two questions: "What wrong did I do? And what would Jesus do?" Hatred and bitterness were not allowed to consume him, or his steadfast faith.

When we allow our children to run outside and play, we accept the fact that they might fall and scrape a knee or break a leg or bump their head. To avoid any scrapes and hurts, we would have to keep them locked up in a bubble. But in our love for them, we choose not to keep them sheltered inside, we let them play, knowing that they will get hurt, because small hurts are part of normal childhood play. When they come crying home with a scraped-up knee, we look at the site of a wound, be it minor or major, and take appropriate action. We clean out the wound and apply germ-killers and bandages. We address the wound head on.

We do not turn our heads and look the other direction. We do not ignore the dirt inside the cut knee. We do not take lightly the big bump on the head, or heaven forbid, a broken bone. We promptly give help, and when necessary we seek medical attention.

So, my question is this: shouldn't we also do this when there are emotional or spiritual wounds?

This is how Chris, my husband, dealt with his broken marriage. He faced the uncomfortable things head on. He was not content to let the dirt stay in the wound and ultimately kill his heart. Instead of allowing anger to be weaponized as a tool of hatred, he used its energy to propel him toward love and healing.

Conversely, I have another friend whose marriage ended some 40 years ago. To this day he cannot look at or speak to his ex-wife. If her name comes up, he quickly shuts down the conversation and basically forbids anyone to speak of her. He is only comfortable if he thinks of her as dead. Clearly, his actions have shut the door to the graces of healing and love, which are God's method of healing broken relationships. Unfortunately, my friend continues to say no to God's healing love.

But Christ invites us to become like Him, and to live in perpetual light; to choose light over darkness; to choose love over hate. It is the way of Christ, and Christ is the Way to God. His invitation offers the only sure path to wellness for not only us but also for those that we influence.

Martin Luther King said, "Darkness cannot drive out darkness: only light can do that. Hate cannot drive out hate: only love can do that." (Martin Luther King 1986)

Will we join Chris as a repairer of the breach, or will we let our jagged edges act as knifepoints that widen the divide? Will we weaponize anger?

Sometimes those who fight back are considered the stronger ones, while those who choose to forgive, and refuse violence, are considered the weaker. There is no glamour in being the servant who takes the basin of water and the towel to whatever human tragedy is encountered, but Jesus our Lord did this very thing. It is the triumphant position, in the end.

We wash the wounds of others because our wounds, too, were washed by Jesus' blood and kissed by His love. We help repair others with the gold of redemption because Christ has redeemed us in the same way. Jesus calls us to do as Chris Thompson did: resist the dark power of weaponized anger and instead use the energy of anger to propel us into Jesus' forgiveness, healing, wholeness, and redemption; the Kintsugi of our souls.

The Ninth Golden Thread

Love…we can't live without it.

*Love is more than an emotion. Love is the force
that can cause our wounds not only to heal but
to glow with the fresh glory of God.*

*Love itself is a living, active force, and it perpetually
wars against all that is unlike itself.*

*It seeks out and finds the dead places within us where love
and life have withered away; the barren places that perhaps
once sung with life. If we let him, Christ comes in and sets up
camp right at those barren places, He camps out there in order
to renew the work of Love exactly where we need it most.*

*And Christ, being Love, makes all things new. It is He who
eventually heals us. His great Love comes into our empty
places and loves away all that is loveless.*

Chapter 9

When is Love More than an Emotion?

CLAUS SCRUNCHED UP HIS FACE in a frown. He felt angry and alone a lot of the time these days. Mother and Father had been gone for so long that he was not sure he remembered what they looked like. They left him with his grandfather in this small Swiss village, saying that they would only be gone to Italy for a week. That seemed like years ago. Perhaps it was.

Grandfather looked after his physical needs, but little else. Sure, there was enough food to eat, and Grandfather bought him a new pair of trousers when he snagged big holes in the knees of his old ones. And, if he were not so lonely, life would not be half-bad. There were goats to milk, hay to be cut, wood to be stacked; chores that, honestly, he loved. At least once a week, Grandfather asked him to find some yellow flowers in the mountain meadows and put them in a jar on the table. There were some unusual things about his grandfather and loving yellow flowers on his table was just one of them. But Claus obliged him and always brought in a handful of yellow daisies, or yellow buttercups, or yellow Punduzzies, when he could find them.

The Punduzzies? Oh, that was just what he called any yellow flower for which he had no name. There were lots of Punduzzies in the valley.

But, despite enjoying working alongside his grandfather, Claus was lonely. And in his heart, anger grew toward his parents. It felt like they abandoned him. For all he knew, that is exactly what happened.

When he asked his grandfather why his parents did not return, the old man would only mumble something, then turn away.

Today there were gray clouds hanging over the valley, and that did not make him feel any better. Life seemed to be the same color as the clouds.

He decided to hike up the mountain to see if he could find some sunshine. He grabbed his walking stick, his hat, and a sandwich made from whatever was left over from breakfast. Bread, butter, a slab of cheese and a tomato. That was it. Oh, and a small jug of water.

He climbed for a couple of hours before he could find even a hint of blue sky. It would be a couple of hours more of climbing before he would reach the meadow by the lake. Claus began having an imaginary talk with his parents as he climbed.

"Why did you leave me?" He asked them angrily. "What did I do to cause you to want to go off without me? Are you ever coming back for me?"

He poured out his anger and his sadness as he ascended the mountain. Sometimes he would stop to wipe the sweat from his neck, and the tears from his eyes.

He finally reached the meadow somewhere around mid-day. The sun was high in the sky and bright as fire. He sat down on a nice flat rock and unwrapped his little lunch.

He took a big bite of the chewy bread. Chewing and lost in thought, he did not notice the little blonde girl who sat down beside him. He jumped when she spoke.

"Hello, Claus, I am glad you came to the meadow today." she said in her tiny little voice.

"What? Who are you? How did you get here? How do you know my name?" he asked. Who was she? He had never seen this little girl down in the village, nor on any of his many hikes.

"Claus," she said in a bubbly stream of laughter, "I have always known you. You just don't remember."

Well, that was certainly true. He had not a shred of memory of the fragile little child who stood beside him.

"Are you hungry? Do you want part of my bread, or a bit of my cheese? I have some water, too," Claus said, trying to be polite.

The little girl took what was handed to her and ate it with great delight.

"Thank you, Claus. You are a kind boy. That is why I came out to join you in the meadow. I knew you needed me. Look there, do you see that bird? Do you hear the honeybees humming?"

He stopped chewing and listened. Indeed, he could hear the bees and he saw a little bird flitting from bush to bush. It was a little

purple bird, a type he never noticed before. But he noticed it this time, and thought it was beautiful.

"Claus, you are sad and thinking your parents don't love you," she said.

Upon hearing his inner thoughts spoken right out loud, he choked a little on the tomato he was chomping down on. How did she know?

Without missing a beat, she continued. "Hey, you haven't even asked me my name. Did you know that my name is Love?"

The little girl prattled on, "Spell that with a CAPITAL "L" please! And my last name is 'Neverdies' – isn't that funny? When you say it all at once it sounds like 'Love-Never-Dies.' That always gets some laughs when I tell people about it," Love giggled out loud.

"Sometimes, when I see a sad person, I walk right up to them and stick out my hand and say 'Hi, my name is Love Never Dies!' They always lose their sadness when I tell them my name. It sounds silly, but really, it does make people laugh. And we all need to laugh more, from time to time. Especially, you, Claus! You don't laugh anymore, hardly at all!"

"Well, I have my reasons," Claus grumbled. "Besides, you don't know anything about me at all. But, trust me, if you did, you would know that I have my reasons not to laugh much."

Now Claus was perturbed with this girl named Love. How did she know all these things? Maybe she heard him talking out loud to his parents on the trail. But what nerve she had to say those things out loud! Claus was not about to tell anyone how sad he was, or the hurt he felt in not being with his parents.

So Love was a little rude, for his taste. But truthfully, in a strange way, it felt good to him that she seemed to know his secrets without him having to tell them. Her words uncovered a place inside of him where he ran to hide when he felt sad. No one ever entered that room in his heart. He privately called it "my very alone place." But, irritating as it was that she seemed to already have broken into his secrets, Claus still somehow felt safe with her. And safe was a good feeling.

"I know," she said. "Your parents dropped you off at your Grandfather's house and they have not come back to find you for such a long time now. That would make almost anyone sad. I bet you think that they threw you away and that they are off having lots of fun without you." her voice trailed off.

Then she looked him in the eye. "But it isn't true, Claus. They love you very much, and they know that you are sad."

He was looking at her straight on, and her words startled him deeply. He was about to ask her how she could be so certain when he suddenly realized that the little golden-haired girl was gone!

Where was she? Was she hiding? He called her; he looked behind the rock. Not there. He looked behind the willow tree that dipped its branches into the waters of the lake. She was not there. Was this a game? He even looked up into the branches at the very tippy- top of the willow tree. Nope, Love was nowhere to be found. She was gone as quickly as she came.

Had the hot sun done affected him? In his extreme loneliness, did he imagine a friend? He scratched his head in wonderment; Was she real? Where could she be?

Then a smile crept across his lips. For the first time in months, he felt a little bit happy. In fact, only a moment later, a giggle slid up from his throat and popped right out of him!

Suddenly, Clause felt strong enough to jog back down the mountain, even whistling a little tune. He climbed the mountain with a broken heart, but he returned with joy. He saw so many beautiful things on the mountain; the sun, a purple bird, and bees making honey. He even talked to Love!

An amazingly sweet feeling was welling up inside of him, a feeling like someone wrapped his cold little heart in a nice, warm blanket of joy. Somehow, he now understood that even if his parents never came back, he was still not alone. He knew, too – way down in his "knower" – that his parents did not leave him because they did not love him. They meant to come back and take him home. But something happened; perhaps something too sad for grandfather to tell him about right now. Somehow, he knew there was a reason for their absence. Perhaps they were truly gone. It was a possibility; but since he met little Love Neverdies he felt strong enough to face it. Even if the worst possibility came true, he still knew he was loved. And that made all the difference.

And so, with love in his heart, he made his way down the mountain like a boy made new.

This must be why Grandfather always wants yellow flowers on his table. Perhaps it is Grandfather's way to say how much he loves my parents, his peculiar way of keeping them with us? And right then, Claus decided he would pick Grandfather the largest bouquet of Punduzzies he has ever seen.

And so ends our story of Clause, who climbed a mountain in search of answers and returned with joy. Why?

On the mountain Claus met a little girl who happened to be named Love. Love came to him as a person. Of course this story is only a fable, but the fable can be a metaphor for the secret struggle we all carry in our hearts. Do I matter? Am I loved?

Just like the little girl came to Claus in the story, Christ, who is love in the flesh, comes to us as a person, too; sometimes when we least expect it. Will we let him in? Love is real. And when true Love visits us, it always echoes to us the heart of heaven.

Love Neverdies spoke a language that Claus could understand, and she spoke of his feelings in a way that let him know she understood exactly what was bothering him. Claus was suffering from an abandoned, broken heart, and only Love could heal him.

Our planet is a raw and rough place to live, and it provides ample opportunity for wounds to amass. Finding – and traveling on – the road to love and healing is required for fulfilling, joyful and purposeful living.

To move on with life, we must say yes to Love when He visits us. Only He can heal us. We must say yes because the Healer will always honor your choices. He will not go beyond that which He is invited to heal. All those who truly wish their souls to be deeply healed allow themselves to be touched by His love, to be known by Him, and to know Him in return. They are the ones who risk letting God be God; they do not limit His presence or His inner work. This takes great courage. He may take us down paths we would rather not

travel, but healing is on that path. At least He stays with us; we do not travel alone.

The mere act of living on Earth subjects us to the pounding evolution of decay. Time is at war with our physical beauty, mental brilliance, talent, relevance, and even the very life within us. Time is brutal to all living things. We get old, and sometimes we lose our marbles along with our supple, smooth skin and shining hair. Eventually we die, just like the trees, the flowers, the wild lions, and the sweet fruits that drape the trees of the orchards. Time ticks on until, minute by minute, our time on this earth runs out. What is the meaning of it all?

The secret to the meaning of Life is Jesus. Through Christ, we have more than a religion; when we become one with Him, we join ourselves to heaven. We connect with "Love Neverdies"– a connection that makes us perpetually stronger in every way; stronger intellectually, stronger in the soul, stronger in wisdom and in understanding, and most important, stronger in Love. The best anti-aging solution is the presence of "Love Neverdies" in our lives.

Even our physical bodies are enriched and strengthened by the presence of Jesus' Spirit, the spirit of Love. Yes, in the end, our bodies will still age and die. But the amazing thing about a life lived in connection to Jesus is that we will have truly lived, not merely existed, during our time on the Earth.

Love's advances in us are evidence of the work of the third person of the Trinity, the Holy Spirit. We are told in Scripture that the Holy Spirit is tasked "to lead us into all truth." Simply put, to know God one must first embrace the person of Jesus and, second, open our

lives to the work of His Holy Spirit. It is the Spirit that opens heaven's vaults of wisdom, understanding, self-knowledge and all other secrets that humanity has yet to discover. To embrace Jesus is to have all the doors to these treasures opened to us; to follow the Holy Spirit is to be led through them into the wisdom of how we can apply these liberating truths to our lives and our world. And because of Jesus, we who have accepted Him as our Lord will one day escape this broken and limited world and be joined with God in heaven.

Love is so powerful there is only one thing that can stop it. It is us. Daily we choose, sometimes without even realizing that choices are made. Who would say NO to Love? No one, of course. No one wants a life emptied of love. Love is not an easy path; there is no getting around that very inconvenient truth. Love demands much of our treasured resources. Still, who would purposefully choose to deny, or even to kill, love? I do not think many people consciously choose to kill love, but the things that kill love are subtle and deceptive, and common to our humanity. Love Killers do not present themselves for what they are. Unfortunately, because of this, we all choose them on a far too regular basis.

Beware of the Love Killers

Love Killers disguise themselves as natural reactions to unfairness, or sometimes even as our "rights." Love Killers disguise themselves as revenge, as blame, as "getting even", or even as guilt and shame. Even if we have a "right" to feel the way we do, these responses drain the flow of love right out of our hearts if they gain a foothold in our lives. How do we avoid this? We must detect them early and get rid of them as soon as they pop up their ugly heads.

So what are the Love Killers?

First, guilt and shame. These negative emotions inhibit us from feeling love or giving love. We feel unworthy, so we shut our hearts, and opportunities to give and receive love are lost.

Next, there are lies. Lies undermine the foundation of any relationship, for relationships are built on trust. Love cannot be built on a foundation that has been subverted by lies of any sort.

Ah, and then comes anger. When it works its way into our lifestyle, anger is a boiling pot of acid that destroys everything around it.

Then there is unforgiveness. Ouch! We have all heard this over and over, from both religious and secular counsel. Unforgiveness can become a form of arrogance, a judgment of another person. Or it can also be an act of holding on to the crime because of what the criminal owes us. Unforgiveness demands a payment; it demands the score must be evened. Love is always a casualty when scores are evened.

Our Lord, when teaching his disciples the way to pray, included an important insight into the trap of unforgiveness. He prayed "forgive us our debts, as we also have forgiven our debtors." (Matt. 6:12), tying being forgiven ourselves to the act of forgiving others. This is a key to unlocking love in our lives if we will just practice it. We want to be forgiven for our mistakes, but if we are unwilling to extend that grace to others, we cannot expect forgiveness to flow freely in our lives, either. Jesus clarified forgiveness as essential, as a lifestyle not an occasional event. By putting this in the model prayer, he indicates that it should always be a part of our conversations with God.

And one more thing about forgiveness: we cannot be fooled into thinking that a tiny bit of unforgiveness can allowed to remain in our heart of love. These two things cannot coexist. Either Love will triumph or unforgiveness will. Those who may labor under the pernicious thought that their judgments, hatreds, and bad actions toward others can be swept under some rugs are dangerously mistaken.

Bitterness is another Love Killer. Like oil and water, bitterness and love cannot mix. Bitterness taints and rots the most tender words and deeds. It corrupts everything of value. How can something so bitter-tasting feel so sweet? I remember getting such a sweet and superior feeling in my gut when I would allow myself the pleasure of bitterness. There was plenty about which I could be bitter, towards myself and towards others, too. And, for terrible and short bursts I sometimes allowed bitterness to well up within me. Such feelings bring a sense of justification, and more than a little moral superiority, if one is completely honest. But bitterness literally defiles all that is clean and pure within us. Bitterness is the door through which self-justification enters. When one can justify their judgmental attitude, prejudices, and ill-will, then boom; healing love is thwarted once again.

Hatred: Hatred and rage are partners in crime. I once knew a man that was so full of rage that a day never passed without his exploding over something. He even hated his neighbors to park their cars on his side of the street. He repeatedly called the police, even though the neighbors were not breaking any laws. This angry man just did not want their cars in front of his house and would become blinded by rage to the point that he would knock his kids and wife out of the way when he ran for the door to talk to the police about these cars!

"You know you shouldn't get in my way when I am mad!" he would say to his wife and children. "I could accidentally hurt you. That is your responsibility, not mine."

His wife would plead with him to get help; she told him his rage was unacceptable and was damaging their relationship. Each time he turned a blind eye and said "Well, Sugar, I am not mad at you. So why is this a problem to you?"

This pitiful man eventually killed everything around him. He killed the love in his home, he killed any chance of having a relationship with the neighbors. He became known for his rage at his workplace and in his community. His relationships died, one by one. And wouldn't you know that this angry man drove a truck with a 'Holy Spirit Dove' sticker on the back window, implying to all that he was a Christ follower?

Impatience: Being loving just takes too much time for the impatient person. Impatience can be defined as refusing to allow the time it takes for the process of grace.

Deceit: Again, deceit is a lie, and liars are never lovers.

Cruelty: The cruel person cannot have true love in his or her heart. There is no room.

Mockery: Love, tender and delicate, can be snuffed out by a mocking spirit.

Apathy: Apathy, the silent and unseen killer, is perhaps the deadliest of the soul diseases. If you allow yourself to get to the place where you "just doesn't give a damn," real hell is close at hand. That is the

time to run to God and beg for a new heart, because your old one has died.

This list of Love Killers is long, but really, it could be even longer. Perhaps you, my reader, could add to these? Surely you have seen other Love Killers in action. No one can live in this world without meeting Love Killers head on, at one time or another.

All Love Killers are deadly and, if left unchecked, they mortally wound the soul. Death enters your innermost being if you allow them to grow. Many people who influence our lives are themselves so full of such poisons that their words come out with more force than they realize, and they scar those that they influence, rather than build them up. In fact, every word or deed that is not motivated by Love has potential to wound. Hatefulness is so common that we often do not realize the depth of our wounds until we see the scars left behind.

Healing cannot come when the killers rule the house. Nothing will work right until Love can displace these terribly destructive emotions. When you know Jesus and His Love, you soon realize that you must put every Love Killer away; all of your anger, rage, hatred and bitterness must be placed on Love's altar so you can allow Him to obliterate those things which have the power to destroy you. Putting these negative habits on Love's altar is an act of the will, so do not be dismayed if you must do it more than once. I tend to put my Love Killers upon the altar but then pull them off when I feel less secure. Getting rid of Love Killers is a process of relinquishing my vendettas, and trusting God, who is Love, to defend me. Love is a living, active force, one that perpetually wars against all that is unlike itself. Love seeks out the places within us where it has never been felt; or

where once felt, has since died. When we invite Love to have its way with us, Christ comes to set up camp right in that very place of "lovelessness" if we permit Him. It is Christ, being Love, who can heal us. His great Love warms away our cold lovelessness.

"Love hinders death. Love is life. All, everything that I understand, I understand only because I love. Everything is, everything exists, only because I love. Everything is united by it alone. Love is God, and to die means that I, a particle of love, shall return to the general and eternal source." — Leo Tolstoy (*War and Peace, Thoughts of Prince Andrew Bk XII, Ch. 16)* (Tolstoy 1869)

When is love more than an emotion? Love is more than an emotion when we are wakened to its power. Love is more than an emotion when we finally realize, as Tolstoy says, everything in this world was made by Love; and everything is therefore united by love. Love is the fundamental building-block of all life on this planet. We cannot survive without it.

The Tenth Golden Thread

When Love is your North Star...

Love not only transforms the evidence of our past scars, it also energizes us and points us forward; it teaches us the keys to the Language of Scars.

Love is more than an impersonal force of goodness in the world. Love is a person, a redeemer, a soul-artist. Love is the Alpha and the Omega; Love is Christ, from beginning to end.

Why do I say that nothing works right without Love? To drive your Christian life forward without love is like driving a car forward with no engine. It may look great on the car lot, but a car without an engine won't drive. And Christianity without Love won't drive either.

So, Christian, keep the engine of Love in your faith. Make sure to keep the oil of forgiveness changed on a regular basis. Even though your engine needs a tune up at times, just stay on the highway of Grace and you will get to where you need to go in this life and beyond.

Chapter 10

Nothing Works Right Unless there is Love

MICHELANGELO WAS BORN ON MARCH 6, 1475, in Caprese near Arezzo, Tuscany. As a child, his artistic genius distinguished him from other children his age. As he grew up, his artistic genius was obvious to all.

In November 1497 the French ambassador to the Holy See, Cardinal Jean de Bilhères-Lagraulas, commissioned Michelangelo to carve a Pieta, an image of the crucified Christ lying in his mother's lap. Michelangelo agreed to do so; he was only 22 years old at the time the sculpture was commissioned, and was 24 years old at the time of its completion. Though he was so young, the statue was quickly regarded as one of the world's great masterpieces of sculpture. At the time of the Pieta's unveiling, the artist and writer Giorgio Vasari, (1511-1574) a contemporary of Michelangelo, reflected,

> "It would be impossible for any craftsman or sculptor, no matter how brilliant, ever to surpass the grace or design of this work or try to cut and polish the marble with the skill that Michelangelo displayed. It is certainly a miracle that a formless block of stone could ever have been reduced to

perfection that nature is scarcely able to create in the flesh." - Giorgio Vasari, *Lives of Artists,* first edition, 1550 A.D.; 2nd edition, 1558 A.D. (Editors, Encyclopedia Britannica 2005)

In addition to the Pieta, Michelangelo carved the magnificent David, Moses, St. Peter, St. Paul, and dozens of other works of stone. To this day, observers gasp at their lifelikeness. So, how did Michelangelo do it? How did he carve these magnificent figures from formless blocks of stone? His own writings indicate where his genius lay:

> "In every block of marble, I see a statue as plain as though it stood before me, shaped and perfect in attitude and action. I have only to hew away the rough walls that imprison the lovely apparition to reveal it to the other eyes as mine sees it." ~ Michelangelo (Editors, Michelangelo Gallery n.d.)

Michelangelo was a visionary and the secret to his genius is that he saw what others could not see. When he looked at a piece of marble, he saw lovely figures, waiting to be set free. His calling was to use the tools of his trade to cut them loose. His secret provides a metaphor for the deep work of Christ's love in our lives. Similarly, Christ has a vision for each one of our lives. He sees the lovely apparition of our true self, if only the tool of love is free to hew away the rough walls of pain and scars that imprison us. Love is more than an impersonal force of goodness in the world. Love is a person, an artist. Love is Christ.

Under the skillful hand of Christ, our disfigured scars take on new meaning, just as His scars did. After the resurrection, Jesus' scars became the evidence of his authenticity. Doubting Thomas insisted on touching Jesus' scars before he could believe that this man was the authentic Christ, risen from the dead. And as soon as Thomas

touched the scars, all his doubt vanished. He was set free. (John 20:28) Is it possible that your scars or mine might also have the power to set others free? Do our scars add to our authenticity? What might happen if we let doubters see and touch our wounds, even while we are still healing, instead of waiting to be "perfect again" to share our story?

The resurrection of Jesus Christ was not a complex game of smoke and mirrors played by his promoters to keep the "Jesus Movement" going. Jesus' wounds and scars were real -- a physical line in the sand, a touchpoint of history. Even after his resurrection, the Perfect One kept His scars. Jesus' scars proved his reality; they proved the power of God; they proved the power of Love to raise back to life what was dead. And your scars and mine, redeemed by Jesus, reflect the same story.

Because God is love, Love never fails, Paul tells us in I Corinthians 13. He goes on to say that without love, we are nothing, and nothing we do amounts to anything. What a sweet and lofty thought. But in real life, in the day-to-day mix with people who may be irritating us, love does not always feel sweet and lofty at all. Here is how this played out in one chapter of my life.

Before Mama died, she and I took a road trip. For the most part, the trip was pleasant and great fun. I flew to California and stayed with her for a few days. Then I drove her up to Corvallis, Oregon, to visit family. She was extraordinarily strong in spirit and body, but there were days when her age sort of caught up with her. On those days, she was touchy, even grumpy. And, on those days she acted not so darling. In fact, she made me downright angry a couple of times.

Really angry. In fact, I could not even talk to my mother for fear that I would let that anger tumble out in a stream of mean words.

To be completely honest, I wanted to be mean. I wanted my mean words to hurt her and make her feel what others endured when she was being less than lovely. But, thankfully, my conscience was exceptionally active on this trip. More than once, I heard the gentle voice of the Lord caution me not to spread meanness, but to spread love. Well, I was fresh out of mama-love and literally experienced some of the same feelings I felt when I was 13 years old, when I thought I was way smarter than my mom. Aware of my regression, I knew that the most loving thing I could do at that moment was NOT to speak. I just tried to listen. Then the Holy Spirit went to work. Inwardly, all I could hear were Bible verses about Love. I am telling you, my mind went into high gear and placed on center-screen every verse and saying about love that I ever heard! It was awful.

As the divine words rolled across the center-screen of my mind, I could not help but compare my current feelings to what was on the screen. I was not living up to the challenge of authentic love; in fact, I was not even close. It literally took me two full days before I could converse with mama beyond "yes" or "no" questions.

Thankfully, my thoughts eventually softened, and I no longer felt like being mean. I went on to enjoy the rest of the trip with my mama. How grateful I am that love won out on that road trip now that she has passed on.

I truly do believe in the life of love. But like most of us, I believe it more on paper than when faced with a 92-year-old mama on a tear! In principle, I just love the idea of love. But, when it came down

to acting lovingly with my naughty little mama in those tough moments, I was less committed.

Still, I did choose love, and you can too. I was not saintly, mind you; I chose love like a kid that must say yes out loud to her parents while still yelling "NO!" to them on the inside. But in the end, we must follow Love. Do not bother to preach it, brother and sister, unless you plan on living love out on the stage that exists within your own four walls.

My friend Dona prays, a lot, for specific people. She prays so much that she sees herself as an intercessor. She spends a lot of time interceding for grace, truth, and mercy to come into the lives and situations that are brought to her attention.

One day in her prayer time, God stopped her mid-sentence with a powerful thought.

"Do you love them?" He asked her.

She was stunned by the question, and speechless before God. Isn't the very act of prayer an act of love? As she pondered this question, Dona realized that, simply put, the answer is no. Prayer can be motivated by other things as well. Prayer can be motivated by duty, or anger, or fear, or even frustration.

At once, my friend Dona knew that this was clearly God speaking to her. And she knew that to be more effective in prayer for others, she must add more love to her prayers, activating her faith through love. (Gal. 5:6)

Love is an intentional state of mind, a state of mind that must be chosen daily. Choose Love as a way of life; it is a choice to be made,

moment-by-moment and deed-by-deed. Love is the currency of God's Kingdom, and it cannot be counterfeited. If we are walking in the Divine flow of God's Love, it will show up in our language, our actions, and our intentions.

This brings me to why I say that nothing works right without Love. To try to drive your Christian life forward without love is like having a car with no engine. The car may look good, but it will not drive. It just does not work. But what about when you have the engine, and are trying to love, but the engine stalls?

Another example of this in my life was when, years ago, I was deeply hurt by some very religious people. They even seemed to be attacking me and were mean to the point of becoming my enemies. I reacted in self-defense, of course. But in my prayer time God said, "Let me be your defense." That was hard. Self-defense was a highly developed skill of mine, due to the conflicts I lived through. But I learned that self-defense and love are nearly always antithetical to each other. One cannot hold each of them in the same palm. Self-defense always wants to clench the fist, while love always wants to open the palm and reach out, letting love flow, spread out, and cover that which is uncovered.

In this incident God whispered in my spirit that He wanted to be my defender. But it was so hard to trust him because the source of my hurt came from people who claimed to be following Him! This was very confusing and frustrating to me. I was also hurt because I kind of believed, deep down inside, that God liked them better than He liked me. After all, they were famous and well known, with a large and successful public ministry. Wasn't that evidence of their superiority?

I was young, not yet battle-hardened, and not wise to the ways of God. And, at the bottom line, I cared what these religious leaders thought of me, very much. I wanted them to love me, even though I was having a hard time loving them.

In time, I let go of caring what these religious people thought of me and by making myself care more about what God thought of me, instead. I also kept my eyes on the task of staying in right relationship with His laws of forgiveness and the pathway of love. It was not quick or easy; it took years for the wounds caused by these people to heal. But eventually, practicing forgiveness and walking in the pathway of love became my avenue of healing. Today I can honestly say that I love those people who persecuted me. I still do not approve of their ways of living, or of their unloving actions. But guess what? What I think does not matter to them, and what they think no longer matters to me. The laws of forgiveness and the pathway of love has set me free.

The great Methodist evangelist Tommy Tyson once said, "The person who has the least to apologize for should be the first to apologize. For, indeed, his load is light compared to the burden of guilt that the offender carries."

Are you the person with the least to apologize for in a broken relationship? If this speaks to you, as it did to me, give it a try. I applied these words, and they helped me get unstuck on the pathway of love.

Love your enemies

"You have heard that it was said, 'You shall love your neighbor and hate your enemy.' [44] But I say to you, Love your enemies and pray for those who persecute you, [45] so that you

may be sons of your Father who is in heaven. For he makes his sun rise on the evil and on the good and sends rain on the just and on the unjust. ⁴⁶ For if you love those who love you, what reward do you have? Do not even the tax collectors do the same? ⁴⁷ And if you greet only your brothers, what more are you doing than others? Do not even the Gentiles do the same? ⁴⁸ You therefore must be perfect, as your heavenly Father is perfect." (Matt. 5:43-48)

What did Jesus mean when he said *this*?

These words of Jesus go beyond the type of love that sends best wishes to a colleague at work, or a thoughtful greeting card for a friend. *"Love your enemies and pray for those who persecute you"* requires a sacrifice. For starters, to do this requires you to sacrifice your comfort zone, and almost always, your pride. But sacrificing for others is fine medicine for you and me. Everyone is born self-centered, and like a knotted, root-bound plant, self-love left to itself only serves to insulate us from reality; it causes us to grow twisted and inward. To flourish and grow in a balanced and successful way, we need the medicine of love that requires us to go beyond ourselves; to not just do for others what is easy, but to sacrifice on their behalf. And so ultimately, to love your enemies is to choose the way of the cross.

In reading the New Testament, one comes across verses referring to living a "crucified life." These verses sound so obscure and remote to me. What does it even mean? But if you look closer, "the crucified life" is simply the way of Love. To love like Christ, we must intentionally crucify our own self-wishes, self- preservation, and loveless acts of self-protection for the good of another. Do you want to love like Christ? Then be prepared to deny yourself. This is the way of

the cross. Do you know Jesus? Do you know Love? These are the two questions that reverberate through the universe and down through the corridors of time.

But back to our daily, practical situation, what if you just can't muster up any love for your enemy, or even pray sincerely for those who persecute you, no matter how much you choose the way of the cross? When Jesus' could not muster the forgiveness within himself, consider this: he asked God to do it for him.

"Father forgive them for they know not what they do," Jesus prayed. (Luke 23:34).

We too can do this. When it seems impossible to forgive someone, we can also pray "Father forgive them for they know not what they do (and even if they do!)." And, If we really want to gain the upper hand, we can go the next step and bless that person in our prayer, asking God to help them become the good person that He originally intended for them to be; we can ask God to draw them back to his original plan and purpose for their life.

As you pray for your enemies and persecutors in this way, you will find things changing inside yourself as well. A new freedom will grow in your heart. You will find yourself finally letting go of things that have bothered you for so awfully long.

The bottom line in this: however we manage to do it, we must choose love. We must choose it not just once, but every day. How can I ever find the grace to keep making these choices? The key is Jesus. Jesus is a bottomless well of love and life from which we can draw daily to fill our bucket of love. Staying close to Jesus – through

prayer, His word, and walking in His ways – is the key to cultivating and understanding a life of true love.

I believe that Christ is Love and continually challenges us to make love our lifestyle, not a religious gesture. Was my love apparent on the day I was dealing with my 92-year-old mama? No, honestly, it really was not. In the heat of the moment I chose momentary survival and self-protection. I chose to isolate myself. I chose not to be vulnerable. I chose silence, rather than dialogue.

That simple two-day conflict with my mama reminds me how hard it is to love in the context of everyday life, especially with immediate family. Yet, love cannot remain just a lofty concept. To be valid, love must be real to those who see us in our jammies, not just those who see us on some stage. From the family nexus, an authentic love can spread out to the other parts of our lives, like concentric ripples in water.

Here is another test of the work of love. What if I am judged by others as inadequate?

I come from a Christian tradition that teaches that certain sins or lifestyle failings, even if corrected, will forever disqualify a person from ministry. Certainly, the things that happened in my life crushed my religious reputation to the point of no return. After all, I was not only divorced once, but three gut-wrenching times. That alone disqualifies me from the ministry, according to many Christian traditions. So have I lost my calling? Do I still have any purpose in life?

Because of my past weaknesses, am I now inadequate to serve Him? This question agonized my soul and filled my prayers.

Then one day, it dawned on me. There is a ministry that I can lead out in; one for which I will never be inadequate, and from which I can never be disqualified. In fact, every weakness or sin I endured and recovered from makes me better qualified for this ministry. What is this ministry?

It is the ministry of Love. I can never be disqualified from the ministry of Love. In fact, every difficulty, every sin, every suffering, makes me better and better fit for the chores of love.

Suffering, sin, and loss deepen my capacity for true compassion. Humility gained from loss serves to connect me deeply to others who are hurting and need Jesus' Love. Redemption of my circumstances expands my hope for others as well as myself. All of it makes me a better lover of God and lover of people. There is literally no hurt or sin or loss in life that keeps me from being better at loving others, once the storm has passed.

The highest calling on my life is not to preach in a pulpit or sing on a glittering, smokey stage. The highest calling on my life is to spread God's Love. And brother and sister, this is your highest calling as well. Joy unspeakable! No matter what happens to you in life no one can take your purpose and calling away!

If I am ever attacked by those who look at my failures and see me as lacking, I will not defend myself. I will either be defended solely by God, or not at all. His Love alone will cover me. Isn't that Glorious? There is no better covering and protection than God's Love. Love is the bedrock of the universe, and its animating force.

And, indeed, at the end of all time, how will we answer to God for our lives, our ministries, and what we have done with our lives?

"Then the King will say to those on his right, 'Come, you who are blessed by my Father, inherit the kingdom prepared for you from the foundation of the world. [35] For I was hungry and you gave me food, I was thirsty and you gave me drink, I was a stranger and you welcomed me, [36] I was naked and you clothed me, I was sick and you visited me, I was in prison and you came to me.' [37] Then the righteous will answer him, saying, 'Lord, when did we see you hungry and feed you, or thirsty and give you drink? [38] And when did we see you a stranger and welcome you, or naked and clothe you? [39] And when did we see you sick or in prison and visit you?' [40] And the King will answer them, 'Truly, I say to you, as you did it to one of the least of these my brothers, you did it to me.' " ~(Matt. 25: 34-40)

In the end, my friends, we will not answer for how perfectly we lived, but for how perfectly we loved.

The Eleventh Golden Thread

*Years ago, I had a prophetic dream about connectedness,
a type of connectedness I would not fully understand for
decades to come. I saw something in my dream world that was
so strange and deeply significant that I was shaken to the core.*

*The dream was symbolic, and only after a lifetime
can I begin to fully grasp its meaning.*

The dream still speaks to me in ways I cannot explain.

*Come meet the Basement People – captives of shame,
hiding in the shadows. They have been neutralized by shame;
their sense of purpose stolen. They were rendered immobile
by the ugliness of their wounds and their scars.*

*But Jesus invades their basement hideout and sets the captives
free. He heals and restores them - right there in the basement.*

*He leads them back out from the basement's shadows into
His marvelous light, the sunshine of his love and
transparency and brilliant purpose.*

Chapter 11

The Basement People

I PULLED UP INTO THE driveway. I hadn't been gone but a couple of hours, but something was different; something was wrong. My home, normally a welcoming place made of old cedar logs, big river stones, and a garden full of flowers, did not seem so open-armed this afternoon. The door that leads from the broad porch to the kitchen was slightly ajar.

How odd. I knew that I closed that door and locked it when I left.

I quietly climbed the stone stairs to the porch and investigated the window, looking into the kitchen. All the cupboard doors were open and there was a canister of flour carelessly dropped on the floor. It shattered when it fell, sending flour and broken pottery bits all over the floor.

For an instant, I was paralyzed by fear. Someone broke into my home.

Quickly, I exchanged fear for high alert, and urgent questions began to tumble through my mind. Were they still inside? What were they looking for? Why did they ransack my house?

As I stepped in the door, the damage unfolded before my eyes. Strewn across the room were broken lamps and china vases and picture frames. My most treasured Chinese export blue and white bowls lay in pieces on the floor. The sofas in the living room next to the kitchen were ripped open with long knife gashes in their upholstery, spilling down and strewing feathers all over the room. Valuables were missing. This was more than a robbery. This was vicious. It was clearly an attempt to destroy my belongings.

With one cruel destructive crime spree, my memories were gone, priceless photos were destroyed, collections I delighted in were broken and crushed. In a trance of shock, I closed the door behind me.

Suddenly, I heard a car roar into the driveway and slam on its brakes, gravel plinking like little torpedoes on the rock retaining wall. My head whipped around to look out the window where I saw six terrifying-looking men crawling out of an orange metallic car. They were talking and laughing as if they were about to go into the store to buy a case of beer. Yet violence hung around them as surely as the smell of burnt tobacco and sweat. A couple of them lit up cigarettes before they took a run up my steps, two at a time.

I bolted down the hall, hoping to make it to the basement door before all of them got into the kitchen, but they were in the house before my hand reached the basement doorknob. They saw my desperation and laughed. The guy who seemed to be the ringleader said to the others "Don't bother with her now; we can take care of her later."

One guy picked up a Cuisinart cutting blade off the kitchen counter and hurled it toward me. The blade whizzed by my head and sank into a cedar log. Instantly I knew they came not only to burglarize my

house, but to kill me. Their confident and casual manner communicated that they were at ease with what was already done, and with what they were about to do. It was horrifying. They were cocky and sure that even if I did manage to get to the basement, I would not escape.

This was clearly the second time today that they broke into my house. As I ran past my study, I noticed out of the corner of my eye that the phone lines were ripped from the wall. The burglars nearly emptied the house, and what was not taken was heavily damaged. Clearly, they returned to finish the job.

I locked the door behind me and headed down to the basement. The old cedar door with hand-forged locks was sturdier than most basement doors, but still no match for six trained killers. They could – and I felt certain they would – break it down. But how long did I have before that? Was there anything I could do to save myself?

When I got to the bottom of the stairs, I saw my two small daughters huddled together, frozen with fear. Beyond them, I heard voices – lots of voices. As I looked more closely, I saw that in my basement were a dozen or so people. They were just sitting around the game room, aware of the threat upstairs, but seemingly helpless. In fact, when they saw me, it was clear they were looking to me for hope, or answers, or perhaps even to lead their rescue.

At that moment, however, my only concern was to save my children's lives and my own. I grabbed my girls by the hand and headed toward the double-doors that led from the basement out into the yard, away from the house. As I opened the exterior door, I told my terrified daughters to run and run fast. But as soon as we got outside, I looked up to the third-story bedroom windows and saw a man with

his gun trained directly upon us. We were trapped. Attempts to escape were futile; there was no hope of outrunning bullets. Quickly, we retreated to the basement.

This dream came to me on April 13, 1985, while I lived in Brentwood, Tennessee. The dream was so vivid and so real that I awoke with sweat pouring off my body. As soon as I awoke, I knew that I must remember everything in this terrifying vision, because somehow this dream was a message to me about my life and, as it turned out, the lives of many others as well. I grabbed a pen and paper and began to scribble it out in the dim glow of a night light. As I wrote, I also thought I heard the Lord tell me to read Isaiah 54. But for now, I scribbled the details down before they faded in the daylight. I would save that scripture for later.

And so, I continued writing.

As I recall, by the time the girls and I were back in the basement and realized we could not escape, the crowd inside somehow grew to be dozens of people. Who were all these people and why were they in my basement? But I must compose myself, I thought sharply. I must think, identify, and understand. I must find a way out.

I began to speak to the Basement People and at first it seemed like my mouth was full of cotton balls. My words were garbled. I heard a voice coming from deep within me, a voice I recognized as the voice of the Lord. Jesus seemed to be talking straight into my ear, instructing me what to say. With each attempt to speak, my words became clearer and clearer. Each little group of people received these words as comforting and preserving. In fact, these words, sent by the Lord, gave them great joy. I went from group to group of these

Basement People and told them exactly what was being told to me. The words felt full of power enough to do miracles, even though our circumstances themselves did not change.

After a moment, a handsome and beautifully dressed man appeared and began to follow me as I moved from group to group. Although handsome, he was diabolical; a skilled and fearless heckler, there was dark power in his words. Whatever I said, he artfully refuted with a jeering laugh. His mocking was murderous.

Despite the Mocker, I kept saying whatever Jesus whispered to me. Soon, the power of Jesus' Word eclipsed the power of the mocking man. The people in the basement had great needs for healing, deliverance, and inner peace. Under the circumstances, they were facing death as surely as I and were looking for spiritual resolution. No matter how severe their personal needs were, Jesus' words met them all. Not one person was disappointed or left out.

Suddenly the door at the top of the stairs flew open. Two of the robbers came down the stairs. They were sent to put us to death, but, surprisingly, did not seem to be in a hurry. Leaning against a wall, they paused to enjoy watching the Mocker as he snidely mimicked me. But it wasn't long before they did the unexpected. With people all over the room being healed, suddenly the two killers joined in. They began telling me of their physical needs and the great brokenness they felt in their own souls. When they heard the words of Jesus, the would-be killers, too, were transformed. Their eyes immediately looked different, and even their faces became softer and kinder. Seeing this transformation brought hope to the Basement People, and laughter broke out all over the room.

The growing happiness among the Basement People was not shared upstairs. It did not deter the killers above us, nor did it silence the Mocker. Other men soon followed them to finish the job that the first ruffians failed to complete. But before killing the Basement People, they too paused to watch and listen to Jesus' words, albeit skeptically. Even in my dream, I wondered at these strange circumstances: a basement full of people and a group of thieving terrorists coming down to kill us from upstairs – yet failing. What was happening? What did all this mean?

Then suddenly, I understood. The Basement People were regular people, just like you and me. But something bad must have happened during their lives, something that knocked them off track. They each lost out in life and lost out in a big way. As I learned more about them, I discovered that some lost children to tragic deaths, while others lost significant jobs, or worse, entire careers and ministries. At one time they had been mighty and successful, but now their lives were ground down to nothing. Some people once held positions of great prestige and respect, but all was stolen from them. Others suffered from self-made losses. Humiliation and scandal were written on the face of many whose personal histories were full of missteps and falls. They were Basement People now, with a heaviness of heart that came from a quiet storm of self-loathing.

Shame hung like thick smoke in the basement air.

Shame drove these people to seek protection in the basement. Some believed God sent them into this exile and were now angry with both God and man. The Basement People felt they lost their right to freedom, to live unguardedly in the daylight, where their every flaw could be easily seen. Now they found freedom of a different kind in

the basement, a freedom offered by the basement shadows. Basement-freedom was freedom from judgment, particularly the judgment of religious or socially perfected folk. But basement-freedom depended on hiding in the shadows. The shadows of the basement blurred their obvious losses, softening the harshness.

The crowd in the basement was intimately acquainted with pain. Perhaps their greatest pain was their sense that they would never achieve in life what they were meant to accomplish with their lives. These were people with emotional bruises and obvious scars, and, in a good many of them, wounds were still fresh and oozing.

I could see into their hearts and made a mental list of what I saw there. A large proportion of these people used to be active Christians, even active in Christian ministry. Others suffered similar wounds, but their sources were different. It did not seem to particularly matter what the source of their wounds was; the results were the same. They all lost their previous positions in life and their influential voices were now silenced. Under the circumstances, they gave up; gave up on their callings, threw away their dreams of serving God in great and mighty ways, and, in a very real sense, some even said "to hell with it" – banishing everything that was once the driving purpose from their lives.

The basement was like a battlefield where the dead and wounded were laid aside while the rest of the soldiers marched on and away. Those left behind were left to die alone, truly abandoned.

So, these were the Basement People.

I noticed a woman sitting on a low bench, her head in her hands, with tears spilling out between her fingers. Her head was covered

with a floral scarf tied neatly at her throat. I took her chin and lifted her head.

"Why are you weeping?" I asked. I thought she would speak of her fear of dying in our present situation, but her answer surprised me.

"My life is useless. I am useless. I have nothing to show for my life but years of mistakes, wrong turns, and failure," she sobbed. "Look at me. I am no longer beautiful; I have no money or home. I embarrass my kids, and my friends have scattered. I do not regret losing things. But my greatest loss is that I have squandered every ounce of my life's purpose."

Then the Lord whispered the sweetest words into my ear that I ever heard. I, in turn, whispered them to her.

When she heard these words, her head popped up and her eyes turned a brilliant shade of blue, almost lavender. She was instantly transformed. The glow of a young bride crossed her face. Years faded away from her countenance; miraculously, she was young again. Gone were the deep worry lines on her forehead and the frown lines about her mouth. Her hair, which was gray and thin, now tumbled out of her scarf in rich, dark curls. A force of life itself overtook her slight frame.

As she stood and began to walk, her feet barely brushed the floor, as if a prima ballerina was born right before our eyes. She wanted to dance and so grabbed the hand of the first man she saw, one of the killers – rough, unshaven, brusque, and clumsy. Her touch, however, gentrified him. Her smile brought dignity to this angry man who fully intended to kill us all. Just as quickly as the years faded from her face, vengeance and cruelty faded away from his.

Something in her touch relieved his pain and caused a deep-rending tension to simply evaporate. The ruffian sorely wanted whatever this woman had that was bringing such beautiful waves of peace and waves of wholeness to them both.

Somehow, the killer knew the answer was Jesus. He quickly accepted the heart of Jesus into his own with tears of repentance mingled with joy. As it turned out, the man sent to kill us was only recently released from a long prison sentence for murder. Now he was made clean, redeemed from things deeper and meaner even than murder – the deep stains of sin on his soul. He instantly became like a new baby inside, all pink and new, untouched by evil.

Simultaneously, others in the basement were transformed. Something like an old-fashioned church revival was breaking out, permeating every inch of the basement. No one was untouched by it, except the Mocker. He still made fun of everyone and told them that what they were experiencing was fake and would soon pass. His message was that the transformations all made no real difference, and the Basement People would end up as worthless as ever when this frenzy was all over.

The Basement People came to my basement as misfits and discards. But now in this crowd of misfits a new kind of energy was flowing, a better energy. The new energy consisted of incredible love. And power. And newness. The Basement People's past was not a problem to Jesus, whatsoever. As they turned to Him, everything old became new. The basement, which was destined to become their place of death, was now invaded by Jesus, and became instead their turning point, the place of a second chance, a chance for a new life. Clearly the Lord was in this very room. Even though the Basement People would still face a wall of judgment when they left the basement

and attempted to reintegrate into society and the traditional church, this army of misfits was changed. They were full of new hope and redemption instead of being covered with shame.

Still, there was one tragic scene that remains burned into my memory. There was one man who came down the stairs, not to mock or to kill or even to discredit anyone. He came asking for help. He wore a Ralph Lauren denim shirt, a nice belt, jeans, and dressy loafers. He was a well-known con-artist, famous for tricking his best friends out of thousands of dollars. But he walked up to me and said the strangest, most sincere thing.

"I want to be holy," he said.

As he said these words, a light overtook him and suddenly, he began to glow. Soon I could barely see him because the light was so intense it was like looking into the sun. Pearl-like bubbles of light covered him and flowed over his shoes and onto the floor. He was no longer even visible! He was consumed by a beautiful mass of brilliant white bubbles that caused the whole room to be as bright as a million suns. He no longer seemed to be even human; he was transformed into an instrument of worship. His entire being was focused on and directed toward God, and only worship and otherworldly sounds of praise began coming from his mouth.

The Lord told me to tell the people not to touch the transformed man or they would die. I announced the warning, so the crowd circled him and worshipped along with him. This man was Holy unto the Lord, as well as wholly given unto the Lord.

But strangely, two seemingly devout Christians began to whimper instead of worship. They wanted to touch the transformed man!

They thought that if only they could touch his glory, perhaps it would rub off on them! Their desire for this grew quickly and was soon greater than their desire to obey God. Thinking they knew better, they trembled and reached out to touch the holy man, even though others repeated the warning.

"Do NOT touch him!" several said. "Did you not hear? God says do NOT touch the glory! Only worship God!"

Yet they were mesmerized by the light, like moths drawn to a flame. They continued to reach out to him, reaching, stretching to touch the glory. Finally, their hands brushed the holy man's arm. Instantly, they both fell dead.

The power of their rebellion, though cloaked in religion, was greater than their love of God, and they paid the ultimate price. Shock, sadness, and pity rippled like waves through the people in the basement, but the Mocker threw his head back and roared with laughter.

Soon after their death, the Lord asked me to gather the people together and tell them that it was safe to go home now. He said to tell them that the Holy Spirit would be coming to each of their homes before the week was out.

One lady was suddenly defensive, presumably about deeply ingrained religious boundaries. She spoke up rather loudly. "Well, does that mean we have to speak in tongues?" she asked.

Amid the dangers of the basement, the old denominational question seemed out of place. Nevertheless, God gave me a simple word to calm her fears.

"You will just have to ask the Holy Spirit about that," I said. "But I do know that you will have good conversations with Him, and you, along with your household, will have many great blessings."

The answer seemed to satisfy her.

All six men who came to rob and murder us were instead transformed by Jesus. We all witnessed the power and love of Jesus; we were all forever changed by what we witnessed. Suddenly the Lord told me to tell the people who the Mocker was. The Basement People were impressed by his beauty and intelligence at first, even though it was plain that everything the Mocker did was ugly. His mission among them was to thwart the words and actions of Jesus.

"Please look at that man." I said. "The Mocker is evil. He came here to deceive and distract you from hearing the words of Jesus."

As soon as the words were out of my mouth, the Mocker let out a chilling, wicked stream of laughter, turned and vanished. For some reason, people in the basement did not even suspect that the Mocker was the Devil in disguise. The Devil was walking among us and even joined in our conversations. But the Mocker did not look like the Devil to the Basement People: he was unusually elegant and beautifully dressed. But now they were free. I was comforted by the realization that even though he completely deceived the Basement People, he was not allowed to prevail.

After the Mocker was gone, the Basement People were magnificently restored to a full life. All shame, sense of uselessness and lost life-purpose became consumed by the Power and the Love that permeated the very air we breathed that day. The Basement People were now free, and it was safe to leave the confines of the basement.

But there would be a phase two for the Basement People. As they left the basement and attempted to re-enter normal church life, their presence at church would be a test not only for them but for the church at large. Many wondered if they would be marginalized as damaged goods or would these people be accepted and embraced by church folk? Would they be allowed to lead? To serve? Would they be accepted by a church culture that tends to revere and celebrate "celebrity pastors" and dynamic leaders and young singers whose lives appear to be perfect and prosperous?

My sense of what God wanted to say to the Basement People was this:

> "Do not concern yourselves with what others may think of you; hold fast to Love's directives. Pursue your calling, your anointing, and your destiny with the passion and grace that Love has bestowed upon you. Live fearlessly; Live intentionally; Live with dignity. Live beautifully; you have each been repaired with gold. But be aware that your resolve will not be celebrated by everyone, including some in the religious world. Be on guard; your joyous new call will be challenged when you least expect it; and sometimes even by those whom you trust and love the most."

Early in my Christian faith I absorbed a scriptural doctrine that taught I should become perfect, like Jesus. But the phrase "perfect like Jesus," in my American mind, came to mean something quite different from what scripture intended. "Perfect like Jesus" somehow meant materially successful, in my mind; with problems easily overcome by faith in the name of Jesus. I unwittingly expected that in following Jesus, I would automatically hoist myself to the top of humanity's heap. I never imagined that in the process of following

Christ I might once again be broken, tumbling from the top of the heap to the sidelines, again in need of repair. But this was the story of the Basement People, wasn't it? Many of them made it to the top of the "Christian" heap, then fell off again; some even fell many times. Sometimes it was their fault, sometimes it wasn't. Yet no matter the cause, Jesus met them there, again, and they were restored. I began to see a deeper truth in that dream; that "the way up is found by the way down."

Now, after a lifetime, I better understand the message of my Basement People dream. Mature Christians, at the end of the road, are not the ones with unmarred, perfect lives, all the right answers, and an abundance of material goods to prove they are blessed. Mature Christians are the ones who overcome and don't lose the faith. They are the ones who fall off the heap but return to Jesus when knocked down; they return to Him when they would sometimes rather walk away. Others may walk away at first, but later return to God, with greater humility and more to give. They overcome not because they are perfect, they overcome because they keep coming back to Him.

"He who has an ear, let him hear what the Spirit says to the churches. **To him who overcomes**, I will grant to eat of the tree of life which is in the Paradise of God." Revelation 2:7

The Twelfth Golden Thread

What do I see these days when I look in the mirror?

I see Patti Roberts Thompson with lots of scars. But I am no longer ashamed of them. Today, those scars radiate with redemption. They are beautiful accessories to my humanity and God's faithfulness.

Nothing was for naught. Nothing has been lost. Everything has been gained. I can unwrap my most feared scars and only find beauty; and, there is a language in my spirit that sounds like it comes from Heaven. It is the Language of Scars.

And so it is with you. When you look in the mirror, what do you see? Scars or redemption?

If you see scars, allow Jesus to touch them and transform them. Choose to forgive. The day will soon come when you, too, can unwrap yourself, and behold the glowing beauty of who you have become.

Chapter 12

Take the Rocks Out of the Box

Establishing the provenance of a work of art or an antique is a necessary step in authenticating an item and assigning appropriate value. In the fine museums of the world there are teams of people who are assigned to establish provenance, each specializing in different historic periods, and different mediums of artistic items of value. A museum does not accept a donation or purchase an item for its collection unless the provenance is well established. This is because the authenticity of an item is crucial to pronouncing its true value.

Researching the provenance of paintings, other works of art, books, wines, and items of supposed value calls for solid documentation. Documented evidence of provenance for an object helps establish that it has not been altered, is not a forgery, a reproduction, or stolen or looted art. Provenance assigns the work to a known artist, and a documented history can be of use in helping to prove ownership. A chain of ownership is also extremely valuable in establishing authenticity and value.

Recently, I purchased a painting that seemed of little worth. I bought it simply because I thought the painter produced some beautiful clouds above his main scene. The painting went unnoticed by seem-

ingly everyone but me. The frame was scratched, the wood marred by dents. Even had the frame been perfect, it was not a pretty frame. The painting suffered because the frame itself was ugly.

The ugly frame, however, did not matter a bit to me because I was not considering hanging the painting in my home. I merely bought it to study the beautiful clouds.

Day after day I would prop the painting up in the light and study those clouds. I have always been fascinated by the movement, color, and shape of those billowy breaths of God that float across the blue dome above. As a child, I would lie down in the cool grass of our yard and watch their eternal dance. I would get lost in their magnificence; lost in how they could shape and reshape themselves, and how their colors would deepen and soften as they passed beyond my sight and on to the delight of some other little girl who, lying in her yard, focused her eyes on the same cosmic beauty.

After observing the clouds in my painting, I dropped my gaze to the main subject matter. There in a winter scene were windmills, farmhouses, and skaters skimming the ice of a frozen river. The paint was old and sported fine-line cracks, yet the beauty was not at all affected. I did not know the age of this painting but could surmise that it was incredibly old. The board on which it was painted was also a point of wonderment to me. And the painting that began as a "lesson in cloud studies" was now becoming more and more an adventure of discovery.

Chris, my scholarly husband, became interested in studying the painting, not for clouds or skaters, but for provenance. For several months he visited museums and libraries looking for other works by

this same painter. And, he did not have to look too far or too long. A quick delve into the internet proved to be heart-stopping! The artist to which the painting was attributed was Aert Van Der Neer, born in the early 1600's and dying sometime after 1672. Van Der Neer has about 640 known paintings that are sprinkled around the great museums of Amsterdam, London, New York, and in private collections of the very wealthy.

I sent pictures of the painting to Sotheby's and a few other auction houses. The Old Masters authorities of these various auction houses all said about the same thing to me. "It is a copy of an original Van Der Neer, or a painting done in the 'manner of' a Van Der Neer." They exclaimed that it was in a "later hand" and not quite as detailed as a true Van Der Neer. "Later hand" in regular-folks language means that the painting was done by another painter, perhaps in the 18th century.

Oh Pooh. We were almost wealthy. My little cloud painting was just a beautifully rendered copy of some 17th century masterpiece. But still, the clouds were ever as lovely.

I bet you wonder why we just came to a full stop and took a little art lesson, don't you?

Please retain what I have told you about the importance of provenance, and we will move on.

In the middle of the 1970's I was given a beautiful box made from semi-precious stones. The top and the sides were fashioned out of smooth, sliced planes of solid jasper. The bottom of the box was a big slice of amethyst. This box has never been too far away from me since I first received it, and whenever I moved, it was lovingly

wrapped, secured from harm, boxed-up and labeled: "Fragile. <u>DO NOT DROP</u>."

The box was a gift from the husband of my youth. To establish its provenance, allow me to tell you where he got it. He purchased it from the artisan himself on a missionary trip to South Africa. The artisan must have been quite gifted because the box not only derives its beauty from the semi-precious stones of which it is made, but also from how beautifully it is crafted.

I was given this lovely treasure, a box made from semi-precious stones, on my husband's return to Tulsa from South Africa. It seemed only fitting to put small keepsakes, especially other interesting stones, into this valuable box. Eventually, I placed within the box several little treasures; a rock with bits of garnet shining through, a small amethyst egg, and a piece of polished malachite that struck my fancy. I also kept a 6-carat yellow topaz in the box, and an assortment of smaller, loose semi-precious stones. One of my favorites was a large oval of Lapis Lazuli. Although this might not have had much value on the market, the Lapis Lazuli, too, remained in my box.

Then I placed a completely different kind of treasure in my box. After a trip to Israel, I deposited a small square rock that I picked up while visiting the historic site of Masada.

Anyone with a knowledge of Jewish history recognizes the significance of Masada to Jews and Christians. But in case Masada is unfamiliar to you, allow me to briefly explain. Masada is an ancient fortification in the Southern District of Israel, situated on top of an isolated rock plateau, akin to a mesa, on the eastern edge of the Judaean Desert, overlooking the Dead Sea. It was on this high

mountain in the deserts of Israel, once a great place of refuge, that a terrible carnage took place.

While ruler of Israel, Herod the Great built a lavish and lush mountain retreat high up in the Judean hills and named it Masada. Herod's retreat boasted at least two palaces, swimming pools, bath houses, and every sort of amenity to make it a proper resort for a Roman ruler. After Herod's death, the Jews began a revolt against Roman occupation. (67-73 C.E.) A group of the Sicarii (rebel Jews who carried daggers) fought against the contingent of Roman soldiers sent to guard Herod's magnificent resort. The Sicarii overwhelmed the soldiers and took refuge in Masada.

After the fall of Jerusalem and the destruction of the Temple (70 C.E.) another group of Jews joined the Sicarii up on Masada. After the revolt of the Jews was subdued in the rest of Israel, the Romans decided to dislodge the rebels at Masada. Nearly 10,000 soldiers tried everything from starving out the rebels to every known military technique available to them to outwit the Jews and crush this final outpost of rebellion against Rome. But Rome did not prevail.

Finally, the Romans built an earthen ramp up to Masada, cleverly using Jewish slaves as laborers. The Romans believed that the Jews would not war against their own countrymen. And they were right.

Soon, it became clear to the rebel leader, Elazar Ben Yair, that the fortress could no longer be successfully defended. He called together all 967 people who were there fighting alongside him and began to speak. Elazar pointed out that long ago, their forefathers vowed to serve only God, and never to serve another master, Roman or anyone else. He called on them to die as free men and women, rather

than become captives of pagans. All 967 agreed; they would die free. And so, lots were drawn, and 10 men were chosen to kill the 957 who laid down and uncovered their necks. When all were dead except the 10, one man was chosen to kill the nine and then finally, to kill himself. When the Romans broke into the fortress, they would find them all dead, yet unconquered. Thus, to the coming ages, the zealots of Masada left a message of what it meant to prefer serving God above serving any other master, even if it cost one's life. (Editors, Jewish Virtual Library n.d.)

To this day, Jews around the world have a saying that refers to two terrible collective memories in their history: Masada and the Holocaust of World War II. When either event is mentioned, "Never Again!" is the mantra repeated.

The phrase "Never Again!" is subtly woven into the beautiful music of the Jewish people. Never again will Jews be left defenseless against those who wish to annihilate them. Never. Never. Never again.

As I stood at Masada, I could feel the vibrations of the agonies that took place there. It was not an act of a tourism that caused me to quietly pick up a small square stone lying on the ground there at Masada. I am not sure about the origin of my stone; it was so perfectly square that I wondered if it was a remnant from Herod's ancient mosaics. But I knew it must go into my Jasper box. The worth of the rock from Masada to me was not in its status as a semi-precious stone. Its value was in what the stone represented to me personally. As a tile from Masada, it represented a battle, a loss, the defiant death of a dream. Just as Masada represents these losses to Israel, the tile represented the same to me.

After adding the stone from Masada, the provenance of every stone I added to my box was based on its association with a sad or poignant memory. My stones were not just rocks. Although many of them were things of beauty, the memories that gave them provenance in my box were not. For years I could pull out and hold one of those pretty, yet sad, stones in my hand and feel the reverberations of my own history. As I held them, I found myself flooded with bitter thoughts, angry memories, and an inner voice shouting "NEVER AGAIN will I be anyone's victim!"

Most of us have some sort of box, whether literal or figurative, into which we place small remembrances of seasons in our lives. Some keepsakes remind us of lovely memories. But, for some reason, the un-lovely memories get the largest amount of real estate in our boxes. And, when we look again into the box, we often say to ourselves, perhaps even silently, "Never Again!"

We are all victims of someone at some point, even when we try our best to avoid it. Bad things happening to good people must be the cost of being human in this world. As a matter of self-preservation, we put rocks of remembrance in our box to guard ourselves against ever becoming victims again. And yet eventually, a box full of rocks is heavy to carry. It may even keep us from moving forward. Even if the box itself is beautiful, over time the weight of it becomes more than we can bear.

To move forward, there comes a day when the rocks must be emptied from our boxes. This can only be done through the difficult task of forgiveness. Forgiveness is not an option. Jesus himself taught that unless we forgive, we cannot be forgiven, and the weight of those rocks gets heavier to carry with every passing year. (Matt.

6:14-15) That is one of those immutable laws of the universe. It is the way things are. No one gets the luxury of leaving the injustices committed against them in the box. Forgiveness brings freedom but demands us to empty the rocks out of the box and let it all go.

Does this mean that our perpetrator goes scot-free? No, not at all. In the same way that we are called to pray for our enemies (Matt. 10), we are also called to forgive their debts of sin. To forgive a person who has deeply wronged us means we are releasing that person back to God, to do with them as He chooses, and make of them what He designed. In forgiving our enemies, we let go of our vengeance and let God deal with them. How they respond to God, positive or negative, is outside of our control, but the act of forgiveness gets us out of the way. God can do the work much better without our help.

Forgiveness frees us but forgiveness itself is not free. There is an "invoice" for sin; there is always a price to pay. Debts are owed. Who will pay them?

Fortunately, the bill for our forgiveness was not sent to us. It was paid by someone else. This is good news because the cost of our forgiveness is so high that there is not enough money in all the world to pay it. Even a guarantor for our debt would not be good enough, since there is not enough human currency to cover it. We need a benefactor to step in and pay it off, to wipe our ledger clean. But where could such a benefactor be found? For such a benefactor's check to be accepted, of course, the benefactor would have to prove he or she had the money to cover the bill, as well as the full authority to do so. His or her provenance would have to be irrefutable.

So, with provenance in mind, let us look again at the event we spoke of in Chapter 6 that occurred 21 centuries ago, the time that an angel came to Mary and said:

> "Do not be afraid, Mary, for you have found favor with God. And behold, you will conceive in your womb and bear a son, and you shall call his name Jesus. He will be great and will be called the Son of the Most High. And the Lord God will give to him the throne of his father David, and he will reign over the house of Jacob forever, and of his kingdom there will be no end." (Luke 1:30-33)

"Behold, I am the servant of the Lord," Mary answered. "Let it be to me according to your word." Then the angel left her. (v. 38)

Why was Mary so quick to say yes to the angel? Of course, Mary was a girl of great faith, to be sure. But consider this: by invoking the lineage of Jesus connected to the throne of David, the angel established the baby's provenance as the Christ-child, the Messiah. Mary knew exactly what the angel was saying. How is this? Remember that provenance – the process that establishes authenticity and value – is established in part by proving an object's chain of ownership, by documenting its history.

Long before the birth of Christ, God, through the prophets of old, foretold the lineage of Immanuel, the Christ. The very first chapter of the very first gospel in the New Testament begins with documentation of the lineage of Jesus, back to his forefather Abraham. But if you care to go further back than Abraham, the gospel of Luke can take you there. Luke 3:23-38 walks the bloodline all the way back to Adam and Eve. Jesus' blood bore all the markers of human DNA

clear back to the beginnings of humanity. There could have never been a more Jewish Jew than Jesus, nor a more universal man.

And yet, according to the prophets through the Old Testament and the angel who spoke to Mary, Jesus was also Immanuel, God with us. Indeed, our God – the Creator – came to walk the earth in the sandals of a carpenter's son from Nazareth.

When the Bible says that Jesus laid aside His deity to become a man, we must take a moment to let our hearts understand the enormity of that. (Phil. 2:7, 8) Though fully God, Jesus chose to become fully man, born by woman into the sea of humanity. Leaving His heavenly position as the Word of God (John 1:1-5), limitless in power, knowledge, love, and creative ability, Jesus agreed to carry out His father's solution to provide for the unpayable debt of man's sin.

Every word Jesus spoke, every miracle, every sign, and every wonder, was spoken or enacted as an act of obedience to the will of God. Even when he prayed his agonizing pre-crucifixion prayers in the Garden of Gethsemane, Jesus was praying for the will of God to prevail. He knew what faced him at the cross, and he begged God, like so many of us, to please, please, let him of the hook. But unlike us, he added, "Yet not what I will, but what you will." (Mark 14:36)

Another gospel writer, Matthew, writes it like this: "My Father, if it is possible, may this cup be taken from me. Yet not as I will, but as you will." (Matt. 26:39, NIV) So great was the cost of that very human prayer, the agonizing pressure of the moment, that his body expelled blood through the skin.

The angel established the provenance of Jesus' lineage, but it was up to Jesus to be perfectly obedient, and so fulfill the task of the Messiah.

The pressure he experienced that night was not only the knowledge that he would soon die by crucifixion, but also the knowledge of what was in the cup he would be forced to drink from; a cup full of such pain and sorrow that he prayed to be spared drinking from it at all.

What did Christ see in that cup?

The cup contained the sin of mankind, every thought and deed of human despicability. Perhaps as he prayed, He saw every baby savagely aborted, or every abused child. Perhaps he saw every person who has been tortured by someone bigger and stronger than himself, and every woman forced to betray her glory and feel her body used for salacious satisfaction, or money, or a career opportunity, or even for sheer survival. Perhaps he saw the men enslaved and shackled, like cattle, denied their human dignity and value.

What was in that cup?

A very pure and unsullied Rabbi was praying that night in the Garden. Drinking from that cup would cause Jesus to experience something he never felt before: the guilt of sin. But beyond the guilt, the true horror of sin was in that cup, every form of sickness and death that sin brought into the perfect world God created. Every written or spoken description of Christ's agony falls short, and the words are all, at some level, bereft of full meaning. What happened on that cross is both too big and too horrible for human language to capture.

Perhaps in taking our sins, Jesus not only felt the guilt but also experienced the horror of doing unspeakable things. He was holy; but for that moment, when he bore our sins, did he become unholy? Did the presence of Love leave him? Is that why he cried out to God,

"My God, My God, why have you forsaken me?" (Matt. 27:46) Did every shred of love that he ever felt drain away in that moment, and did he feel evil and hatred come into his body in its place? In taking on the sins of mankind did he feel defiled, did he feel evil urges? Or did He also experience the opposite, the feelings of a victim, of the one being defiled?

What did it really mean for Jesus to drink from that cup?

If even a small part of these imaginings is accurate, no wonder Jesus cried out to God for mercy, to let this cup pass from him, if such a mercy could be had. But on that day, no such mercy could be found.

He could not avoid drinking from this cup if he wished to fulfill his reason for coming to this planet. Atonement meant atonement, and there was no shortcut to grace. Unless the full price was paid, atonement would be perjured and rendered invalid.

He must drink the cup.

We can read the account of Jesus' arrest, beatings, trial, and death in the Bible. We can follow the timeline laid out there in the gospels of the New Testament and read a description of each moment of his physical agony. We can even walk the Seven Stations of the Cross. But what we cannot read about, or walk through, or even truly know, were the unseen things that Jesus experienced in the process of our atonement. None of us can know the pure agony of the Messiah's soul on the cross. What Jesus Christ experienced cannot truly be felt by us. While we can know our own guilt and even the grief of our own sin, we are spared the guilt or grief even of our neighbor's sin, much less the aggregate guilt and grief of the sin of all people who have ever lived. But this is what the Messiah experienced. The Lord's

walk of obedience led him through a narrow passage that was lonely, and for a brief time, completely solitary. The Lamb of God hung lifeless and alone in the corridor of time.

According to scripture, for Christ to atone for the sins of the world, he emptied himself. And, in that moment on the cross when he emptied himself of all his "God-ness" and become utterly human, accepting the burden of evil and sin, he felt abandoned even by God. He cried out "Eli, Eli, lama sabachthani?" that is, "My God, My God, why have You forsaken Me?" (Matt. 27:46)

Jesus emptied himself of his divinity and died as a man. He breathed his last tormented breath, then gave up his spirit. He offered everything he was to fulfill the terrible but magnificent plan of his Father to save the world.

Satan surely breathed a huge sigh of relief in the moment of Christ's death, as the ravaged body of his arch enemy was taken down from the cross and laid in a borrowed tomb outside of Jerusalem. Mortality met the cold slab of stone, where Christ's body was meant to lie until the flesh slowly returned to dust.

But, no one saw it coming, including Satan. No one had a clue of the power of Life that inhabited the complete obedience of The Messiah.

Separated from his broken body, Christ's sinless spirit and soul instantly regained all the "God-ness" he laid down. As he drew his last breath as a mortal, Jesus drew his first breath as the immortal savior, son of God – now the triumphant, mighty son of man and son of God. Jesus was the Word of God that created all things; now He was the Word of God that redeems all things. Now he was unstoppable.

He marched straight into hell and forcibly took the keys, which represent the legal right, to the gates of Hell and Death. (Rev. 1:17)

Make no mistake, it is not as if the keys of Death and Hell were hanging on the wall or lying on the kitchen table. Scripture indicates violence – Christ disarmed the keepers of the keys, the rulers and authorities that presided over those realms. He not only disarmed them; he made a public display of them! For Paul to write that Jesus triumphed over them is to evoke the image of Roman emperors marching defeated rulers in utter humiliation through the streets of the mighty city of Rome, marching them to their death. (Col. 2:15)

And yet, for all its grandeur, the story of the Messiah's triumph over Death and Hell does not end with the parade of humiliated rulers and authorities, nor does it end with Him triumphantly brandishing Hell's keys. The story ends with the preaching of redemption.

"For therefore the gospel was preached even to those who are dead, that though judged in the flesh the way people are, they might live in the spirit the way God does." (I Peter 4:6)

Such is the power of preaching! For any person that has inhabited the dark places of the soul, either here or in the hereafter, the most powerful sermon is the one that shows the way out, that opens the door to a second chance, to a new life. And so, it appears through these references, that the final act of the Messiah's triumph was setting people free – people trapped in the dark places of death. Jesus not only wrestled away the keys from the rulers of Hell, but he unlocked the doors of that dark prison with them and led death's captives out into the Light. (Eph. 4:8-9)

And what did Jesus preach to those captive souls? He told the poor inhabitants of the shadowy realms of death that the Blood of the Lamb atoned for their sins and failings. No longer was Satan the keeper of the keys. Each captive could follow him out and go free! All they needed to do was freely choose God, and follow the Messiah, the sacrificed Lamb, the redeemer of mankind, and He would lead them out.

The Messiah killed the permanence of death. Instead of imprisoning souls with its iron grip, death is now the servant of eternal life; it delivers the immortal souls of the redeemed to the gates of heaven where they can be joined forever to the Eternal Lord of Love.

This is the message of redemption.

It is the art of Kintsugi.

It is the beautiful music of the Language of Scars.

But one last thing ...the debt is paid; will you accept it? The choice is up to you.

I am not a universalist. I passionately believe that the scriptures teach that matters of eternity are within the human power of choice. From Genesis to Revelation, the stories are laid out all the same. They are the stories of men, women, God, and choices; it is always the twists and turns of the outcome of choices that create the tale. Clearly, according to Genesis, God gave man the gift of choice. God gave to each living soul the gift of personal sovereignty. You decide your own outcome.

And so, if people do not wish to be near God while they are living, God will not subject them to an eternity with Himself. If they wish to ignore Christ, the Lamb of Atonement, it is their choice to do so.

Hell is real and remains intact as a refuge for those who do not desire to know and be with God. It is a place for those who have triumphed in the supremacy of their own will, defeating God's design for them, at some level. Hell is a place for those who choose anarchy instead of submission to God as King. God does not force you to serve him. He offers atonement, he offers a clean new life; He even offers His Spirit to live in us. He offers His amazing son, Jesus Christ. If we wish to learn of Christ, follow Christ, and submerse ourselves in Love, then God invites us to inhabit eternity in his Presence. Hell exists as the habitation for those who want to escape His Presence.

What is hell like as a place to inhabit eternally? Jesus calls it a lake of fire. It is totally devoid of God, so all His characteristics -- all love, all mercy, all justice, all goodness, all hope, all faith, all comfort, all peace, all beauty and every other grace that makes this planet a bearable place to live – are gone from there. If one would care to investigate and compile a list of deeds and personality traits of every villain that has cursed the earth with their presence, one would begin to see a faint tracing of the cities of hell. Think of the environment of every war, every prison, every death from a dehumanizing disease, every fouled ocean, every molecule of polluted air, every injustice, every beautiful being, whether man or beast that has been destroyed for gain or pleasure, and pile these atrocities up and compound them by repeated acts in every century, and you will have the environment of Hell. Add the unrelenting fire of indestructible destruction and you have described Hell to a tee. In short, Hell is an eternal agony for which we have no words.

Hell is real, and I do not want to go there for a multitude of reasons. But, mostly, I do not want to go there because God is not there. There is not even the faintest hint of God's presence in that wicked place. He is completely and forever absent from Hell.

So, my box of bitter rocks sits before me, still full ... representing my personal hell on earth: my sins, my failures, my tormentors, my imprisonment to the crushing events of my own life.

Will I let the gift of the Messiah's death and resurrection grant me the freedom and power to empty the rocks out of the box? Will I let go of its contents? Will I find the courage to do so in the courage of the Messiah, the One who took all the terrors of humanity upon himself?

Yes. Yes. YES!

Saying Yes to Jesus feels to me like the greatest privilege and the heaviest obligation. Such a cost was paid for sin! And I cannot deny that it was paid for me. To this Messiah I owe an empty and clean box. You and I both can finally get rid of the rocks in the box. With his help, we can be free.

If we say YES, the first step is to empty the box, to pour out every bitter stone. We can give them to Jesus. He bought them with his blood; they all belong to Him. Trading beauty for ashes is His specialty.

Once the box is emptied of sorrows, we are free to spend the rest of our lives filling the box up with works of beauty and mementos of mercy. Our words can be chosen for blessing, rather than cursing. Instead of lamenting about our sorrows, we can sing with praise and adoration to the Lord of the Heavens, our Christ.

What do I see these days when I look into the mirror? I see Patti Roberts Thompson, still with lots of scars. But those scars radiate redemption, and the Patti in the mirror is holding a clean box, filled with mementos of mercy and diamonds of joy. My scars are now accessories to my humanity. Nothing was for naught. Nothing of value was lost. Everything has been gained. Today I can unwrap my most feared scars and see only beauty; and, in my spirit I hear a sweet language that sounds like Heaven. It is the Language of Scars.

You, too, can unwrap yourself, and behold the glowing beauty of who you have become.

Do you see the gold that has filled up the broken places, the crushed heart, and the cracks in your being? Do you see that the Master Artisan has made your scars radiate with light and beauty? Do you see that you are his most cherished piece of Kintsugi?

You are, indeed. You are.

References

Associated Press. 2008. "Businessman Rescues Oral Roberts University." *NBC News.* 5 February. Accessed August 3, 2019 http://www.nbcnews.com/id/23017687/ns/us news-giving/t/businessman-rescues-oral-roberts-university/#. XUXA1 JKi00

Bentley, Mac. 2003. "39 tribes call state home." *oklahoman.com.* 16 Feb. Accessed July 5, 2019. https://oklahoman.com/article/1914848/39-tribes-call-state-home.

Cherokee Historical Association. n.d. *www.cherokeehistorical.org.* Accessed July 5, 2019. https://www.cherokeehistorical.org/unto-these-hills/trail-of-tears.

Conrad Hackett, David McClendon. 2007. "Christians remain world's largest religious group, but they are declining in Europe." *Pew Research Center.* 5 April. Accessed July 19, 2019. https://www.pewresearch.org/fact-tank/2017/04/05/christians-remain-worlds-largest-religious-group-but-they-are-declining-in-europe/.

Donne, John. n.d. "http://triggs.djvu.org/djvu-editions.com/." *DjVu Editions.* Accessed August 3, 2019. http://triggs.djvu.org/djvu-editions.com/.

Editors, Encyclopedia Britannica. 2005. "Giorgio Vassari: Italian Artist and Author." *Encylopaedia Britannica.* 5 April. Accessed July 23, 2019. (https://www.britannica.com/biography/Giorgio-Vasari, https://books.google.com/books?id=IXvcvv1Fnw8C&pg=PA5&lpg=PA5&dq=.

Editors, Jewish Virtual Library. n.d. "Archaeology in Israel: Masada Desert Fortress." *Jewish Virtual Library.* Accessed July 21, 2019. https://www.jewishvirtuallibrary.org/masada-desert-fortress.

Editors, Michelangelo Gallery. n.d. "Famous Michelangelo Quotes." *Michelangelo Gallery.* Accessed July 21, 2019. https://www.michelangelo-gallery.com/michelangelo-quotes.aspx.

Hoig, Stan. n.d. "LAND RUN OF 1889." *The Encyclopedia of Oklahoma History and Culture.* Accessed July 5, 2019. https://www.okhistory.org/publications/enc/entry.php?entry=LA014.

Martin Luther King, Jr. 1986. "Martin Luther King Junior." *Good Reads.* Accessed July 29, 2019. https://www.goodreads.com/quotes/943-darkness-cannot-drive-out-darkness-only-light-can-do-that.

NAMB. 2016. "A Comprehensive Listing of References to Jesus ('Isa) in the Qur'an." *North American Mission Board,* March 2016. Accessed July 22, 2019. https://www.namb.net/apologetics-blog/a-comprehensive-listing-of-references-to-jesus-isa-in-the-qur-an/.

Tesch, Noah. 2011. "Dome of the Rock." *Encylopaedia Brittanica.* 5 October. Accessed July 29, 2019. https://www.britannica.com/topic/Dome-of-the-Rock.

Tolstoy, Leo. 1869. "Leo Tolstoy Quotes." *Good Reads.* Accessed July 21, 2019. https://www.goodreads.com/quotes/21330-love-is-life-all-everything-that-i-understand-i-understand).

tulsahistory.org. n.d. "1921 TULSA RACE MASSACRE." *Tulsa Historical Society and Museum.* Accessed July 29, 2019. [https://www.tulsahistory.org/exhibit/1921-tulsa-race-massacre/.

About the Authors

Patti Roberts-Thompson

Patti Roberts Thompson – singer, minister, author, and producer – was the daughter-in-law of Oral Roberts and the lead female singer of Oral Roberts Ministries for nearly a decade. She performed on the ministries' national television specials, daily 30-minute programs, and did countless live ministry events. Throughout her early career, she also recorded nearly 20 best-selling vocal albums and did hundreds of live performances, literally all over the world.

But after 10 ½ years of marriage to Oral's son and heir-apparent protégé, Richard Roberts, Patti and Richard went through a grueling divorce. The divorce was more than the death of a marriage; it was also the death of her decade in ministry with OREA, and her career. Her life began a dizzying freefall from the glittering heights of religious show-biz fame to the alleys of obscurity where former Christian celebrities find themselves, after tumbling off the stage. Patti's journey back from these dark places was not a straight line, but today her life has come full circle. She tells the tale of her journey and the things she learned along the way in these memoirs, *The Language of Scars.* Her story is one of redemption, resilience and restoration that offers wisdom and hope for all.

Other works by Patti Roberts-Thompson include: *From Ashes to Gold* (1983, Word Books, Patti Roberts with Sherry Andrews (sold over a half-million copies); *Dance of the Broken Heart* (1985, Abingdon Press, co-authored with John Thompson); El Shaddai the Musical, co-authored with John Thompson, arranged by Ron Huff and John Thompson and adapted for keyboard by Carol McMillen. The musical was published by Morning Gate and distributed by Alexandria House, ©1986.

Carole L. King

Carole Lynn King, an award-winning writer, author, editor, and educator, is a graduate of both Oral Roberts University and Pittsburg State University. She brings a lifetime of writing experience to *The Language of Scars* project as the book's co-writer, developmental editor, and publishing assistant. Like Patti, Carole also married a fellow ORU student who became an ordained minister and launched into a visionary ministry together with him. "Dream no small dreams here," Oral preached, and ORU students everywhere took up that challenge with gusto.

But after 25 years of marriage, visionary ministry, and four children, Carole's husband also walked out the door. Like Patti, she found that his exit took not only her marriage but also her ministry and career. Her 10-year leadership role with the non-profit Christian counseling center she co-founded with her husband evaporated overnight, and there was no compensation. Divorce was devastating and disorienting to all she believed, but the loss of 25 years of investment in joint ministry was irrecoverable. But with four hurting teenagers now to raise as a single mom, there was no time to flounder. Carole

turned to writing, a skill she had cultivated since childhood. As of 2020, Carole has published over 500 articles, won multiple writing awards; served as a business journal editor-in chief; co-written and published eight books, conducted original research for a book on business culture, produced web content and worked extensively in marketing communications. She is also an educator and adjunct college instructor of humanities, English, and writing. She obtained her master's in communication at PSU in 2016 and is an actively publishing writer.